D1800070

POCKET IMAGES

Around
Rossendale

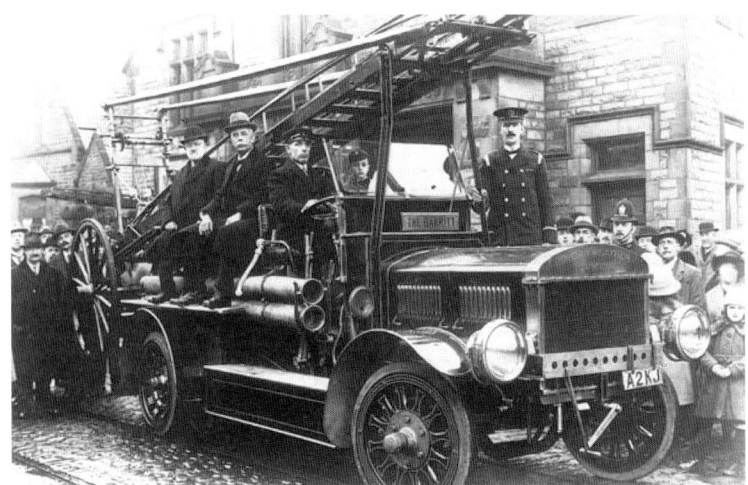

The christening ceremony of the *Barritt* Fire Engine outside the fire station, Burnley Road, Rawtenstall on Saturday 13 November 1920. Sitting behind the driver is James Barritt, chairman of the Fire Brigade, Lighting and Markets Committee for many years, after whom the engine was named and whose furniture removal business is illustrated on p. 105. Next to him is Alderman James Taylor, officiating in the proceedings as the Mayor of Rawtenstall. The fire officer on the right, Percy R. Webber, was appointed Superintendent of Rawtenstall Fire Brigade in 1914 and introduced many improvements to the fire and ambulance alarm systems including the installation of electric call bells in firemen's homes. This motor fire engine, built by Merryweather and Sons, was the second purchased by Rawtenstall Fire Brigade and was 'of a most up-to-date type' with a capacity for pumping 450 gallons per minute. After its christening the *Barritt* was to be driven to Waterfoot for a deep lift test from the river near Bethesda Chapel, then up Turnpike, Newchurch for a hill-climbing test and finally to Hall Carr Mill, Rawtenstall for a pump test. On 20 October 1938 this appliance was, unfortunately, involved in the first fatal accident for the Rawtenstall brigade since its formation in 1887 when Fireman William Taylor was seriously injured falling from the vehicle on the way to a garage fire in Ramsbottom and died the following day. The weather was very stormy at the time and it is not known whether he was blown off by the strong wind or whether he lost his grip.

POCKET IMAGES

Around
Rossendale

SUSAN A. HALSTEAD

The
History
Press

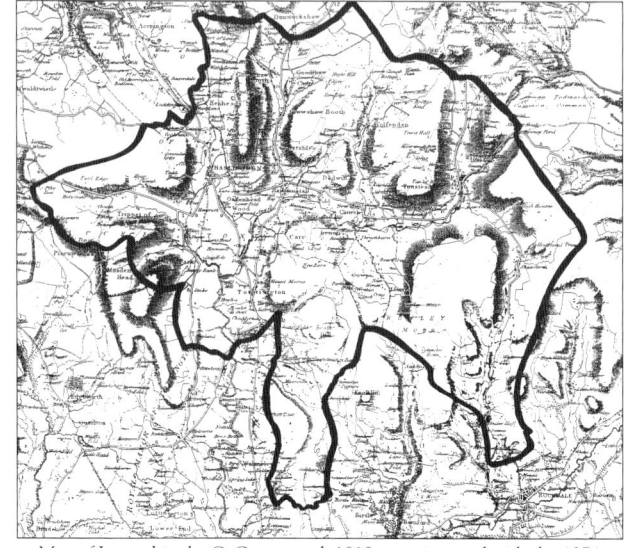

Map of Lancashire by C. Greenwood, 1818, superimposed with the 1974
Rossendale district boundary.

First published 1996
This new pocket edition 2007
Images unchanged from first edition

Reprinted in 2011 by
The History Press
The Mill, Brimscombe Port,
Stroud, Gloucestershire, GL5 2QG
www.thehistorypress.co.uk

British Library Cataloguing in Publication Data
A catalogue record for this book is available from the British Library

ISBN 978-1-84588-399-7

Printed in Malta

Contents

Introduction

'Here I have stood to look at and to look over the uneven moors, brown and bare, warming beneath the dying glow of day, to where the sky was one great stretch of colour, intermingling, deepening, dying – while the little farmsteads threw lengthening shadows from their tiny gables and, with a golden fire flashing from each window pane, flung a farewell to the dying day – the trees crowning the heights in gloom, and putting on a ghoul-like presence as though spectres of the coming night. Is it not a rebuke to us, and to our civilisation, that sights such as these may be seen in own valley, and not one in a hundred have eyes to see them, and not one in a thousand the time?'

(*Rambles round Rossendale* by J. Marshall Mather 1894).

If this were true in 1894, how much more true is it a century on with all the frantic bustle of modern life? Maybe we should all take time to stand and stare. Photographs have the ability to give us instant access to the beauty of 'sights such as these' and an insight into the subject which intrigues us all at one time or another – that of how life was lived. For those with little time or inclination to study the history of their area in depth and for children with their limited attention span (but maybe this applies to more of us than we like to admit!), photographs can offer a glimpse of lives captured forever in an everyday activity or at a special moment.

The photographs I have chosen are only a small sample of those held in the Local Studies collections in Bacup, Haslingden, Rawtenstall and Whitworth Libraries with another four kindly loaned by individuals. As former Reference Librarian in Rossendale, I have deliberately restricted my choice to these collections, seeking to publicise the wealth of information held by libraries in all its many formats, from books and maps to videos and computer disks. The photographs have been donated to the library collections over many years and, although I have attempted to achieve a balanced selection covering all the different areas of Rossendale, I am only too well aware that some of you may feel aggrieved that your particular 'bit' of Rossendale has not been represented at all or has received less favourable treatment than others. This is not a personal slight or preference on my part, only an indication of the gaps in the library

collections and I, therefore, make a plea to all you hoarders out there – if you have photographs of your Great-aunt Annie or the street where you were born or the procession you marched in when you were ten years old, please, please do not throw them out of your attic next time you spring clean. Offer them to your local library or, if you prefer to keep them within your family, at least allow copies to be made by library staff at no cost to yourselves, so that these invaluable records can be saved for future generations.

I have tried, wherever possible, to verify the details given with the photographs but this has not always been possible, so – a second request! – if you are aware that anything in this book is incorrect or you can contribute some additional information, please contact the Community History Library so they can amend their files accordingly; staff there have been warned!

The second criterion for the choice of photographs was to select those which have not previously appeared in print. This was not the easy task I first envisaged! I consulted the illustrated works on Rossendale in stock at Rawtenstall Library to enable me to avoid duplication but I then continually discovered photographs in a variety of published books which had evaded my eagle gaze. Subsequently, a few have slipped through the net but some I have consciously retained because of the significance of the subject depicted or simply because they are such evocative photographs. That the selection task was so difficult is a tribute to the many active local authors in Rossendale whose diligent work has helped to record so much of the area's history. Much extensive and valuable, but unpublished research, has also been deposited in local libraries and I owe a debt of gratitude to these committed historians to whose work I have referred constantly whilst undertaking my own studies. My only regret about compiling the book now, after moving to another Reference Library, is that I will not be able to impress customers with my knowledge and ability to answer their enquiry instantly without having to refer to a book! The format of this book does not allow me to include a bibliography, but I should like to acknowledge here the help and assistance provided for this publication and during my time as Reference Librarian by: Chris Aspin, Ken F. Bowden, John Davies, Peter Deegan, Alan Hitch, John Simpson, Malcolm Starkie and John B. Taylor.

The visual appeal of a photograph has considerably influenced my choice of photograph. Yes, I have included buildings no longer in existence and street scenes which have altered, but my overriding concern has been whether a newcomer and 'foreigner' to Rossendale, as I have been, would enjoy browsing through the photographs even though unfamiliar with the area. Therefore, 'people' photographs and/or unusual or interesting scenes figure prominently; details of the names or the background may be missing but I hope they can be enjoyed for what they show us about dress or modes of transport or the reflection of a way of life which has long since disappeared.

If your appetite is whetted, you may wish to learn more about the history of your house, street or village. Rossendale is especially favoured with, in addition to publications by the authors mentioned above, many histories of its towns and villages written by past historians who have been forward thinking enough to document events even in small communities, which indicates a pride in Rossendale which we would do well to emulate. These histories and much other material are available for you to consult in your local library, so after this journey you may like to make another one!

I am going to take you on a tour of Rossendale, the area of which I have defined using the district boundaries established in 1974, setting out from the north east, crossing the Bacup boundary with Burnley, and then travelling in an anti-clockwise direction eventually arriving in Whitworth. The roads are bumpy and it may rain, so be prepared! Bon Voyage!

Susan A. Halstead.

Please note: References in the photograph captions to the current use or ownership of buildings relate to the situation as it was in 1996 when this book was originally published.

Acknowledgements

I have many people to thank, all of whom have freely contributed their knowledge and time, but, unfairly, only my name appears on the cover. My thanks are due to:

Lancashire County Library: Blackburn Division for kind permission to reproduce photographs from the collections at Bacup, Haslingden, Rawtenstall and Whitworth Libraries. Mary Elizabeth Stansfield and the Taylor family for the generous loan of their photographs and information to accompany them. Helmshore Local History Society for the supply of a large number of excellent photographs to the libraries in Rossendale, many of which have been reproduced here. All those individuals, too numerous to mention, who have donated photographs to the libraries or allowed copies to be made. All those individuals, again too numerous to mention, who have recorded the history of Rossendale in published or unpublished form. Derek Darlington, formerly of Crawshawbooth, and Joe Taylor of Whitworth for their ready willingness to check the relevant sections of my manuscript and allow me the benefit of their extensive local knowledge. Jackie Ramsbottom of Clough Head Information Centre for checking the Grane section and enthusiastically sharing her research and information. My former colleagues in Rossendale libraries who cheerfully volunteered to read my manuscript and provided much valuable assistance and constructive advice: Ken F. Bowden on Bacup; Carole Eastham and Victor Marcinkiewicz on Haslingden; Keith Burrows and Nick J. Bury for their endurance in proof-reading the whole text; Tricia K. Barnfield for the same and for unstinting assistance over many years. My husband, Trevor, for being chief 'building-spotter' during our forays around Rossendale and for keeping me well-fed and watered while locked in the study! Lastly, to all the other Rossendalians: library friends and colleagues, professional colleagues in other departments, especially the museums, and library customers from whom I have learnt so much during my time in Rossendale, enabling me to compile *Around Rossendale*.

One

Across the North:
to the Whitewell and
Crawshawbooth Valleys

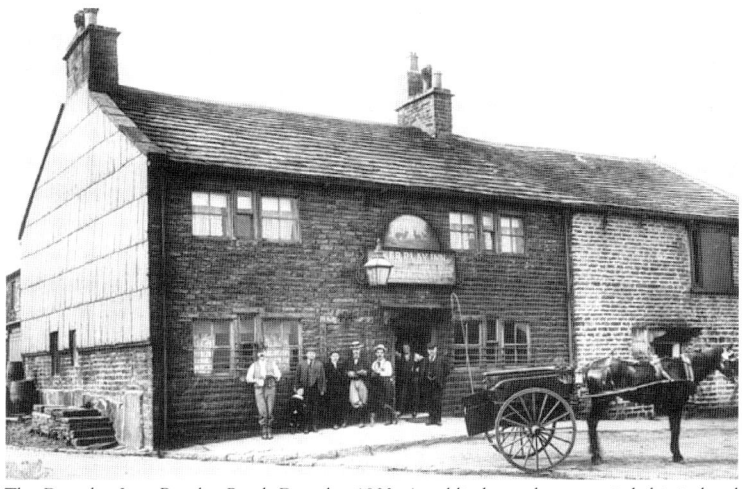

The Deerplay Inn, Burnley Road, Deerplay 1900. A public house has occupied this isolated position just on the Burnley side of the Bacup boundary since 1709, guarding the gateway to the 'Golden Valley', so named after the increased prosperity brought by the industrialised textile industry. Originally on the opposite side of the road before this former barn was converted, the sign above the door reflects its hunting past and the Rossendale Hunt used to meet here before its demise in October 1911.

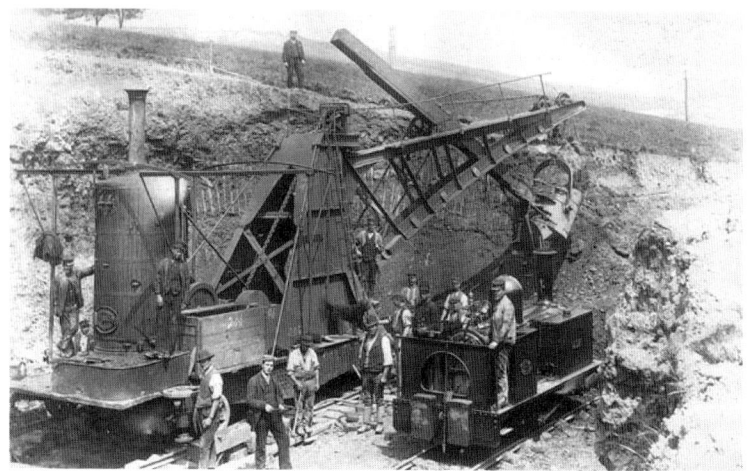

Clough Bottom Reservoir, Water, c. 1892. There were initially three reservoirs planned in the Whitewell Valley to satisfy increasing demands of urban populations but only this one was constructed; the opening ceremony on 7 May 1896 was exactly five years after the first sod was cut. R.H. Emmett, the first postmaster in Lumb, took many photographs of the excavation work which are now held at Rawtenstall Library. The contractor, Enoch Tempest, lived up to his name as a young man with a reputation for riding the countryside in an inebriated state!

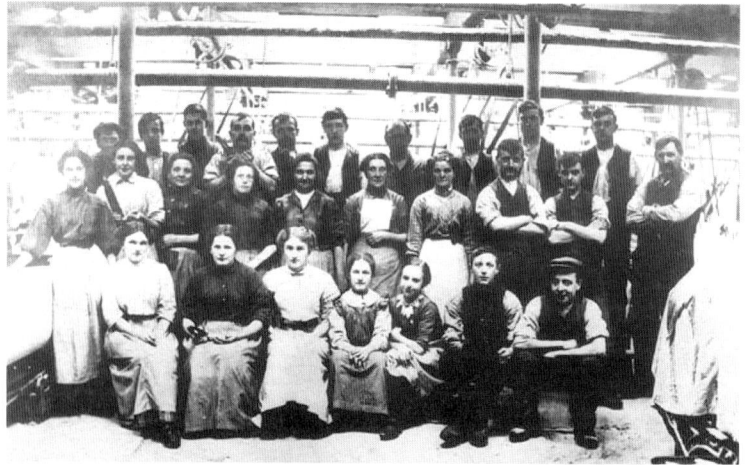

Spring Mill, Dean, 16 December 1913. Workers walked from surrounding farms to this cotton mill during the winter lighting their way with candles in jars 'like a lot of fireflies'. A boiler explosion on 9 June 1858 killed three men and scalded nineteen more, but the mill was rebuilt and only demolished a century later, around 1950.

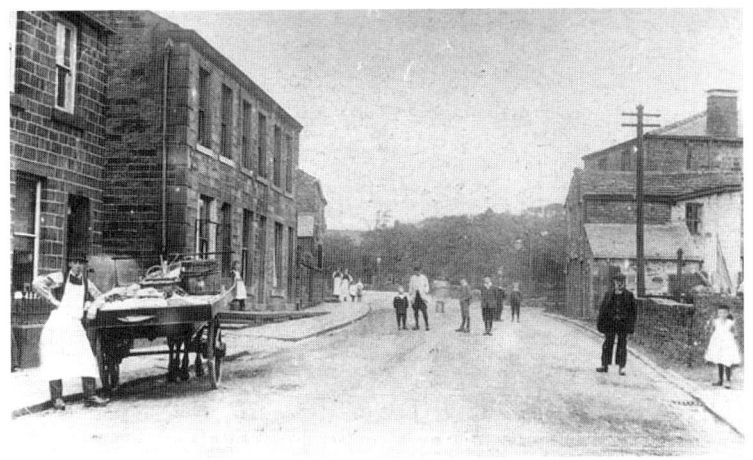

Above: Burnley Road, Water, *c.* 1900. Looking north on a traffic-free road, Dean Lane is on the right next to the building now the Lumb General Store. Dean Lane was the terminus for the electric trams which began running from Waterfoot on 21 January 1911 and replaced an unreliable and unpopular motor bus service operating on this route. Trams provided transport for the inhabitants of Water until 31 March 1931 when buses took over for a second and final time.

Right: Ronnie and Dorothy Hoyle at Lumb Corner, Lumb, *c.* 1939. Clogs, such as those worn by Dorothy, were much appreciated by children who could make sparks fly by running along the street, scraping the irons on pavements or cobbles. Many schools had clog inspection before classes and a good cleaner for clogs was banana skins! The wearing of clogs as protective footwear became almost universal throughout industry in Lancashire but soon after this photograph was taken their popularity began to wane.

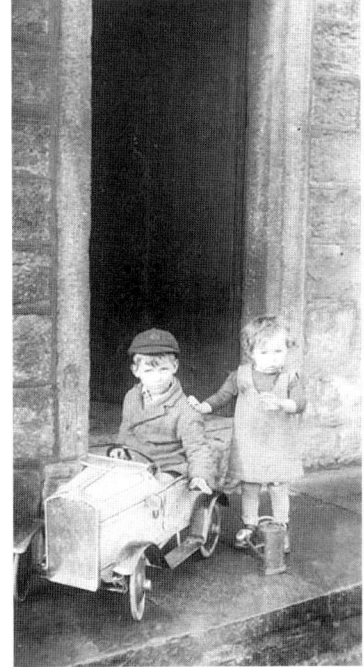

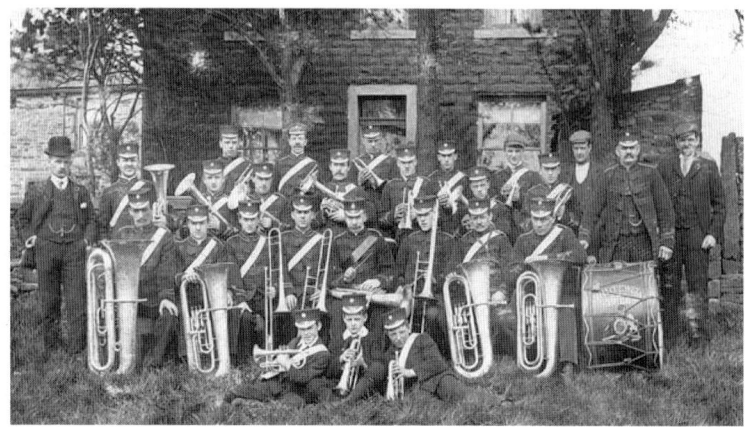

Above: Whitewell Vale Prize Band, 2 June 1906, taken by Gaskell's. A strong musical tradition in the Lumb Valley was firmly established from the 1740s with over a century of music-making from the 'Larks of Dean', a group of handloom weavers singing established religious works and composing their own tunes. One of their number was asked to teach the twenty members of the Whitewell Bottom Band founded in 1811 by the Whitehead brothers, who were probably the most influential industrialists in Rawtenstall's history. Brass band fever swept Rossendale in the 1850s following the introduction of a championship in Manchester (see also p. 93), but band members shown here may not have felt as committed as the Lark, James Nuttall of Dean, who had 'cherished music in place of matrimony'.

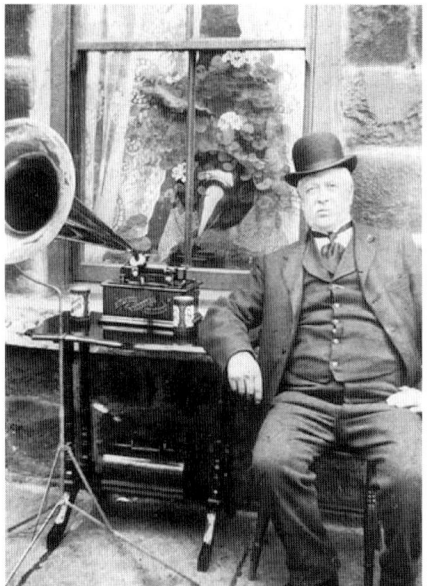

Left: James Lowe at Scout Bottom, 1906. The phonograph was first demonstrated in Rossendale in December 1890 at the Mechanics' Institute, Bacup. James Lowe used his to give music recitals at Sunday schools and to record conversations on to the cylinder. The price had dropped from around sixty to two guineas in 1900 bringing it within reach of ordinary people, but manufacturers were soon producing discs for use on the gramophone, invented by Emile Berliner in 1888, so the phonograph was becoming increasingly old-fashioned by the date of this photograph.

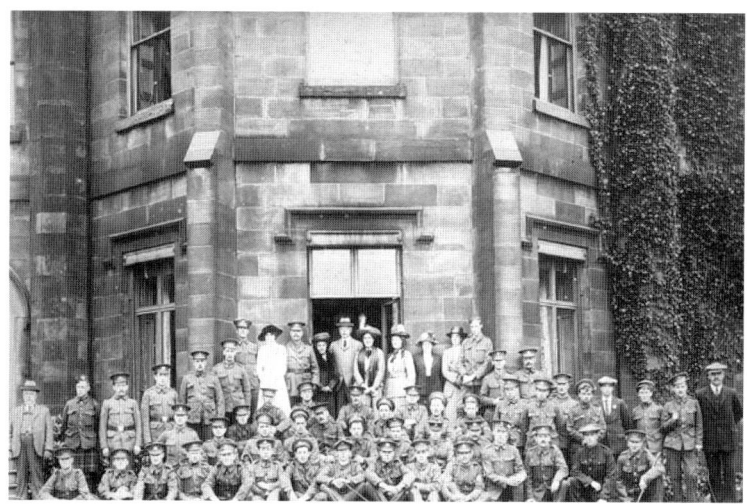

Crawshaw Hall, Crawshawbooth in 1915, showing soldiers from Bacup and Haslingden wounded in the First World War. William Brooks, the second Baron Crawshaw, is standing in the centre of the doorway with his family. He succeeded to the title in 1908 on the death of his father, Thomas, who had been knighted in 1891 becoming Rossendale's first baronet and raised to the peerage the following year, taking Crawshaw as his title. Thomas' father, John, born in Whalley in 1786, was a calico printer who formed the successful partnership Butterworth and Brooks at Sunnyside Printworks, which received awards at the Great Exhibition of 1851. His commercial interests extended to quarrying and mining and with increasing prosperity it became possible for him to acquire Sunnyside House and then Crawshaw Hall as family homes. The Brooks family was not only a major employer but also a significant influence on the life and development of Crawshawbooth; this included donating land and contributing towards the cost of St John's church built in 1892 and opening this hall's grounds for many Sunday school fetes.

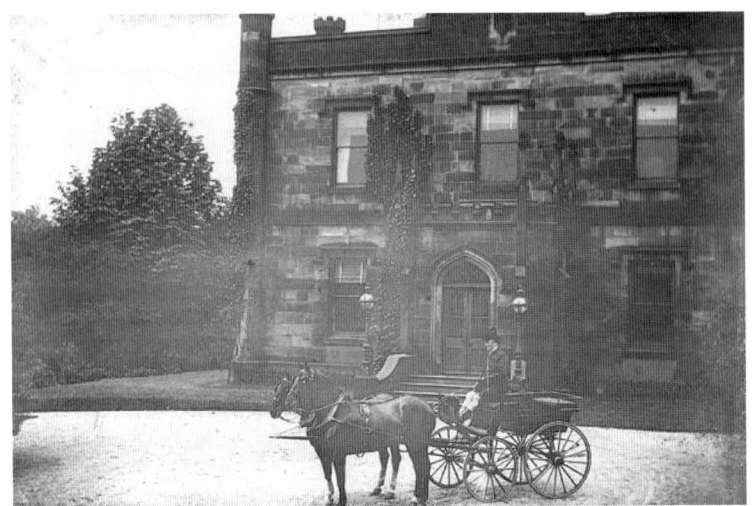

Crawshaw Hall. A phaeton and coachman await one of the Brooks outside this Grade II listed house, which was built in 1830 in twenty-seven acres of rolling woodland for John Brooks. He was a master of the Rossendale Hunt from 1860 to 1882 and, during this time, the hall was the site of many hunt balls with 'chinese lanterns adorning the trees'. It was occupied by the family until Cicely Kate Brooks died in 1975 and is now a residential home for the elderly.

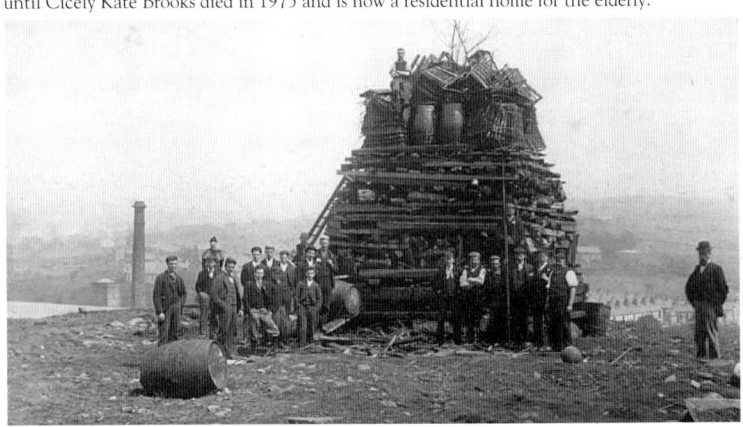

Bonfire at the top of Pinner, Crawshawbooth in 1902. Preparations are in hand to mark the coronation of King Edward VII on 9 August in the year after he acceded to the throne. Bonfires originally had the more serious intent of communicating messages, particularly of invasion, but later signalled celebrations. The chimney belonged to Britannia cotton mill but was demolished in 1981 following concern over its safety. Note the solitary female at the back of the group who, no doubt, was supervising the work!

Right: The Barracks, Rakefoot Bridge, Crawshawbooth, *c.* 1891. From left to right: Thomas Moulds, gentleman's outfitter, Tom Pickup, joiner, watchman at Sunnyside Printworks. Soldiers from Burnley were billeted here for thirty-two weeks in 1831 during a strike at the printworks and it was later occupied by men constructing Short Clough Reservoir for the same company. From 1887, when a fire brigade was established by Rawtenstall Local Board (see p.106), it housed a stable and fire station serving the north ward of Crawshawbooth, but was demolished to make way for St John's church. The gas lighting on the bridge had only recently been installed.

Below: The Mansion House, Rakefoot, Crawshawbooth, post 1892. In the doorway are James Aspin, a winder overlooker at Stoneholme Mill and his wife, Margaret, who lived here with their seven children. The house, now demolished, stood opposite St John's church. The first Methodist services in the village were held here in 1808 when it was owned by George Hargreaves. This building should not be confused with the old Mansion House further up Burnley Road, which was built in 1610 but demolished in 1880, and has been replaced now with Mansion House Buildings.

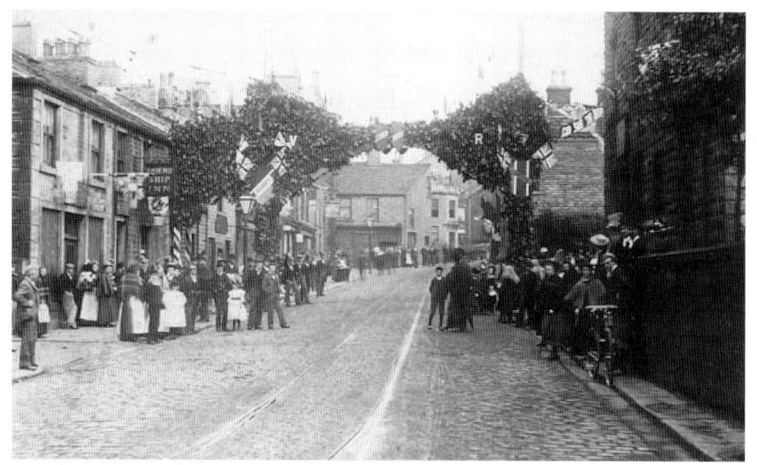

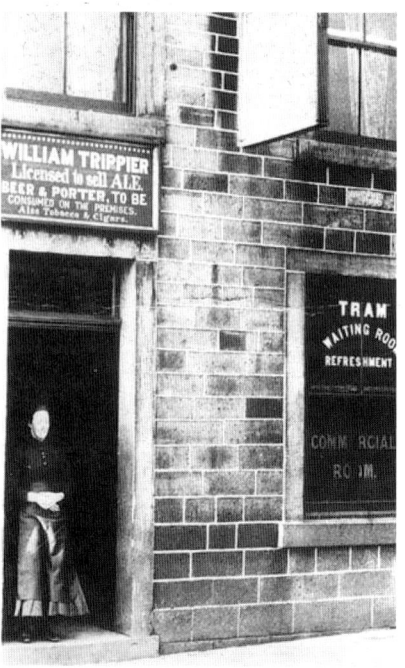

Above: Burnley Road, Crawshawbooth, June 1897. The street decorations are celebrating Queen Victoria's Diamond Jubilee. Lord Street is on the front left of the picture and in the middle distance is the then Manchester and County Bank, at the corner of Co-operation Street, on a bend later straightened out to improve the comfort of the trams. The steam tram tracks were laid by the Rossendale Valley Steam Tramways Company in 1891 but were replaced for electric trams in 1909 at a cost of £120,000.

Left: Friendship Inn, No. 542 Burnley Road, Crawshawbooth, 1892. Alice Trippier in the doorway was the wife of the landlord, William, who was the licensee from 1882 to 1889 and 1892 to 1894. Tram passengers would, no doubt, have appreciated refreshments provided in the inn's waiting room. The premises, now a restaurant, were sold to John Baxter's Glen Top Brewery for £1,880 in 1901 when weekly takings were £24, but closed in 1927 when a public house here was judged unnecessary and sanitary conditions were described as unsatisfactory.

Right: Horace Carhart on the left and Richard Carhart, *c.* 1900. This studio portrait was taken of the brothers, probably in their Sunday best, in the front room of No. 12 York Street, Crawshawbooth by J. Hartley. Their father, Thomas, ran a tailor's business from No. 528 Burnley Road.

Below: Manchester and County Bank, Burnley Road, Crawshawbooth, 1911. Notices in the windows direct customers to temporary premises across the road and the bank was demolished to make way for the construction of the existing building in 1913, later occupied by the Halifax Building Society. Crawshaw's shop beyond has almost disappeared in a road-widening scheme. The tram lines are now used by electric trams.

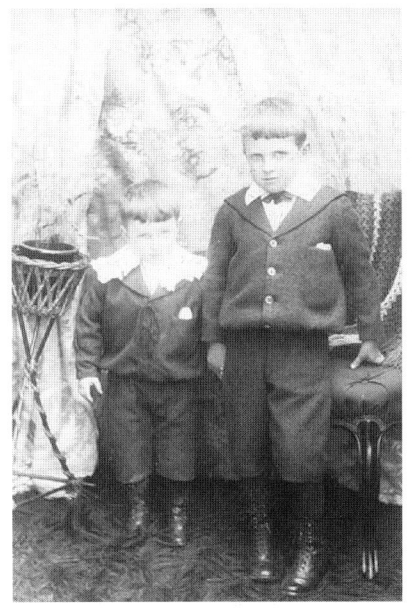

17

Left: Lawrence Howarth, or 'Lolly Penny', *c*. 1907. A well known character in Crawshawbooth, Lolly used to make himself useful, ringing the handbell at Goodshaw parish church, selling church magazines and running errands for the vicar, but he was often tormented by small boys. However, he was always keen on a bargain and, at the barbers one day for a shave, he pleaded that he only had a halfpenny. The barber, Jim, therefore shaved half his face and would not finish the job until Lolly produced the full cost of 1d!

Below: The Black Dog Hotel, Crawshawbooth, *c*. 1906. This inn was open only three days a week in 1842 for the stagecoach service between Burnley and Manchester and later, in the 1870s, the Wint family ran a horse-bus from here to Burnley. Isaac Wint was landlord for forty-six years and when he retired in 1926 it ended a family association of over sixty years. Isaac, a resourceful fellow, sold meat as well as ale and his butcher's shop can be seen at the front left of the building, which was demolished in 1933 to be replaced by the existing premises set further back from the road.

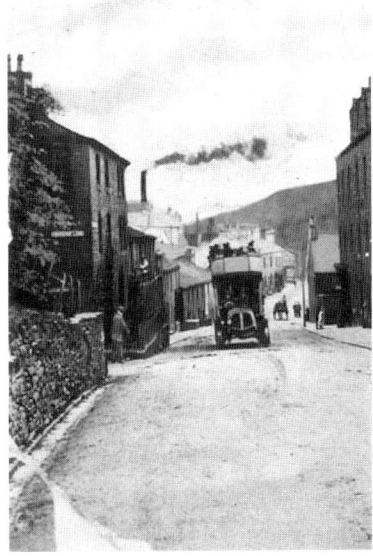

Above: A. Cane, cabinet maker and house furnisher, No. 610 Burnley Road, Crawshawbooth, *c*. 1900. This long-established business trading from 1883 to 1967, advertised in 1950 as 'complete house furnishers' selling 'reliable utility furniture'. The grandson, Arthur, set up a similar shop in Newchurch Road, Rawtenstall and many couples remember setting up home 'with Cane's just like Mum and Dad'. These premises are now occupied by Ram Services Ltd.

Right: The Rossendale Motor Bus, Burnley Road, Crawshawbooth, 1906. (By courtesy of Mary Elizabeth Stansfield). From a coloured postcard, we are looking down the main road of the village from Goodshaw Lane. Competition from the steam trams made horse-buses redundant and this bus was purchased in 1906 to provide a service between Rawtenstall and Burnley and also for private hire. The vehicle, with seating for forty passengers, boasted an average speed of 12 mph on solid tyres over cobbled roads! The service was especially popular at the weekends and was profitable for the first year but ceased operating with the advent of the electric trams.

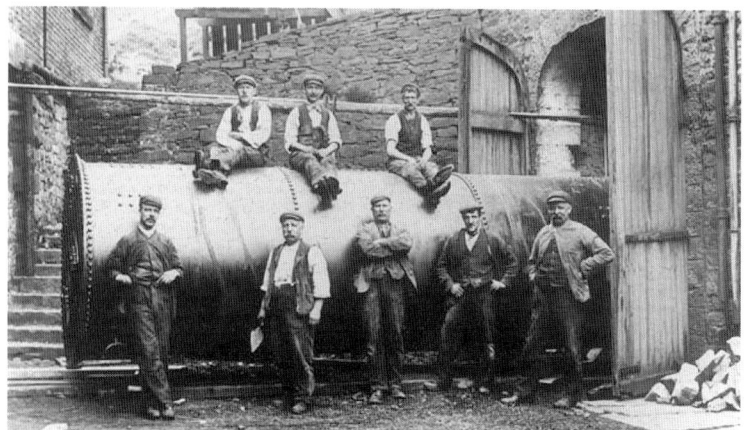

Hawthorn Mill, Folly Clough, Crawshawbooth, 6 May 1907. After Dacca Twist Co. had failed to come to an agreement with the mill owner in 1889, unsuccessful attempts at auction in the same year resulted in the mill still being unoccupied in 1894. Advertisements then offered the mill rent-free for six years if tenants would stock the mill with machinery which would revert to the owner after that period! It is obviously back in business here when a new boiler is being fitted and the mill continued until 1962 when it was badly damaged by fire and demolished.

A neighbourly chat outside Nos. 102 – 106 Goodshaw Lane, Goodshaw, photographed by Mr Hampson. These cottages stood in front of Hawthorn House and were demolished in the late 1960s during the redevelopment of Goodshaw village.

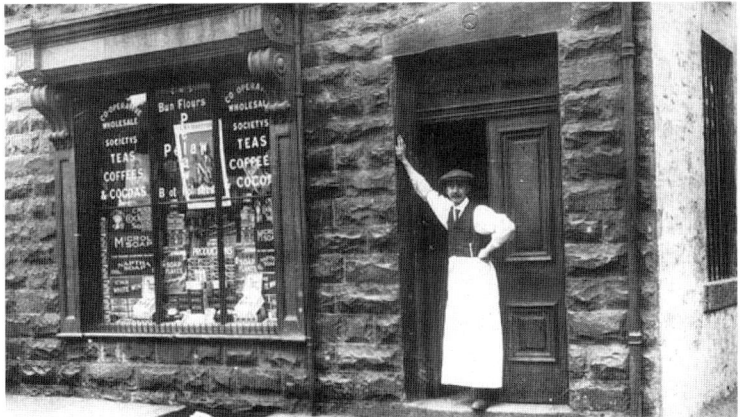

Charles Ed. Dean in the doorway of the Loveclough Industrial Co-operative Society, No. 928 Burnley Road, c. 1920. This shop opened at the top of Goodshawfold Road in the early 1880s to join many others in Rossendale established as self-help organisations to encourage savings and improve living standards. The larger stores also acted as community centres and the society in Crawshawbooth, which traded from 1864, also offered a hall to accommodate 400 people for meetings and a library with over 100 volumes.

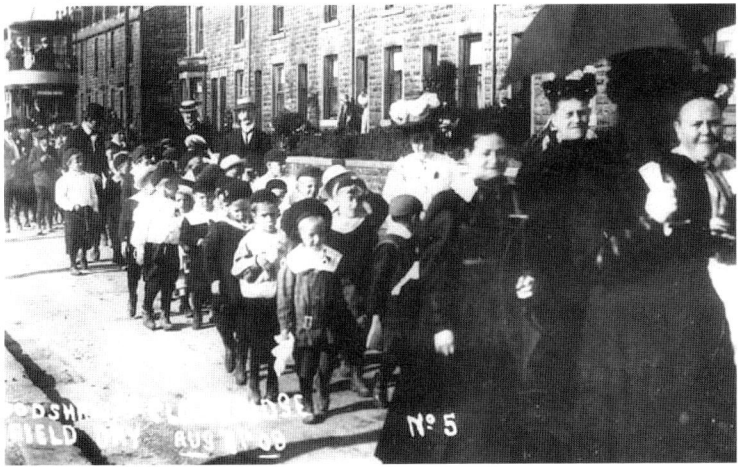

Goodshaw and Clowbridge Field Day, Saturday 7 August 1909. Walking south and passing No. 1,031 Burnley Road, Loveclough is the 'scholars' procession' in the annual midsummer festival for Goodshaw Sunday School. For the first time in its history, Clowbridge was included on the route and children from there formed part of the procession. Goodshaw Prize Band led the way, accompanying hymns sung at various places under the direction of the organist, Harry Bridge. The children were later served refreshments at the end of a day considered 'a decided success'.

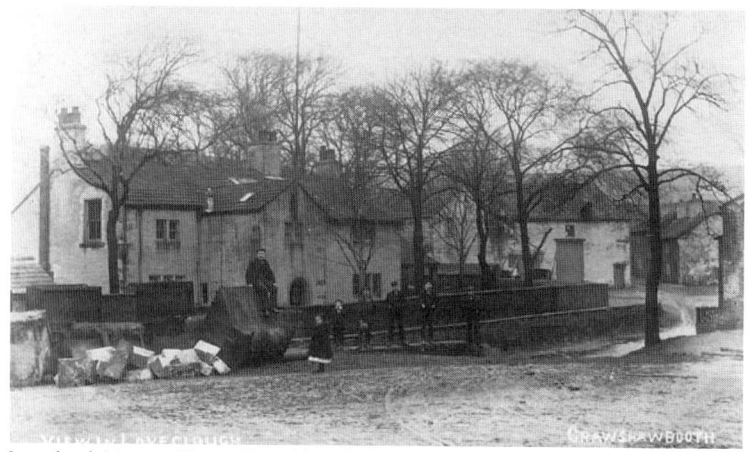

Loveclough Mansion House, The Fold. A datestone from a fireplace inside the house inscribed 'R. H. 1741' probably refers to an ancestor of Richard Holt who owned Loveclough Printworks in 1832. The company bought the house in 1870 and the social club for the Calico Printers' Association acquired the premises in 1897, introducing fine facilities such as rooms for concerts, billiards and cards, a library and a bowling green. The barn with a large door is now a private house and the buildings on the right have been demolished.

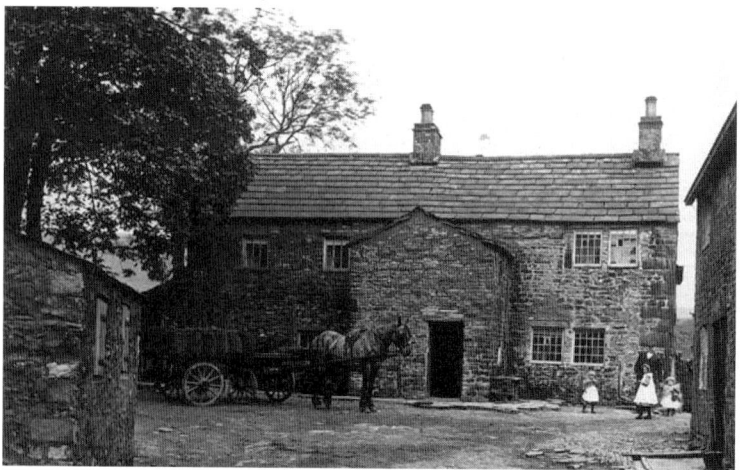

The Fold, Loveclough. Some of the occupants of this farm and cottages possibly worked at the printworks, which at one time employed up to 600 workers and was advanced enough to have electric lights installed in 1883. A fire at the printworks in 1906 caused £100,000 damage, forcing many local people in this small community to move elsewhere for work. Note the coal man with his horse and cart long before the advent of smoke-free zones!

Two

Over Cribden to Acre and Grane

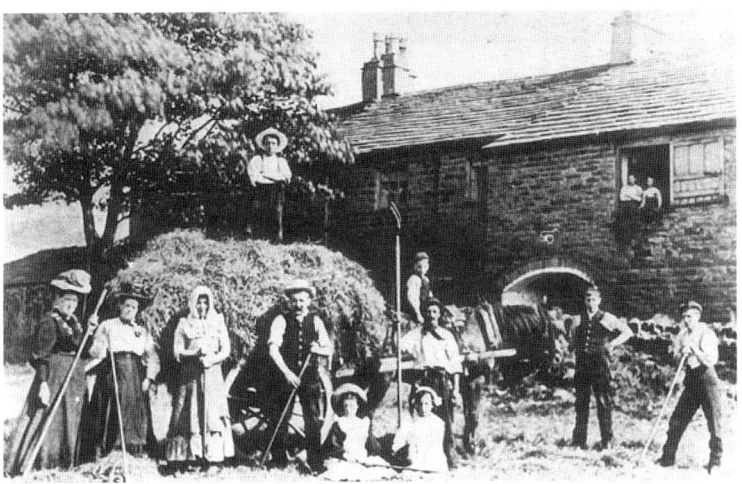

The Pilling family at Mangholes Farm, Acre, c. 1912. From left to right: -?- , -?-, Mary Anne Hamer Pilling (wife), James Edward Pilling (husband), Albert, on the haywagon (son), Cissie and Eleanor (daughters), -?-, Harold on horseback (son who was killed by a cricket ball), James and John (sons).

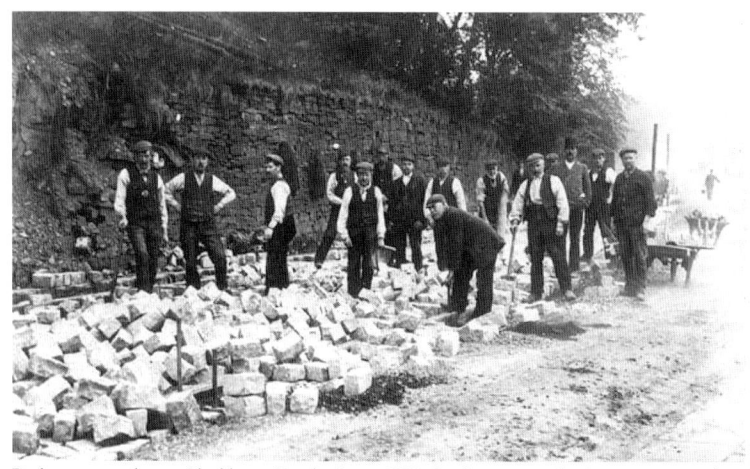

Re-laying tramlines, Blackburn Road, Acre 1908. Looking towards Accrington, work is underway on converting the tram service from steam to electricity. Trams to Haslingden were operated by Accrington Corporation Steam Tramways Co. from 27 August 1887, but problems with gradients made it an unreliable service and Haslingden, therefore, was the first of the Rossendale towns to opt for electrification. Deciding it uneconomic to run its own tram service, arrangements were made with Accrington to continue as the supplier. The first car ran through Haslingden on 5 September 1908 but only as far as the boundary at Lockgate where passengers had to change trams to those operated from Rawtenstall; it was not until 1 April 1910 that there was a through service between Accrington and Bacup. Note the workman in the bowler hat in the top picture who is possibly the foreman.

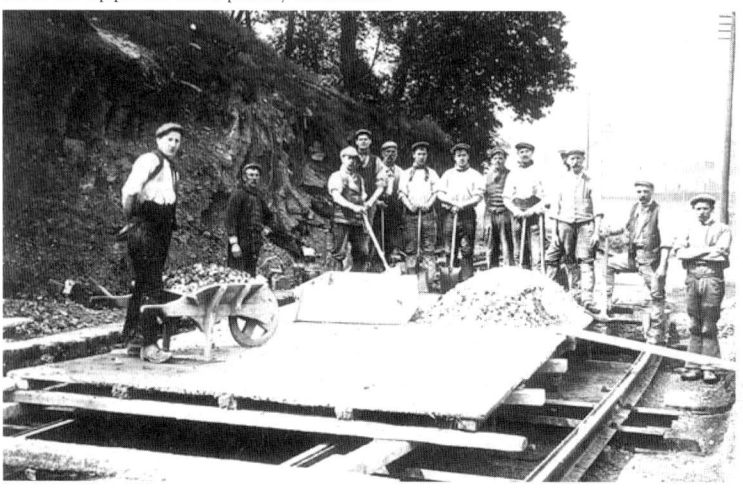

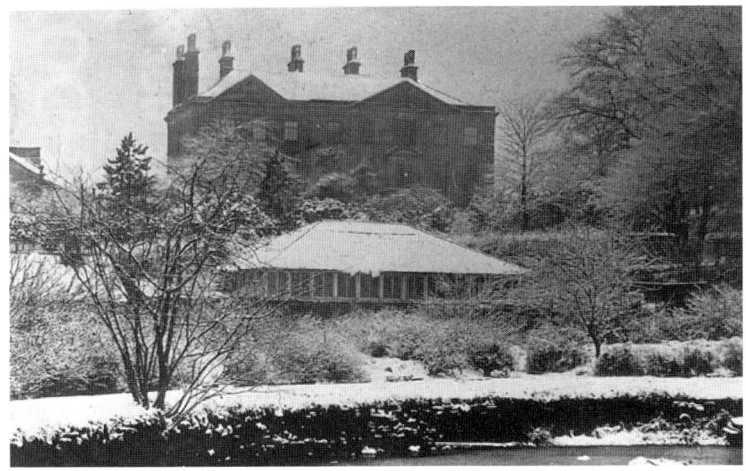

Carter Place Hall, Acre. Thomas Carter surrendered land to his son in 1424 but from 1601 the estate was in the possession of the Chadwick family. After Sir Andrew died in 1768, it is possible that the house was rebuilt by his son-in-law, John Taylor, a blacksmith from Bacup. The baize and flannel manufacturer, James Turner, bought the hall in 1807 which was then extensively altered during the nineteenth century. The Turners, especially William, were a major influence on Helmshore not only as employers but also because of their impact on the social life of the community, helping to improve road and rail links and providing finance for workers' homes, Hollin Bank School and Musbury Church. The grounds of the hall were frequently used for garden parties but, although the house became a listed building in 1967, it fell into disrepair to be demolished in 1989 and residential caravans now occupy the site.

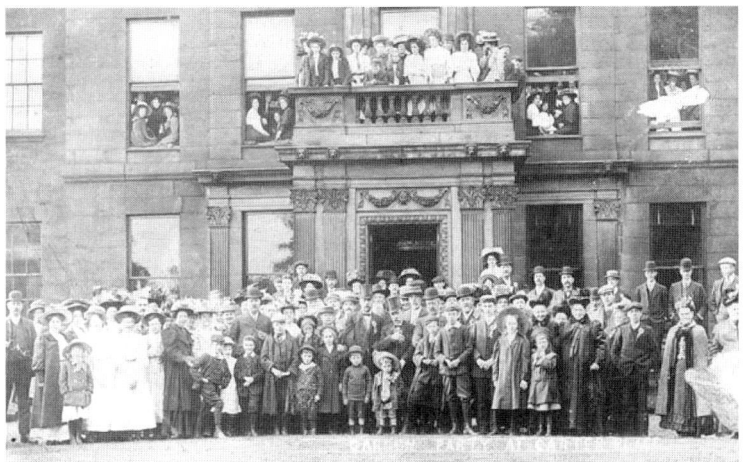

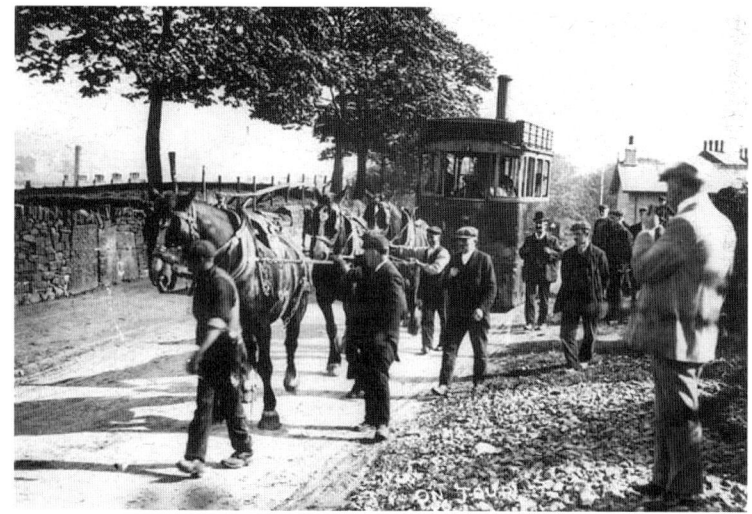

Rising Bridge Road, Haslingden, *c.* 1908. Following the introduction of electric trams, a redundant steam engine, known in Rossendale as an 'armoured train', is ready for dismantling and is towed away by an even older form of transport! Some steam engines were retained, however, and used for clearing snow from tramlines in Rossendale until 1932. The law stated that working parts more than a few inches from the ground should not be visible, but the ecological requirements for the trams to consume their own smoke and be noiseless were not as well observed! The chimneys of Carter Place Hall can be seen to the left of the road.

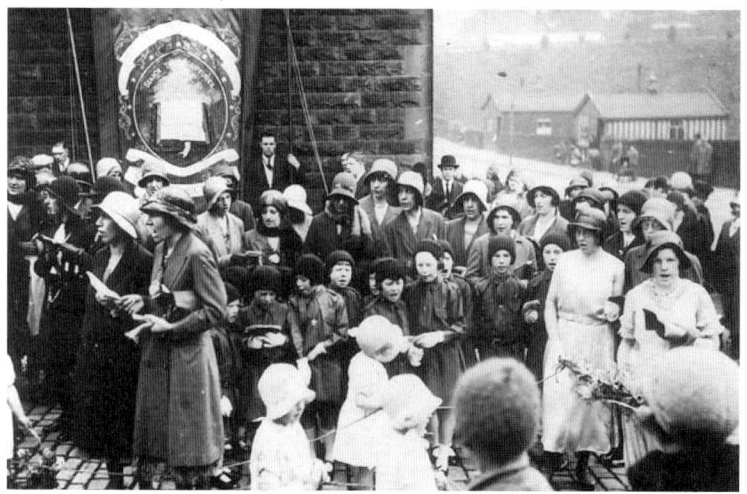

Above: Garden of Vine House, Grane Road, Haslingden. This residence was built in the 1840s as the home of the Warburtons along with Flash Mill, which was run by Thomas Warburton as a hard waste mill and was one of the earliest users of electricity in Rossendale. The Warburtons were a hard-working and generous family, most of their employees ranking themselves as friends, and this camaraderie was demonstrated during the Second World War when they were frequent winners of a local competition in the drive for war savings. Thomas' son, Albert, became a world authority on orchids, some of which are possibly growing in the greenhouses shown here, and was active in the formation of the Haslingden Allotments Society in 1915 which he served as president. Vine House was used as offices for the company from 1922 but was demolished around 1966 and the same fate befell Flash Mill in 1984 after attempts to convert it into industrial units had failed.

Opposite below: Junction of Jubilee Road with Grane Road, Haslingden, *c.* 1930. Members of St Stephen's Sunday School, Grane, are taking part in Walking Day celebrations (see also p. 28) after their church was moved stone by stone in 1927 to its new location opposite the cemetery. The railway line can faintly be seen in the top right of the picture.

Holden House, No. 363 Grane Road, Haslingden, 21 July 1909 (By courtesy of the Taylor family). A wedding party poses at the side of the unmade road for the 'official' photograph in front of this house, still in existence. The groom was John William Holden who later served as a Lance Corporal in the Royal Artillery but died on active service in Murmansk in 1919 and his bride was Elizabeth Lund Taylor, whose parents lived at Holden House. One of the ladies looking from the first floor window was not allowed to be in the photograph because she was pregnant!

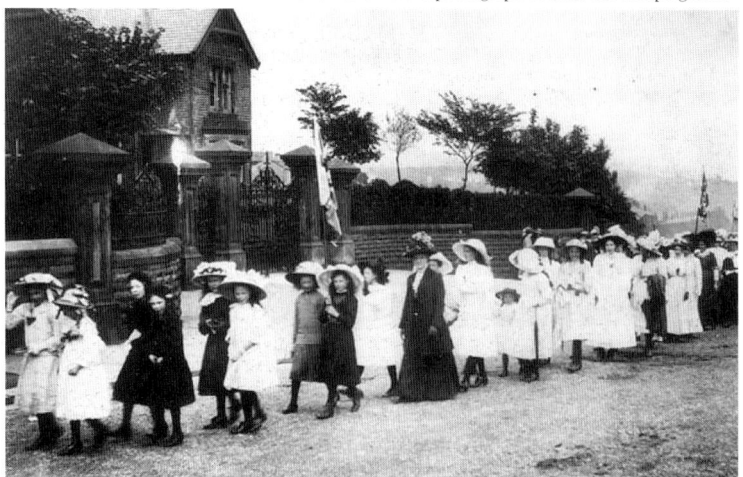

Outside the cemetery gates, Grane Road, Haslingden. Another Walking Day for St Stephen's church, the congregation are, however, returning here to their church on its original site in Grane. Built in 1864, the church was a prominent landmark in a flourishing community in the first half of the nineteenth century before plans to build the reservoirs led to the disappearance of Grane as a village.

Holden Hall Farm, off Grane Road, Grane, post 1900. The Holden family were extensive landowners in this area from 1272 and, in 1551, their land consisted of 132 acres, possibly the largest estate in the manor of Accrington. The last male heir, Ralph Holden, died in 1792, after which Holden Hall was divided up to house farmers and textile workers and it was demolished in 1900 to make way for an extension to the cemetery. The site of the hall is obscured by the barn on the left of the picture. Holden Wood Reservoir in the background was built privately in 1842 by William Turner of Helmshore and John Bowker of Irwell Vale (see p. 52) to supply water for mills in the Helmshore and Ogden Valleys.

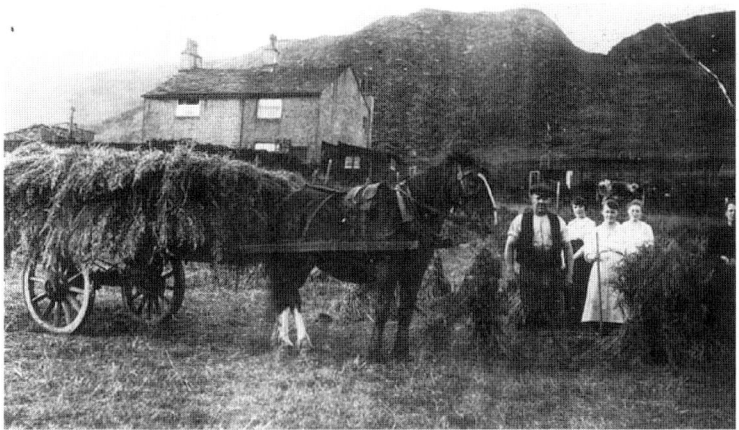

A hard day's work at Kettlewell Hall, off Grane Road, Grane, possibly during the First World War. The Bolton family, who at one time lived at Holden Hall, take a rest whilst posing for the camera. Left to right: William, Nancy, Annie, Maria, Ellen. A local farmer remembers the Boltons growing oats during the war. The problems faced by these hill farmers in harvesting crops in a damp and humid climate were later addressed by Great House Experimental Farm (see p.48) where they investigated different methods of cultivation. An early need for diversification may have been the spur for an alternative commercial venture, shown overleaf.

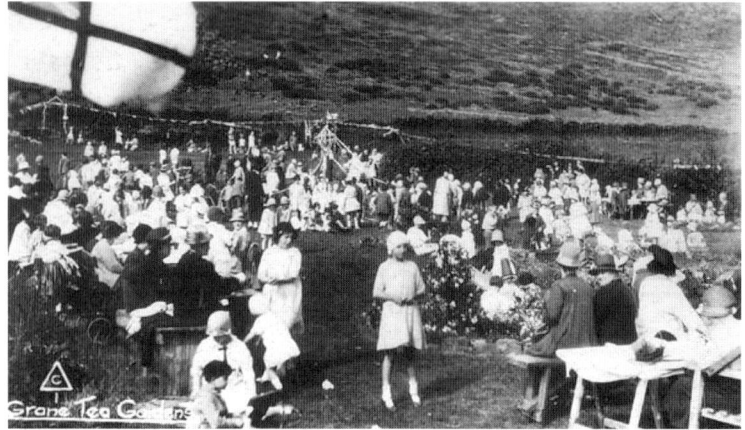

Grane Tea Gardens, Kettlewell Hall in the 1920s. Remembered with much affection by old Graners, these gardens were a popular venue for people from Rossendale and beyond and were open for teas from 1916 to 1941. With plenty of space for children to play games and a scenic view over Holden Wood reservoir for the adults, there could be as many as 3,000 visitors over a sunny Easter weekend.

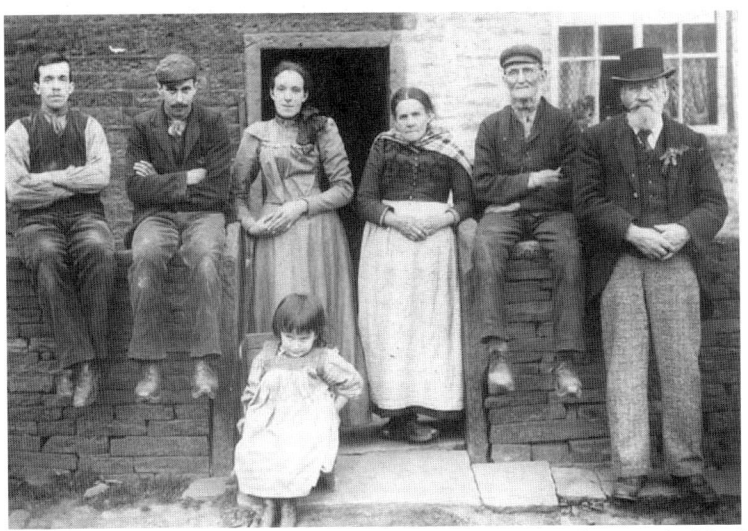

Above: Virgins' Row, Heap Clough Road, Grane, *c.* 1900. Joseph Kirby is on the left of the group and the younger lady is Sarah Kirby. Situated at the bottom left of Heap Clough Road, this row, built in the early nineteenth century, is a good surviving example of purpose-built handloom weavers' cottages where an extension at the back was designed to house the handlooms. One suggestion for the unusual name is that at one time the row was completely inhabited by bachelors! Heap Clough was one of Grane's early settlements with a cotton mill, millworkers' houses and its own public house, the Bird in the Hand, which stood on the eastern end of this row. It was locally known as 'Little Edward's' after the licensee, Edward Taylor, and was demolished in 1938. In the 1891 census, Edward also described himself as a farmer but his neighbours were employed in the cotton or stone quarrying industries. Expansion in the latter trade was made possible by the arrival of the railway in August 1848 and this significantly supported local incomes previously earned from textiles or agriculture alone.

Opposite below: Vicarage Lane, Grane Road, Grane, *c.* 1910. Sitting in the 'governess car' is the daughter of Revd Robert Yates, the vicar of St Stephen's church, Grane, from 1909 to 1913. The vicarage, now Grane Lodge, was situated almost opposite the Duke of Wellington away from the church and centre of the village. In the middle background, the rope-worked incline, leaving a scar today, can faintly be seen bringing stone down from Musbury Heights Quarry to the valley floor from where it was transported by steam tramway to railway sidings on Grane Road.

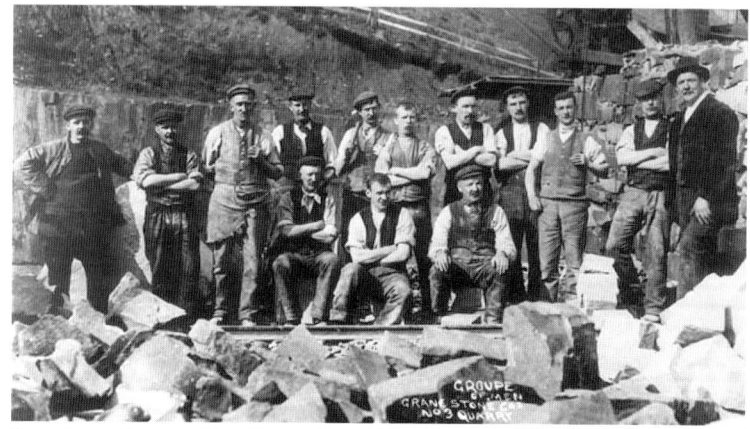

Grane Stone Company, No. 3 Quarry, Grane. Heap Clough Quarry was worked from the mid 1850s to 1914 for Haslingden slates, which split easily into flat flags suitable for roofing and paving and were transported to destinations not only in the south of the county but also as far afield as Trafalgar Square in London. Stone had been quarried in Grane in shallow pits from about 1650 but the Roscow family, living at Calf Hey, introduced more extensive quarrying from the beginning of the nineteenth century.

Broadholden Fold, Grane. The reservoir inspector, James Kay, and his wife Betty lived here with their three children in the 1890s until they had to leave around 1902 to make way for its demolition and the construction of Ogden Reservoir, which was only completed in 1912 after delays caused by subsidence. The last otter caught in Rossendale on 13 July 1902 came from Ogden brook running in front of the house and is on display in Rossendale Museum.

Three

Haslingden,
the 'valley of hazels'

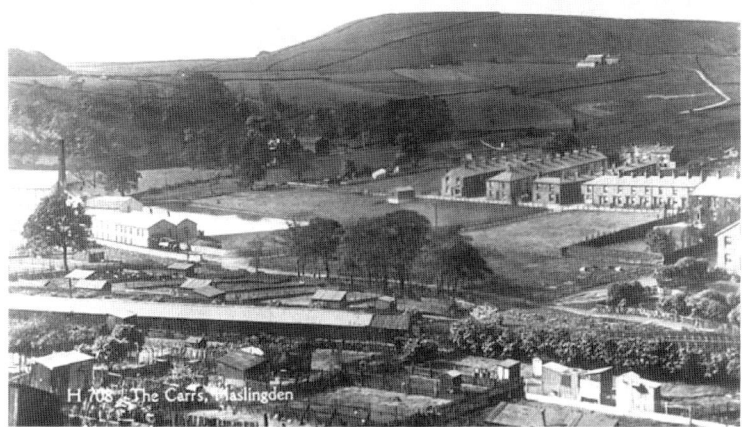

Carrs, Haslingden, *c.* 1930. An attractive village once popular for picnics, Carrs was demolished to make way for the A56 Haslingden bypass and the industrial estate. The new road opened in 1981 and followed the course of the railway line which can be seen at the front of the picture next to a rope works in the long building. Commerce Street runs across the middle; the ivy-clad house in the middle right of the picture is Carr Hill Villa; the cotton mill on the left is Carr Hall Mill.

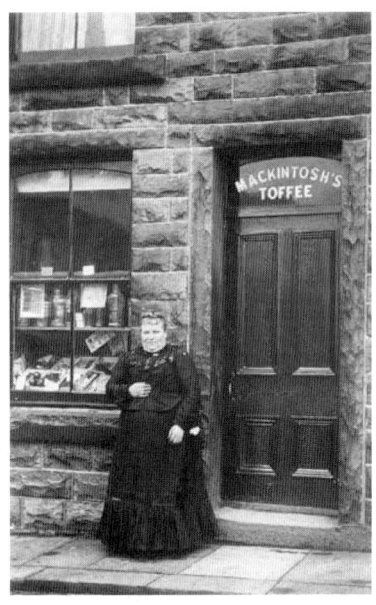

Left: Mrs Robert Collinge outside the toffee shop, Carrs, *c.* 1905. There were many advertisements in local newspapers extolling the delights of Mackintosh's Toffee de luxe, 'It's sweet! It's sweet! Hard to beat – beat' and 'You ought to be eating it! Eating it!'

Below: Blackburn Road, Haslingden. A stern faced Richard Holmes is the driver of the horse and cart, possibly delivering milk, before the First World War. Horses were a familiar sight as a necessary means of transport until the Second World War but they were also used for pleasure and, at the turn of the nineteenth century, it was considered a special day out to travel on a horse-drawn wagonette. Tramlines, setts and mud can all be seen on the road!

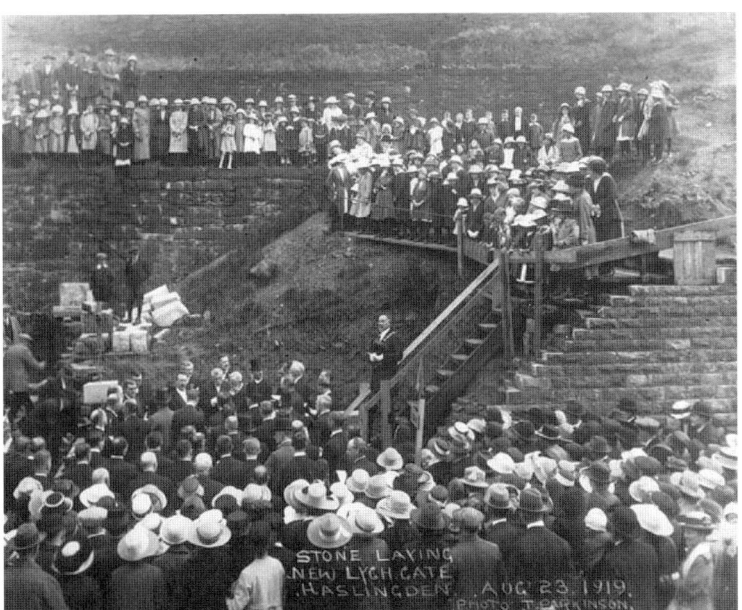

STONE LAYING
NEW LYCH GATE
HASLINGDEN AUG 23 1919
PHOTO T.PARKINSON.

Stone-laying ceremony for the new lychgate of St James' parish church, Blackburn Road, Haslingden, taken by J. Parkinson, 23 August 1919. The mayor, Major David Halstead, is standing on the wooden steps. The present lychgate, stairway and Celtic cross were planned as a church memorial to the local men who died in the First World War. The strip of land on which they were erected was too steep for building and had long been an eyesore recognised by the Beautiful Haslingden Council which had earlier expressed a wish to improve its appearance. Major Halstead recalled that, as a boy at the church day school, he had resolved that the land should belong to the church and later, as a churchwarden and mayor, he bought the land specifically for this scheme. He was amazed to discover that Nicholas Worsley JP, a well known churchman and member of the Board of Guardians, whose family paid for the lychgate in his memory, had also tried to purchase the land but at the time the owner had refused to sell. The ceremony of laying the four corner stones was conducted with masonic honours since Worsley, his two sons and the mayor were all members. The gateway, retaining wall and datestone from Cliffe Tower, Rawtenstall (see p. 55), which had just been demolished, were incorporated into the construction.

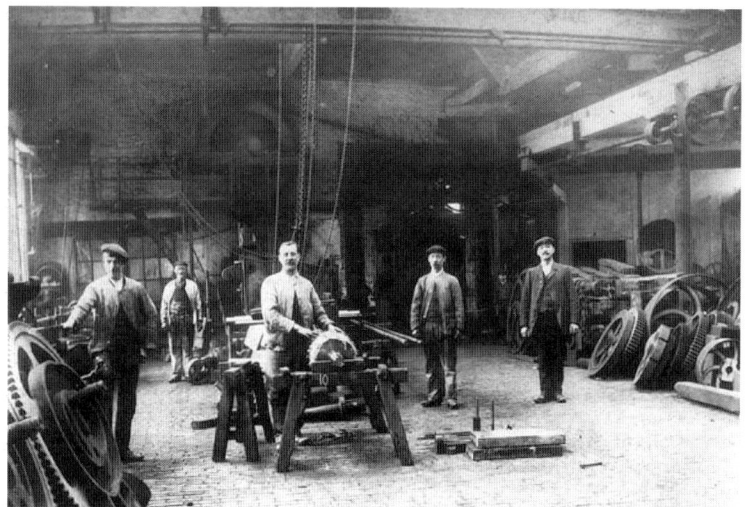

Furneval's Union Foundry, Blackburn Road, Haslingden. John Furneval founded this engineering company in 1848, specialising in the production of calico printing, bleaching and drying machines, although washing machines and mangles were also manufactured. Employing up to eighty workers, the company was described in 1886 as conducting trade with 'the most systematic and intelligent conciseness'. When Furneval died in 1887, his will requested that the business continue running for ten years and, in 1905, C.W. Whittaker and Co. Ltd. of Accrington had taken over. The premises are now occupied by Edlan Elekem Ltd.

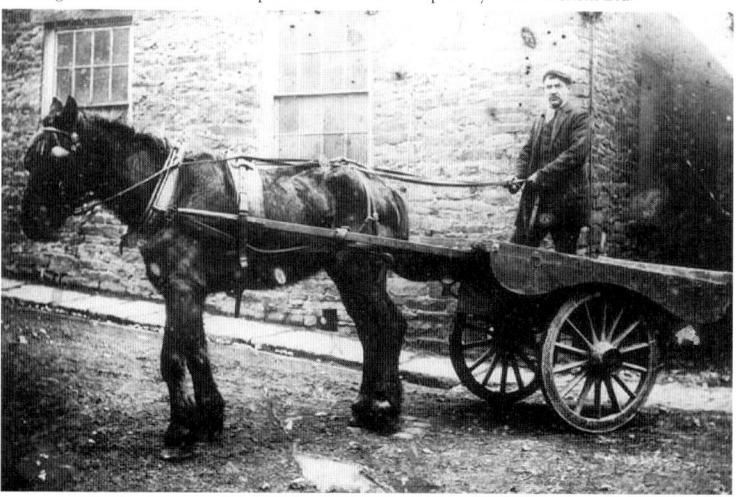

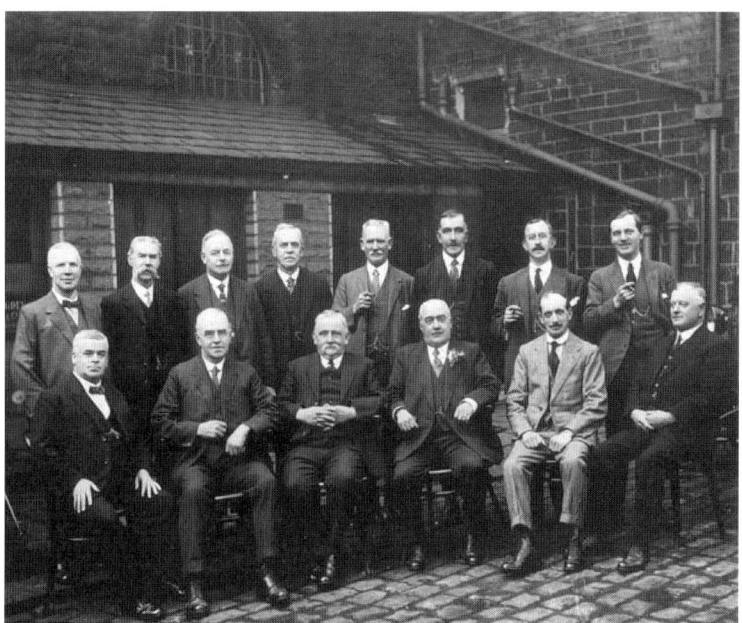

Above: Halmot Court; the last jury at Haslingden, 13 October 1925. Left to right, back row: Joseph Metcalf, George Higginbottom, John C. Dawson, Thomas Haworth, John R. Kyme, Wilfred Heaton, Frank Snowden, Herbert Alston. Front row: Richard Hartley, W.H. Maden, Martin L. Foulds, Thomas Barcroft, Richard Birtwistle, Henry Crabtree. Halmot Courts were a feudal relic from when land was held in return for military service to the king or lord of the manor. Copyhold tenants, whose only proof of their land ownership was their copy of the manor court records, paid a nominal rent in more modern times to the Honor of Clitheroe but were also obliged to serve on a jury for a half-yearly Halmot Court to adjudicate on all matters of land ownership. Halmot Courts were usually held in a public house, such as the Commercial Inn, but the Old Halmot Court House in the Town and National School, Ratcliffe Fold in Haslingden was also used and had been rebuilt and enlarged by Revd Gray in 1829. The Law of Property (Amendment) Act of 1924 abolished the costly and inconvenient procedure of copyhold tenure and the services of this jury would, therefore, no longer be required.

Opposite below: Robert Berry, Bell Row (now Street), Haslingden in front of Glover's Printworks, *c*. 1900. The condition of the road was obviously a matter of concern in 1880 when it was described as being 'literally covered with manure, dirt and ashes', even after the Local Board was established in 1875 to address such problems.

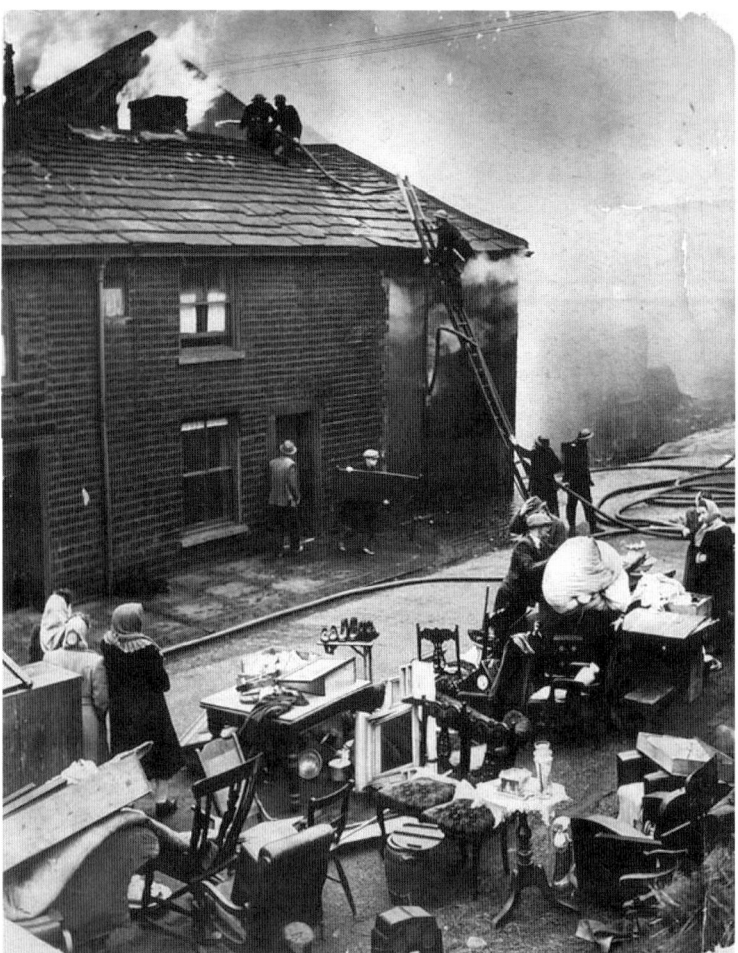

Rakefoot, Haslingden, 1949. James Rothwell's cotton mill on Hargreaves Street was consumed by flames twenty feet high on Monday 7 February, but staff evacuated the building successfully although one employee did return, armed with a fire extinguisher, to retrieve his coat; he emerged ten minutes later without the coat! These houses, now demolished, adjoining the mill on Rakefoot were evacuated as a precaution and furniture and belongings are here being carried to safety by the householders. Many residents were summoned from their work at nearby cotton mills and one lady returned from the cinema to find her elderly husband exhausted by his efforts to move their possessions.

Ebenezer Baptist chapel, Bury Road, Haslingden, before 1899. A breakaway group of fifteen members from Trinity Baptist church (see p. 43) in 1842 had attracted enough support three years later to raise the sum of £800 required for John Tomlinson to build this chapel. Fundraising began again in 1887 for a new building on the same site, this time at a cost of £5,800. The 1845 datestone shown here at the top of the original building has been incorporated into the present Haslingden Baptist church, whose cornerstones were laid on 22 July 1899 by Henry Trickett JP, Mayor of Rawtenstall.

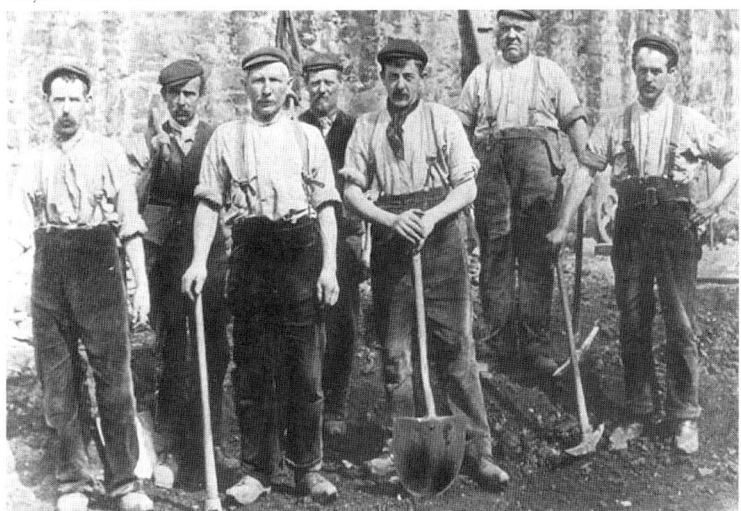

Haslingden Corporation road workers, c. 1900. Almost all the men are wearing clogs, hard-wearing and relatively easy to look after. The remainder of their working clothes, however, including the cravats used to mop dirty foreheads, were more of a problem for the laundress at home in days without automatic washing machines!

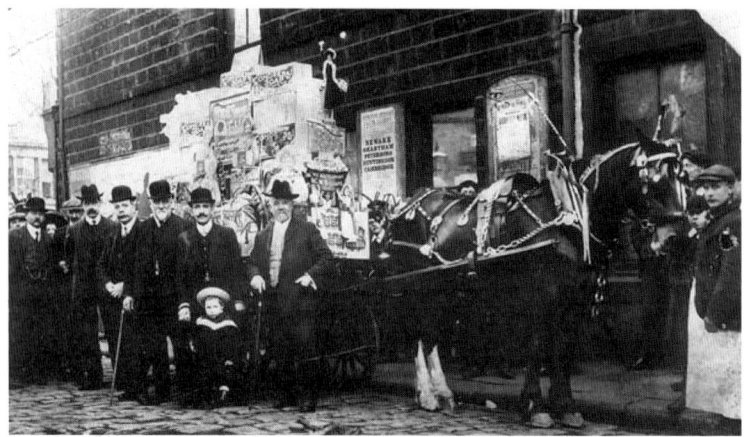

Deardengate, May 1910. The horse and cart are probably decorated for a May Day procession in Church Street. The first Co-op in Haslingden opened in 1852, moving to this site in 1869 now occupied by Berkeley Wines. In its early days, working men would spend two or three evenings a week at the Co-op weighing out sugar and flour. The frontage of the Old Vicarage in the background was demolished in 1936.

Old Vicarage, Higher Deardengate, Haslingden, c. 1904. Alice Robinson and the mother of Ellen Ward are in the doorway. The building, formerly the home of the Lonsdale family, served as the vicarage for St James' church from 1813 until 1887 when it was condemned by the local authority. It was vacated by the Canon Weldon Champneys who moved into Carter Place Hall whilst the new vicarage was completed. Ellen Ward ran a laundry business here until 1912 when it was converted into the Empire Picture Hall.

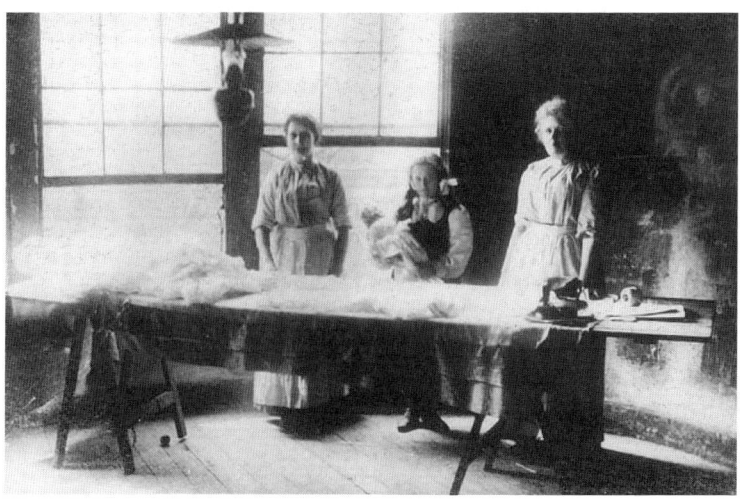

Above: Laundry in the Old Vicarage, *c.* 1909. Left to right: Ellen Ward, Alice Robinson (later Barnes), Mrs Robinson. On the announcement that a music hall and silent picture hall were to open here, there were protests from parents and teachers who considered the shows would be 'physically detrimental' to children. The picture hall was visited in 1913 by Florence Turner, an American film artiste, who received a letter saying 'It must be so nice to be a picture artiste, because you never have to work!'

Right: Yates' grocers shop, No. 65 Lower Deardengate, Haslingden, 1916. Harold Yates ran this business for a time in Deardengate but by 1924 had moved round the corner to No. 26 Manchester Road. Window displays at the time obviously concentrated on quantity rather than variety and Bird's Custard, Brooke Bond Tea and 'fresh and pure' Stork Margarine figure prominently in the arrangements! Although no longer a 'provision dealers', the shop front is little changed today.

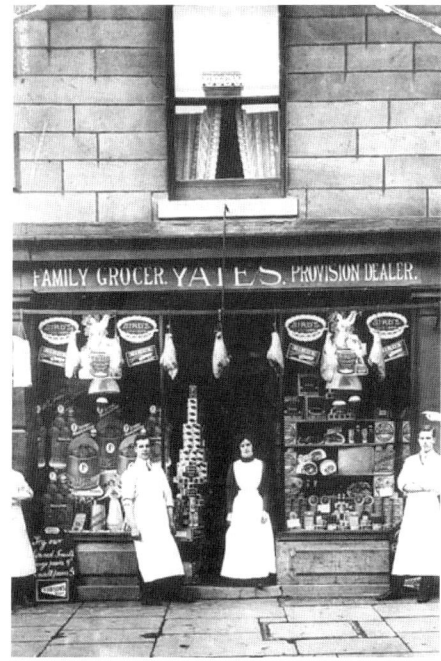

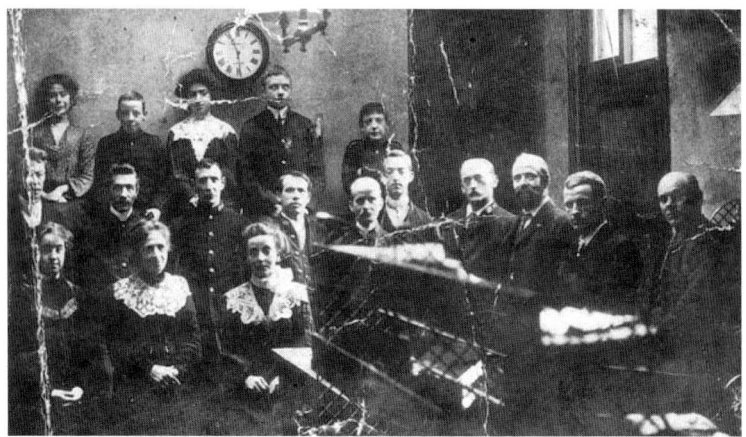

Haslingden Post Office, 1900. These workers moved to Deardengate in 1904 following the failure to improve facilities here at No. 2 Regent Street. This was originally the residence of Henry Cockroft, who became postmaster in 1853 until his death in 1871. He was followed by his daughter, Martha Agnes, popular for her bright and breezy disposition, who gave long service as postmistress until her retirement in 1904. Michael Davitt, later founder of the Irish Land League, worked here as a postman from 1861 to 1868 after losing his right arm in a mill accident.

Greenfield Massage Centre, Helmshore Road, Haslingden. Jack Lewis poses with his horse awarded first prize in a May Day competition. Greenfield Mansion was bought in 1918 for a pioneering electrical massage centre with equipment, such as whirlpool baths, for the treatment of wounded soldiers from Rossendale and Accrington, and continued work begun at the Public Hall Military Hospital during the war. The massage centre closed in 1947 and has been replaced by a sheltered housing scheme.

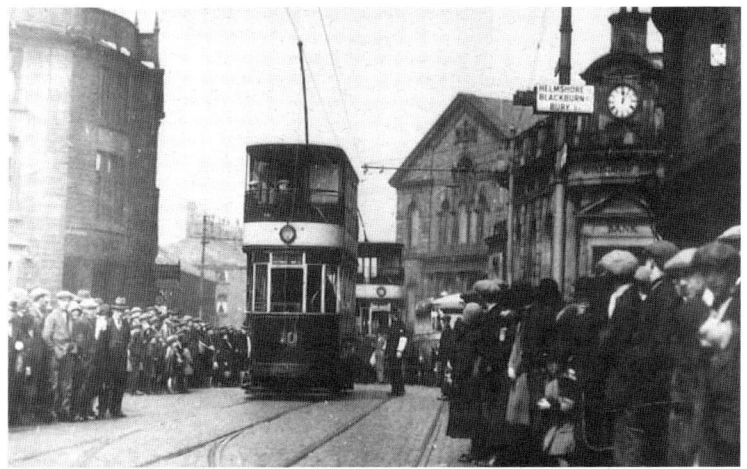

Blackburn Road, Haslingden, 1 May 1930. At the junction with Deardengate the last tram from Accrington is greeted by a large crowd. Although Haslingden never ran its own trams, it was the fourth authority in the country to introduce a motor bus service which ran to Helmshore from 1907 to 1909. The Midland Bank on the right had been built in the early 1920s replacing the Bradbury and Son drapery store and the building beyond is Trinity Baptist church, opened in 1872 and demolished in 1970. Note the single-decker motor bus lying in waiting!

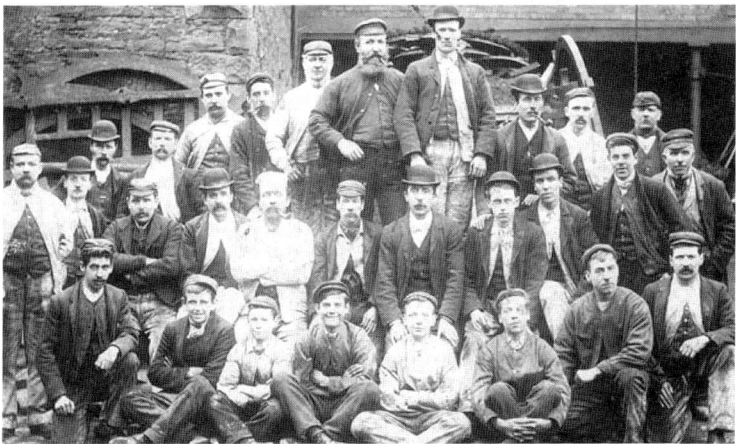

S.S. Stott's Laneside Foundry, Manchester Road, Haslingden, *c.* 1895. This engineering and ironfounding company was established in 1866 by Samuel Storer Stott and Richard Birtwistle, manufacturing steam and winding engines, air compressors for collieries, waterwheels and elevators; their telegraphic address was Elevator, Haslingden. Note the number of bowler hats even in such a manual job.

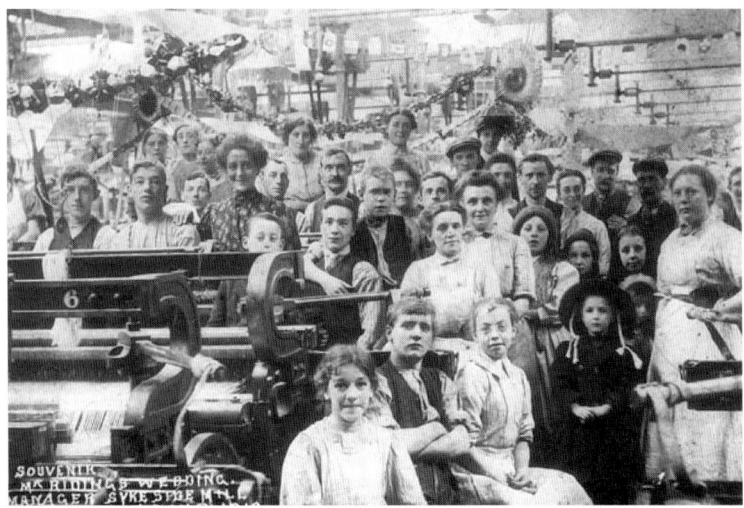

Sykeside Mill, Syke Street, Haslingden, 8 October 1912. The mill has been decorated to celebrate the wedding of Arthur Garnett Riding, who was the manager of Messrs John Warburton Ltd. By 1915, he was living at Sykeside House which had been the home of Alan Rawsthorne, the famous Haslingden-born composer, from 1908 to 1913. John Warburton JP, the founder of this company, had transferred from a hard waste cotton manufacturing business at Bury to Waterside Mill, Haslingden in the early 1860s and was the brother of Thomas of Flash Mill (see p. 27). Note the number of children working in the mill. At this period, children over 12 years of age could be employed part-time and their earnings were an essential part of many families' incomes. In the 1911 census, 53 per cent of 12 year old boys and 44 per cent of girls were in employment in Haslingden and it was not until 1918 that full-time education up to 14 years of age was established. The attention span of these tired half-timers left much to be desired and additional problems were caused by gaps in their knowledge due to missed lessons.

Four

Heading South:
To Helmshore, Stubbins, Irwell
Vale, Edenfield and Townsendfold

Victoria Park, Helmshore Road, Haslingden 11 June 1908. The last piece of turf is being laid on the bowling green which opened on 1 May 1909. The clock tower, which can only faintly be seen in the top left of the picture, was erected by public subscription as a memorial to Alderman H. Wilkinson and was to be presented to the town in July 1908. The park opened in 1901 to commemorate Queen Victoria's Diamond Jubilee but it was only an offer by the Stott and Smith families to buy this land that confirmed the location here rather than the Carter Place estate, which was considered a more attractive site at the time.

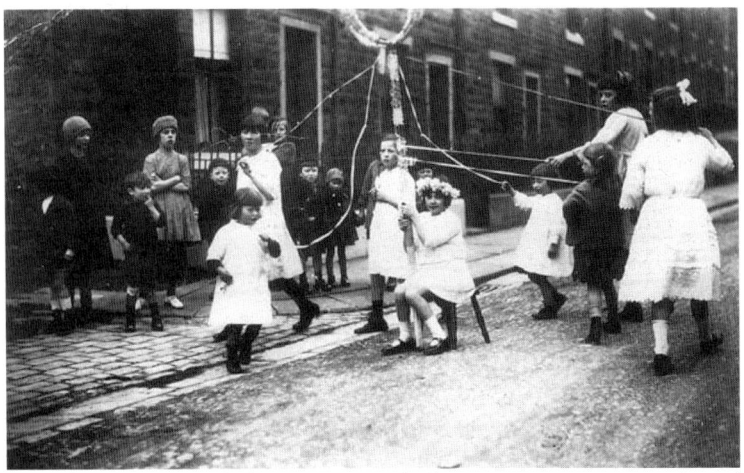

Holden Wood maypole, Helmshore, c. 1923. Mayday festivities, pagan in origin, were banned by the Puritans in 1644 but maypoles and associated customs were restored to popularity by the Victorians. Maybe some of these children need a little training in maypole dancing!

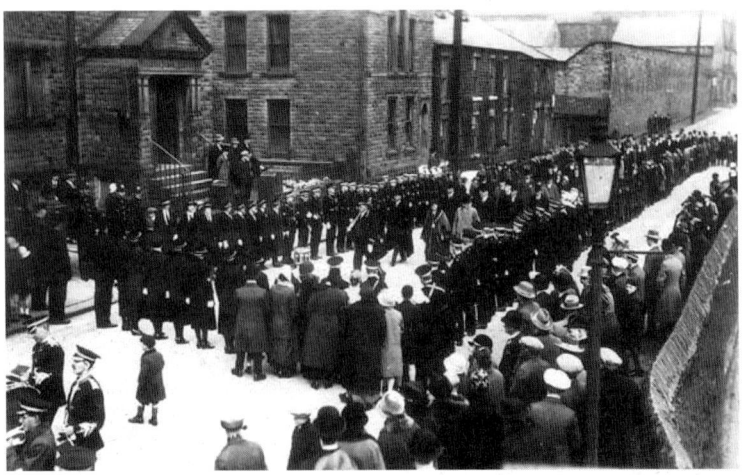

Mayoral procession for Jerry Lord outside Springhill Wesleyan School, Helmshore, 1926. The first Wesleyan site in Helmshore was a schoolroom in 1841, which also served as a chapel until a new church was erected to the left of the picture in 1867. The school shown here opened in 1891 and both buildings were used until an amalgamation with Sion Primitive Methodist chapel in 1962. They have since been demolished and replaced by houses at No. 401 Holcome Road. Jerry Lord played a cornet solo at the Liberal garden party on p.49.

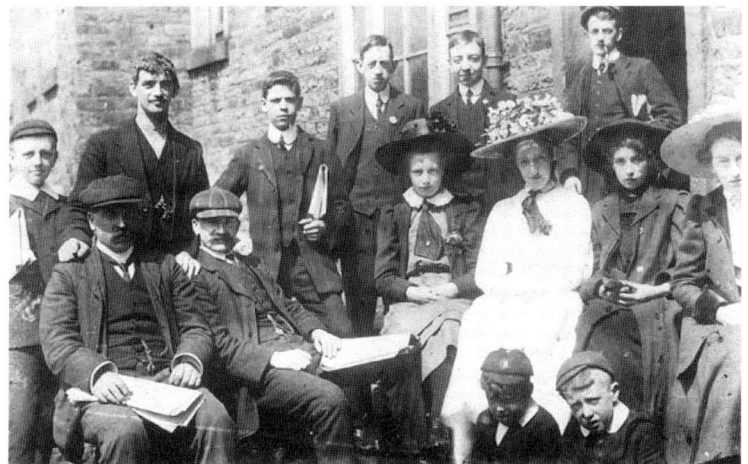

Blue Ribbon Club, Bridge End, Helmshore, *c.* 1910. Established in 1882 following the campaign of the American temperance reformer, Thomas E. Murphy, this association was allowed free use of these larger premises by the Porritt family (see p. 49). The club survived until 1932 organising games and concerts for local residents and encouraging the healthier pursuits of sports and athletics; the brothers, William and Charlie Hollin, became renowned throughout the country for their weightlifting skills. Note the number of newspapers which would have been provided by the club.

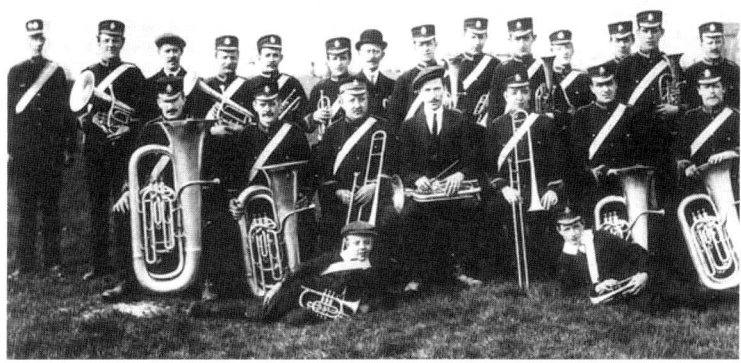

Helmshore Prize Band in the 1920s; the conductor, Richard Aspin, is sitting in the middle of the front row. The band was formed in 1872 and won the first prize at a Crawshawbooth contest in 1906; this was celebrated by a return home in style in a wagonette. In 1909 its twenty-four members spent 22s 6d each on a uniform with red collars and cuffs, worn here. The occasion for the portrait may have been the band's success in 1920 and 1921 at a competition in Stalybridge.

Holcombe Hunt, White Horse Inn, Helmshore, 1926. The hunt could date back to 1617 when Holcombe hounds pleased King James I hunting from Hoghton Tower. In 1913, at the visit of King George V and Queen Mary to Lancaster (see also p. 118), it was described as the oldest established harrier pack in the county. The innkeeper of the White Horse in 1881 had been Daniel Barnes, a man of many commercial interests, described as a 'Farmer of 15 acres, innkeeper and cotton mill manager'.

Fred and Jordan Entwistle, Great House Farm, Alden, Helmshore, 1923. Henry de Lacy, Earl of Lincoln, built the first Great House here when he enclosed the area as a deer park in 1305, the first enclosure in Rossendale. In more recent times, the farm was bought by the Ministry of Agriculture in 1951 and run until 1982 as an experimental farm in an attempt to solve the intractable problems of Pennine hill farms battling against a harsh climate and poor soil conditions.

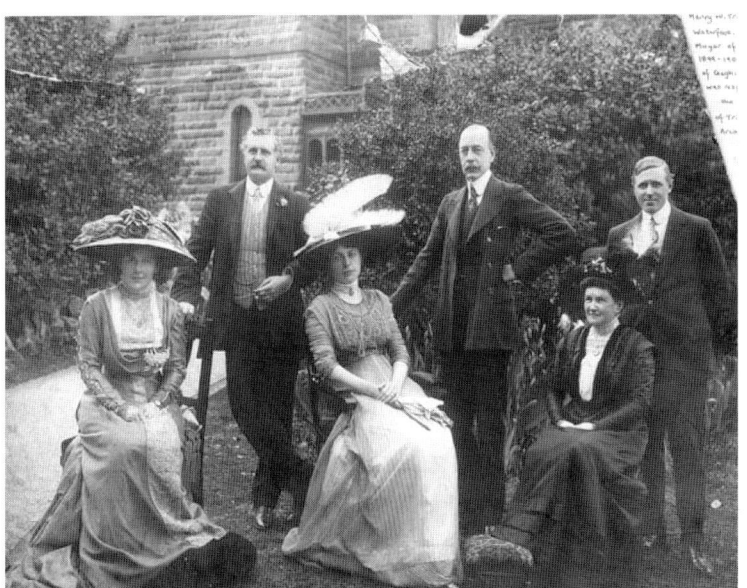

Liberal garden party, Torside, Helmshore, 12 June 1909. Left to right: Mrs Oliver Porritt, Sir Henry Whittaker Trickett JP (slipper manufacturer of Waterfoot, Mayor of Rawtenstall 1899-1903, Freeman of the Borough 1907, knighted in 1909), Mrs Mary Ethel Harcourt, Hon. Lewis Harcourt (MP for Rossendale 1904-1917, known as 'Lulu', Rossendale's third longest serving MP and created a viscount on leaving parliament), Mrs H.W. Trickett, Oliver Porritt JP, son of Harold. Harold Porritt, JP and president of the Helmshore Liberal Club, invited 1,200 guests from Rossendale to his home to meet the local Liberal MP, Lewis Harcourt. Women's suffrage campaigners, including Jenny Baines (see also p. 117), Mrs Morris of Manchester and Miss Garnett of Leeds, mounted demonstrations during the MP's journey to and from the railway station in attempts to influence the cabinet member's strongly held views against votes for women, but they failed to gain entrance to the social gathering.

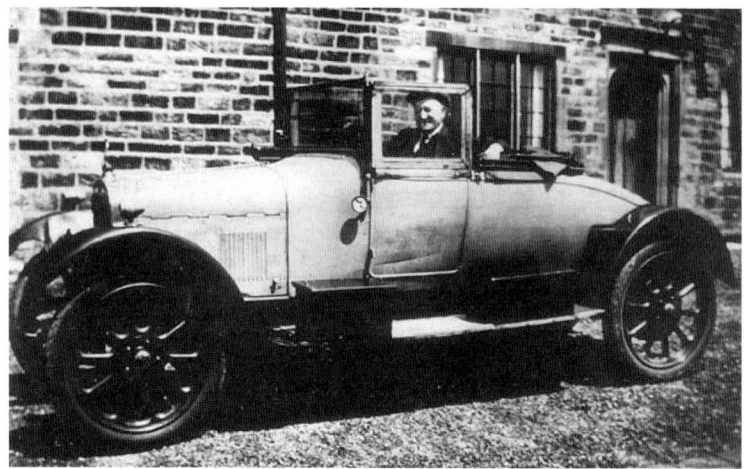

Dowry Head, Helmshore, c. 1925. Richard Moorhouse is the proud driver at the wheel of the car owned by Logan Turner, the owner of the house. Dowry Head was formerly known as Fielding's Farm and acquired its new name between 1912 and 1929. It is now the home of Sir David Trippier who was the MP for Rossendale from 1979 to 1992.

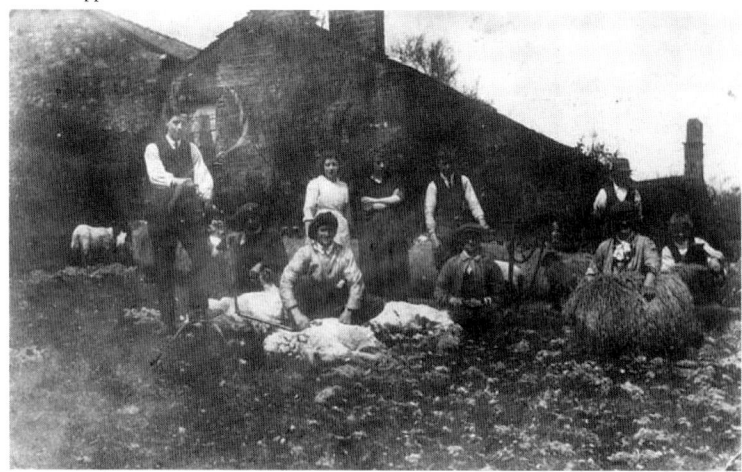

Sheep shearing time for the Metcalfe family at Broadwood Edge, off Holcombe Road, Helmshore. This area was part of the estate of the Rawstornes (see also p. 53) in the 1560s and the farm itself was built in 1722 for Miles Lonsdale who originally came from Burnley. In the 1891 census, William and Jane Metcalfe, both born in Yorkshire, were living here with their five children, Elizabeth, Margaret, Abigail, John and Thomas, some of whom are probably shown here.

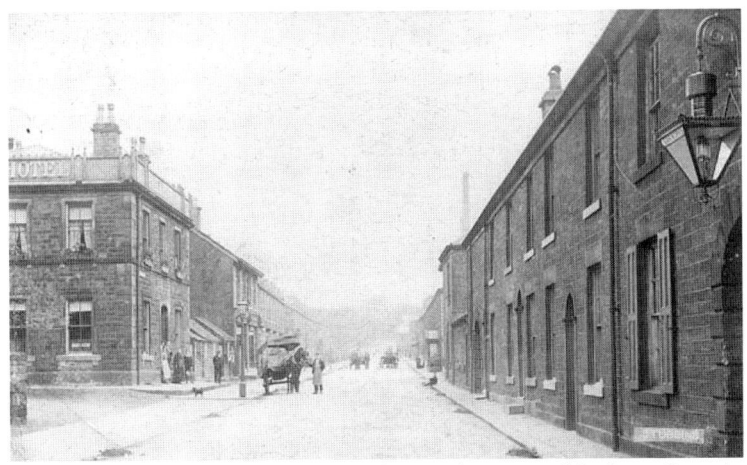

Bolton Road North, Stubbins, c. 1905. The Railway Hotel was renamed the Corner Pin in the 1970s but had been known locally by that name for many years. The 'corner pin boys' were well paid block printers from the calico printing Stubbins Print Works, now Fort Sterling Ltd. They were valued customers and were given preferential treatment with an area reserved for their use. The gas light at the front right is outside the now demolished offices of Ramsbottom Gas Co., the area behind which is now occupied by Cuba Industrial Estate.

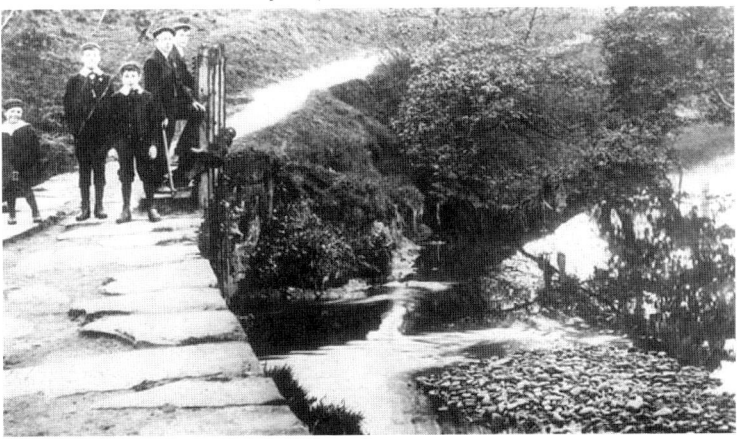

Footpath from Lumb to Irwell Vale, c. 1908. Standing next to the sluice gate for the goit to Lumb Mill are, on the right, Tom Salisbury and, second from the right, Henry Ashworth. Lumb Mill was built in 1824 for Robert Barker for woollen and cotton manufacture but converted to paper manufacture before 1845 and then to bleaching around 1890; its varied history did not, however, save it from closure around 1967 and demolition eight years later. Note that even the young boys are wearing caps.

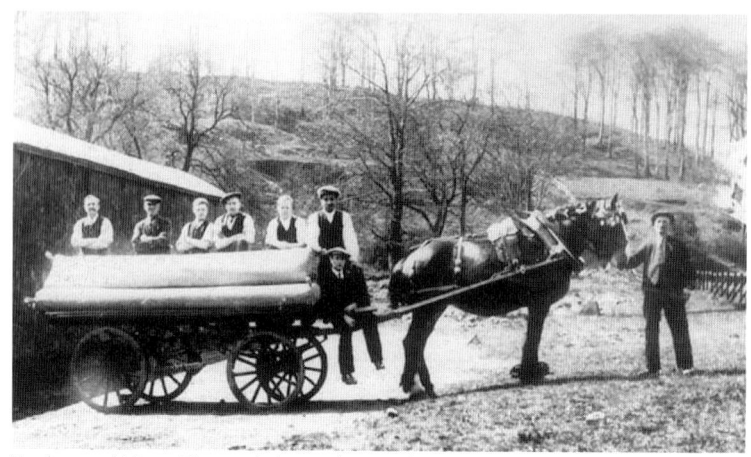

Employees of Messrs Thomas Aitken and Son Ltd., Irwell Vale Mill, in the early 1930s. Mr Redding, later a signalman at the railway crossing, is sitting on the shafts and behind him is Lamb Miller, possibly the warehouse foreman. Jack Garside, holding the horse Jack, was responsible for the horse-drawn transport for the mill, always ensuring the horses were well groomed. This spare land, once used as an allotment garden, has been replaced by a long red brick building now used by a soap manufacturer.

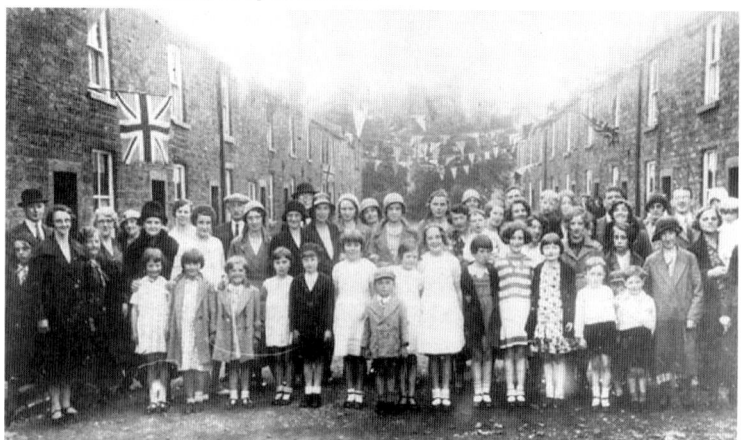

Bowker Street, Irwell Vale, 1933. Celebrations for the village centenary included morris dancing in the street, games and a fancy dress parade in the field adjoining the Methodist chapel at the bottom of this street. This was named after John Bowker, a Prestwich merchant, who bought land in the area in 1798, later building Hardsough and Irwell Vale Mills and these millworkers' homes. These buildings were designated a conservation area in the mid 1970s as a good example of a Lancashire mill village.

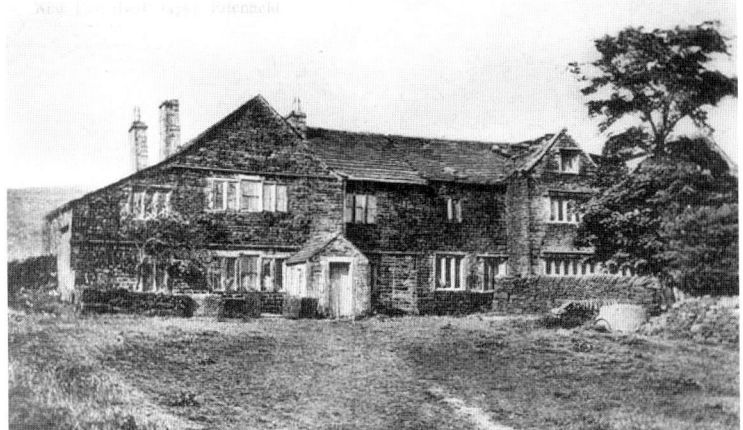

New Hall, Gincroft Lane, Edenfield. One of the area's first stone buildings was built on land purchased in 1538 by Laurence Rawstorne who belonged to a family influential in both Edenfield and the county. A visitor, Mistress Hesketh, and Rachel Rawstorne both died from plague here in 1645. Part of the hall was rented out as farm buildings in 1888 but the stables and barn were converted to a filter house by the Irwell Valley Water Board after 1935. Stone from the hall has been re-used at Gincroft Farm, but the orchard wall is still standing.

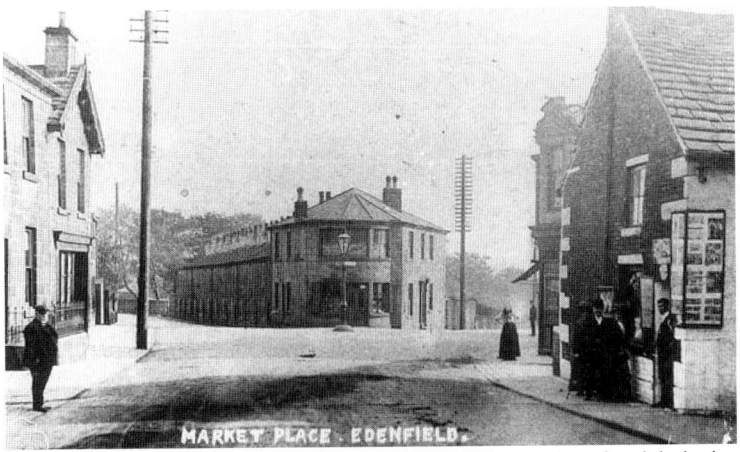

Market Place, Edenfield, 1911. The building at the front right has now been demolished as has the toll-house beyond the lamp. From 1789, Edenfield became the meeting place for several turnpike roads, replacing the early packhorse roads made wholly inadequate by the demands of increasing industrial traffic. Turnpike trusts were empowered by parliament to levy tolls at such toll-bars to pay for road improvements and the Rochdale-Edenfield trust saw tolls double from £350 in 1847 to £765 in 1857.

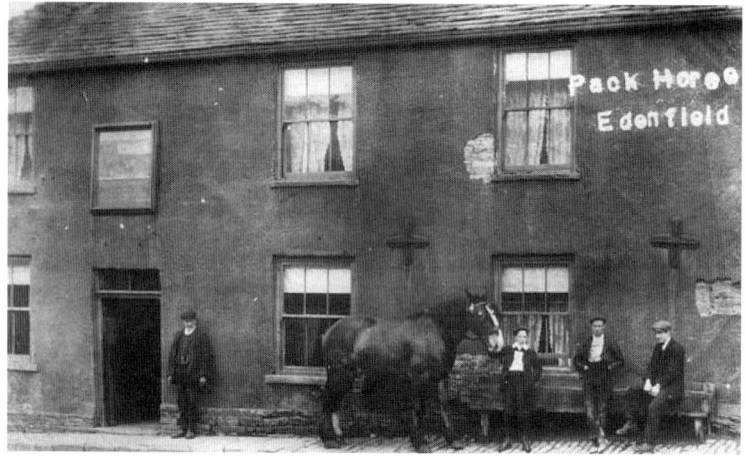

The Packhorse, No. 162 Market Street, Edenfield, *c.* 1905. Left to right: Richard Nuttall and his sons John Will, Jim and George. The earliest alehouse in Edenfield dating back to 1614, this was rebuilt in 1908 and is now occupied by a pizzeria restaurant. Richard Haworth is the licensee on the inn sign and, in 1905 and 1909, he described himself as a farmer and landlord. He was followed in about 1913 by John Pickup Nuttall, possibly a relative of the Nuttalls shown here.

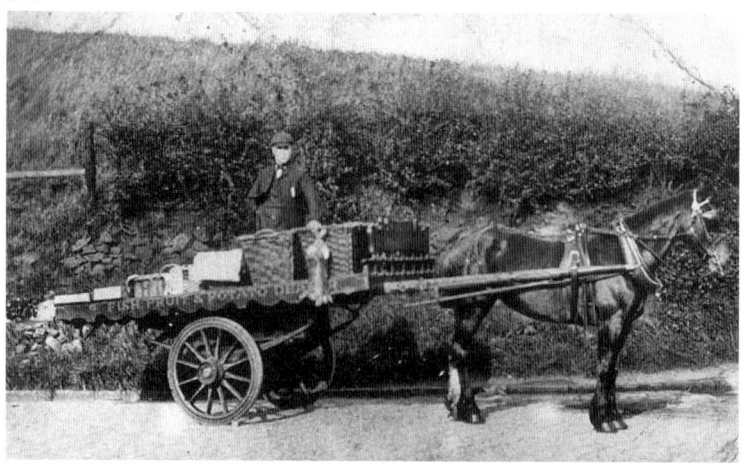

Jordan Rostron, mobile fish, fruit and potato dealer in Edenfield. A Jordan Rostron lived at No. 57 Burnley Road in 1891 with his wife Ellen and six children. He was a woollen manufacturer with two daughters employed as dressmakers and two sons working as woollen dyers. One of these called Jordan was twenty-two years of age and is possibly the one shown here, diversifying into the retail trade.

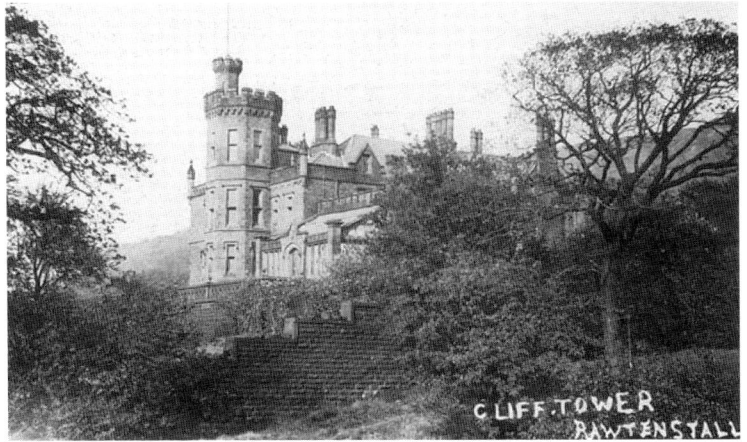

Cliffe Tower, Bury Road, Rawtenstall, before 1919. 'One of the greatest architectural ornaments' of the valley was designed, as many of the impressive buildings in Rossendale were, by Richard Williams. Built in 1858 for Richard Hoyle Hardman of Hardman Brothers at Newhallhey Mill, it was damaged by fire and later demolished in 1919, but the gateposts and part of the walls were used in Stubbylee Park, Bacup and other stonework taken for the lychgate in Haslingden (see p. 35). Another house, Woodcliffe, now stands on the site.

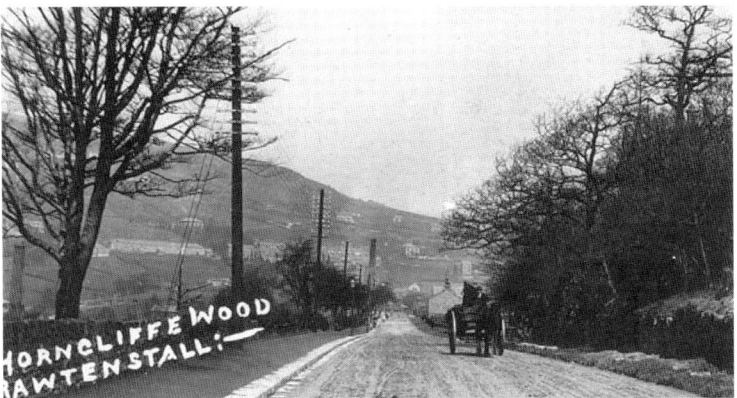

Horncliffe Wood, Bury Road, looking towards Rawtenstall. When John Loudon McAdam, Surveyor-General of Metropolitan Roads from 1827, was developing a new road building technique, it is reputed that this stretch of road was the first in the area to be laid with his experimental waterproof surface which produced a more comfortable ride for vehicles and occupants and reduced traffic noise (see also p. 86). Rossendale Museum, formerly Oak Hill, can be seen on the opposite hillside, behind the telegraph post on the left. The house was built in 1840 by George Hardman overlooking his mill at Newhallhey which is only faintly visible at the bottom right of the road.

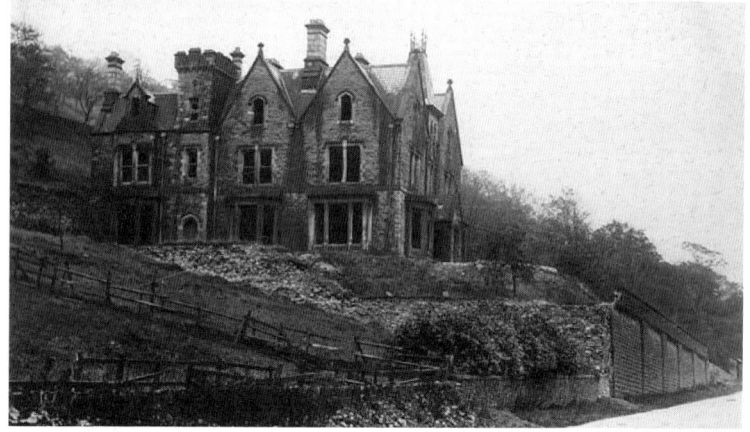

Fernlea, Bury Road, Rawtenstall in the 1930s. James Walton, who worked Horncliffe Quarries, built this imposing house for £10,000 in 1872 with four entertaining rooms and twelve bedrooms. By 1897, it had become a bargain for the discerning house buyer, with a value of £600! It was known locally as the 'haunted house' because it stood derelict for many years, possibly after a landslip. A ground floor cellar at the rear was sparsely furnished at one time as a refuge for tramps and a rehearsal area for travelling actors.

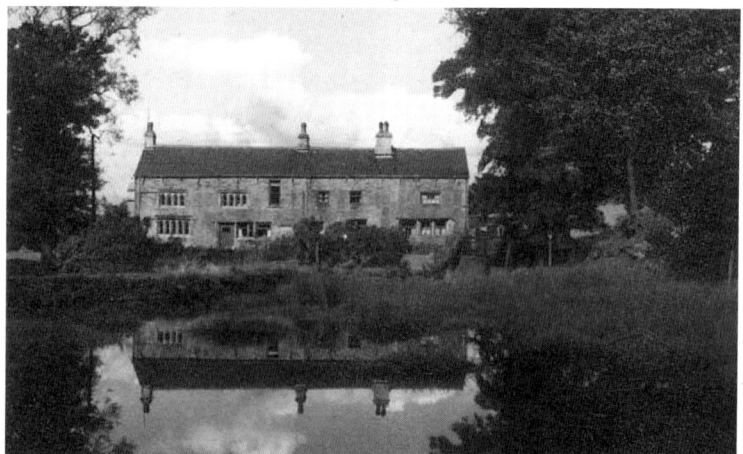

Balladen Old Hall, Rawtenstall, taken by the present owner, Eric Shire, in 1955. Richard and Sarah Ashworth built this house in 1687 and it is one of the oldest surviving dwellings in Rossendale. Balladen Higher Mill, built around 1840, stood in front of the hall to the left of the picture and in 1885 water from the lodge shown here flooded the woollen mill to a depth of three feet. The damage caused by the accident led to James Brierley's bankruptcy the following year and the mill fell into disuse.

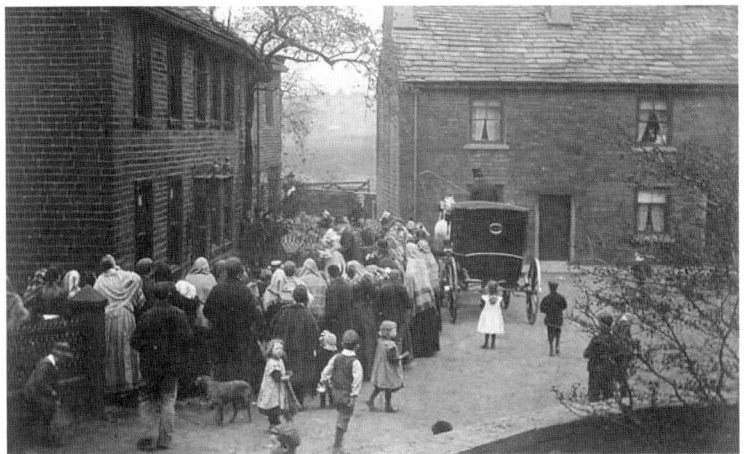

The Holme, Townsendfold. Above left is the home of the Townsend family for seven generations over 200 years, but demolished around 1950 and replaced by new bungalows. The building at right angles has survived and faintly visible behind it is Newhallhey Mill. The Townsends were extensive landowners, owning several properties in Balladen and Haslingden, in addition to a number of mills. Joshua Townsend, who died in 1896, was typical of many of the local, wealthy millowners who involved themselves in public duty and, although in poor health for many years, he was active on the Board of Guardians and a member of Rawtenstall Local Board until 1883. The drive below is to the left of the Holme and still in existence, although without the railings. The post and gate behind the girls marked a toll-bar, the fees from which were payable to the Townsends.

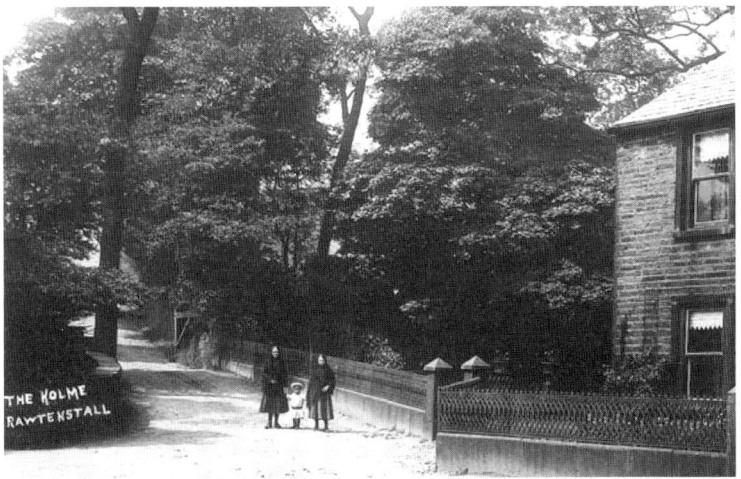

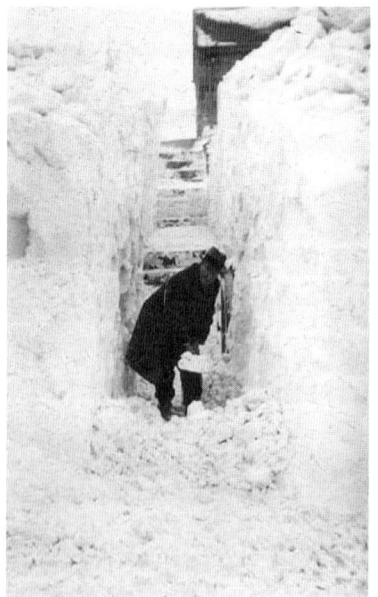

Above: Bury Road, Townsendfold after 1911. Looking away from Rawtenstall, Brookfield House on the left with railings in front was the home of Miss Townsend. Townsendfold Primitive Methodist chapel is in the distance on the right and is now a showroom for domestic appliances. It was built in 1867 by James Walton on land bought from Mrs Mary Ann Townsend for £150 but it closed for worship in November 1970. It is difficult to see a poster facing us on the end of the low wall on the right; it is advertising the Royal Pavilion cinema which opened on Bury Road in the centre of Rawtenstall in September 1911.

Left: W.H. Thomas at Newlands, No. 346 Bury Road, Rawtenstall, February 1940. Such snowdrifts may not be seen again because of global warming! Heavy snow for three days isolated Rossendale almost completely with only the route from Bacup to Rochdale remaining open. Snowfall was the heaviest ever recorded and drifts of twenty feet high in Bury Road were the worst in the area. Schools closed for a week, surely sadly missed by the pupils, and farmers had to use sledges or horses to deliver their milk.

Five

Rawtenstall,
the 'farmstead on rough ground'

Cottages and yard of Newhallhey Woollen Mill, Rawtenstall, taken by James Hargreaves in 1949. The existing mill was built in 1862 by Hardman Brothers and Co., who were in business there until the year after this photograph was taken. The building suffered unusual damage in 1884 when large hailstones broke 1,200 panes of glass! As early as 1887, the company supplied gas to their mills and their employees' homes and those shown here were demolished after 1962 and replaced by the Old Cobblers' Inn.

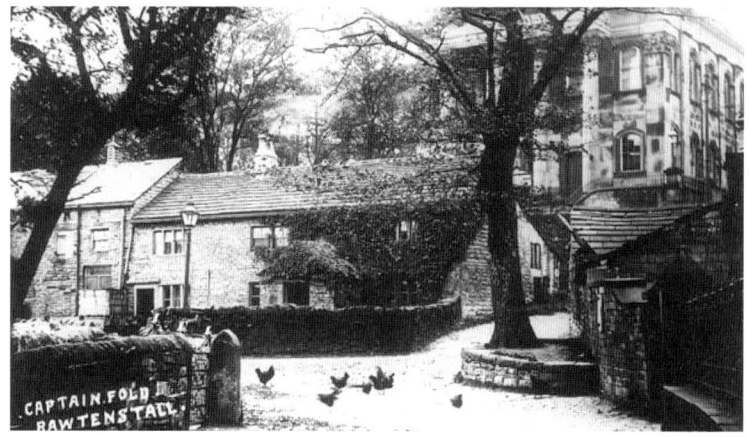

Captain Fold, Rawtenstall. This attractive retreat nestled between Haslingden Road and Bury Road until its demolition in June 1967 to make way for the A682 Edenfield bypass which opened in 1969. Captain Fold is the road at the front of the picture, leading up to Fletcher Fold in the centre and the railings, which can faintly be seen on the right, belong to Newhallhey House. On the left, stables used by J. and J. Whittakers, a well known local firm of carriers, stand on Cow Lane.

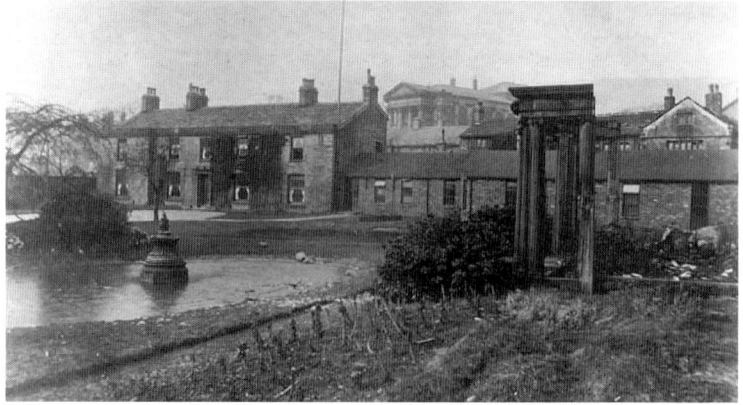

Newhallhey House, Rawtenstall. The hall, visible over the single-storey building on the right, is reputed to have been built around 1600 by a Nuttall of Ramsbottom. Newhallhey House on the left was converted to an auxiliary military hospital in 1915, eventually with sixty-six beds and visited daily by Carrie Whitehead (see p. 62) who also paid for a resident cook. When it closed in March 1919, 700 wounded soldiers had been nursed there. It was later divided into two residences, but all these buildings disappeared along with Captain Fold and the site is now occupied by the western end of the traffic island. The imposing building in the middle distance is the United Methodist chapel on Haslingden Road (see p. 63).

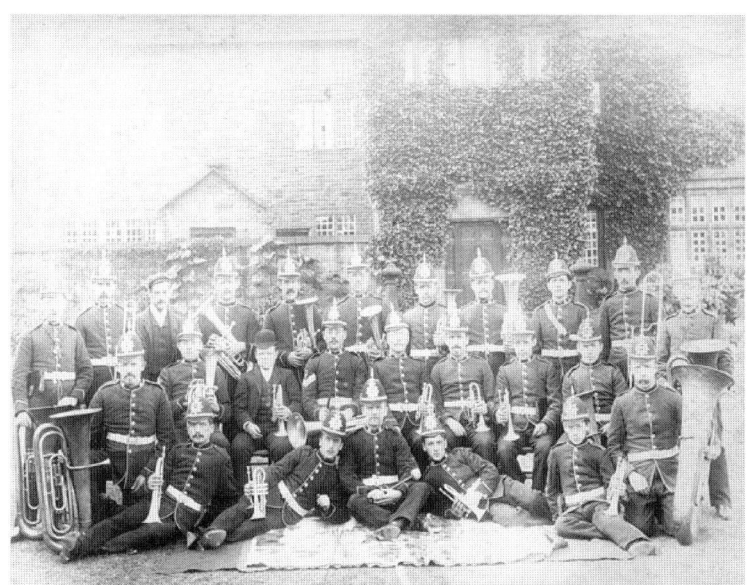

Newhallhey Mill Brass Band in front of Newhallhey Hall, Rawtenstall. The band won considerable fame by winning numerous contests in the 1880s. Left to right, back row: T. Taylor, R. Rothwell, R. Heys, S. Warburton, H. Heys, S. Roundell, E. Hanson, B. Exley, A. Chadwick, J. Taylor, T. Radcliffe. Middle row: J. Ingham, R. Blackburn, T. Greenwood, R. Warburton, O. Houldsworth, E. Warburton, A. Holt, E. Hanson. Front row: H. Cryer, A. Hollows, D. Rothwell, R. Radcliffe, A. Trotter, R. Parkinson.

Above: Higher Plan, off Haslingden Old Road, Rawtenstall. This house, built in 1687, was originally part of an estate bought by William and Henrietta Cockerill of Haslingden in 1804 and later sold to George Hardman to build Oak Hill (see p. 55). Long before the concept of the European Union was formed, Cockerill had seen the advantages of exploiting his skills on the continent and settled in Belgium in 1799, establishing one of the largest engineering works in the world. The building was demolished around 1950 and replaced in 1973 by the ski slope.

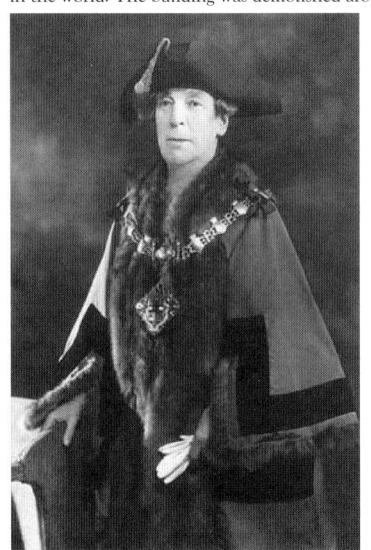

Left: Carrie Whitehead, first woman to be elected Mayor of Rawtenstall in 1935. A grand-daughter of David Whitehead, Carrie, too, was an influential member of Rawtenstall society and she was mayor for three years; a member of the town council for twenty-two years, serving on almost every committee; she was raised to alderman in 1933, becoming the first woman county alderman in 1939. Her interests were many and varied; she helped to found Lea Bank Higher Central School and the Rawtenstall District Nursing Society and she maintained an active involvement with the N.E. Lancashire Needlework Association, Rossendale Girl Guides and St John's Ambulance Brigade. She played a significant role during the Second World War when she arranged for 2,000 women and girls to make bandages and clothes for refugees and 72,000 articles were distributed throughout England and France. She also found time to write three novels with a Lancashire background under the pen name Caroline Masters.

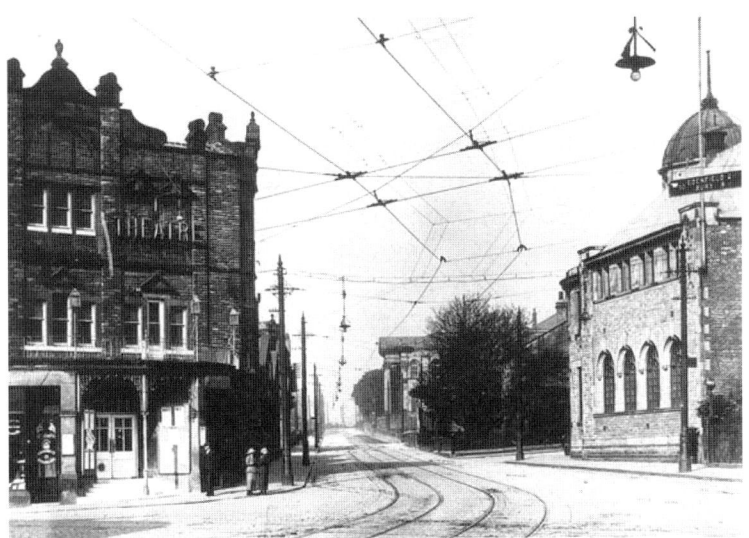

Haslingden Road, Rawtenstall, *c.* 1910. What a different scene today! A large traffic island and fire station have replaced the buildings on the left and the empty road with its electric tramlines is now used by an increasing number of cars. The Grand Theatre with seating for 2,000 opened in 1899 but, unfortunately, was not successful and was demolished in 1938. Beyond the theatre are the Grand Buildings (see also p. 105) built in 1900 and demolished for the road improvements in 1967. The public library on the right opened in 1906 and, on the opposite corner on the site now occupied by a garage, are St Mary's Parsonage and the *Rossendale Free Press* office before its move up Bank Street in 1969. The classical style United Methodist chapel in the distance, which opened in 1857, was financed by the Whitehead brothers following a rift from Longholme Methodist church, but Peter did later express regret at establishing a rival church in such close proximity. Carrie Whitehead later continued the family commitment and was a teacher in the Sunday school.

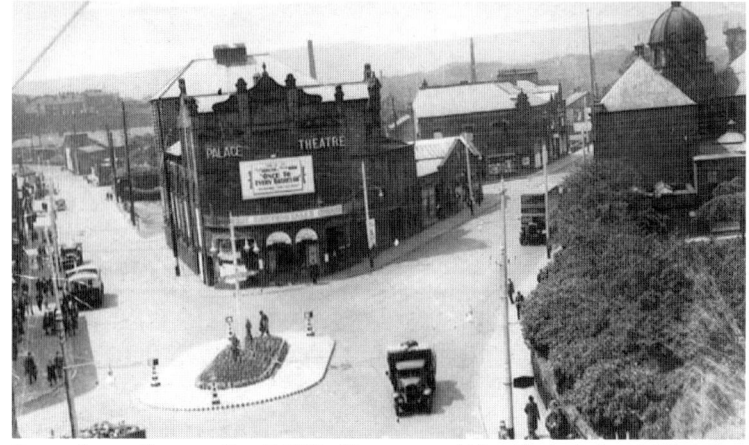

Queens Square, Rawtenstall, mid 1930s. (By courtesy of Mary Elizabeth Stansfield). A later and less common view, the electric tramlines had been taken up after the service ceased on 31 March 1932 but the theatre, renamed the Palace Theatre, has not yet been demolished. On Haslingden Road the double decker bus has just passed Cheapside running behind the theatre to Grand Buildings. Newhallhey House was situated amongst the trees behind and to the left of the Palace. The railway station buildings can be seen at the far end of Bury Road.

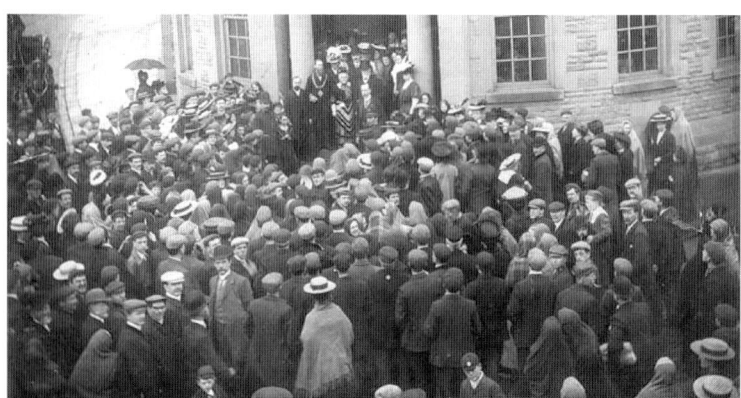

Official opening of Rawtenstall Library, 1 June 1907. Although the library had already opened for business the previous year, the official ceremony was postponed until 1907. In the doorway on the library steps (without the more recent addition of the ramp), from left to right are: James Whalley, Town Clerk; Alderman Samuel Compston, Mayor of Rawtenstall; Mrs Samuel Compston; Andrew Carnegie (with a white beard); Lewis Harcourt, MP (in front of Carnegie); Mrs Harcourt (in front of the pillar). A horse and carriage, probably waiting to transport the dignitaries away, can just be seen to the left of the picture.

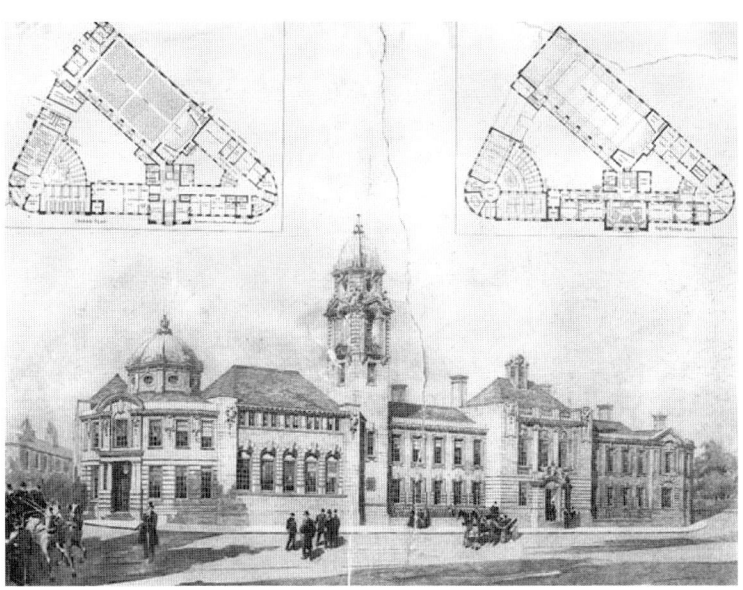

Original plans for the public library and municipal offices, Haslingden Road, Rawtenstall, 1903. How different might the centre of Rawtenstall now look if these drawings had been implemented! Andrew Carnegie, an American multi-millionaire, provided money for many libraries in the UK to 'help those who help themselves – (libraries) reach the aspiring and open to these the chief treasures of the world, those stored up in books'. A competition for the design was won by the Birmingham architects, Messrs Crouch, Butler and Savage, and a grant of £6,921 was awarded by Carnegie on condition that the site be offered free by the council and that the Public Libraries Act of 1892 be adopted to impose a 1d rate for maintenance of the building and book stocks. Costs for the additional work were estimated at £10,000 for the Town Hall and £6,000 for the Assembly Rooms, but, sadly a familiar tale, money ran out and the brick sides and back of the library anticipate these two wings instead of which the gardens were laid out.

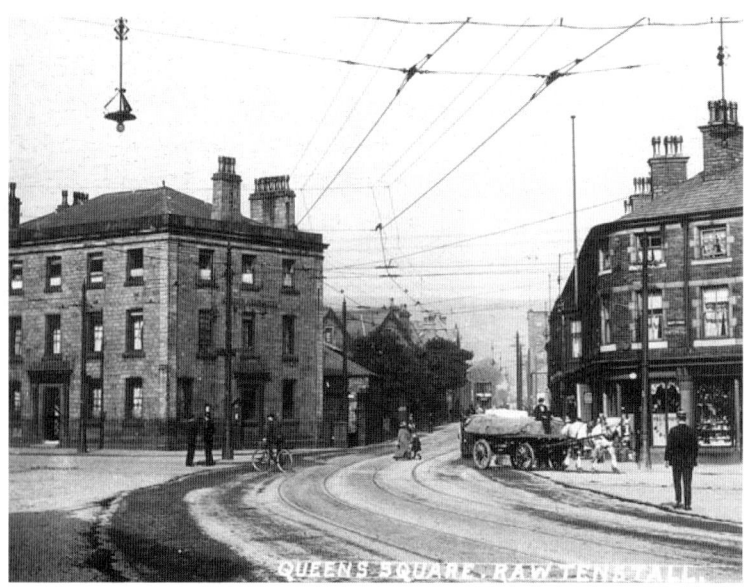

Queens Square, Rawtenstall, c. 1910. Looking down Bacup Road, several different modes of transport can be seen: foot, bicycle, horse and electric tram. When the Queen's Arms Hotel was built in 1837, it was the only public house in the town with the stabling facilities required by the stagecoach service between Colne and Manchester. The St Anne's-on-the-Sea Land and Building Company held its inaugural meeting at the inn in 1874 when many local wealthy industrialists, led by Elijah Hargreaves, the manager of David Whitehead's Lower Mill, saw the possibilities of investing in the seaside resort, which was then developed with Rossendale money.

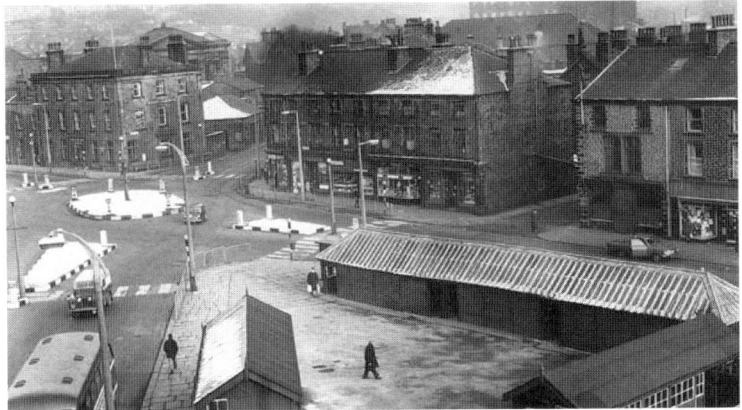

Queens Square, Rawtenstall, *c.* 1965. The bus station, on the site of the former tram terminus, moved to its present location on Bacup Road when work commenced for the Edenfield bypass, which influenced so much of Rawtenstall's development in the 1960s. Once the Ministry of Transport had announced plans for the new road, the local council decided to build a new shopping complex which transferred the town centre further up Bank Street. Ilex Mill, built by Peter Whitehead in 1856 and then still a working mill, can be seen in the background.

Employees of Eastwood and Son, cabinet maker and furnisher, Rawtenstall, *c.* 1905. Edmund Taylor Eastwood built Grand Buildings on Haslingden Road in 1900 (see also p. 105) and moved in to No. 23 for several years. His business had begun in Lord Street, later transferring to the Bury Road premises now occupied by the Rawtenstall Discharged and Demobilised Sailors' and Soldiers' Club. An advertisement in 1894, which would be frowned upon today, advised ladies that 'if (your young man) is not interested in your conversation about Furniture, he will not be much good to you as a husband'.

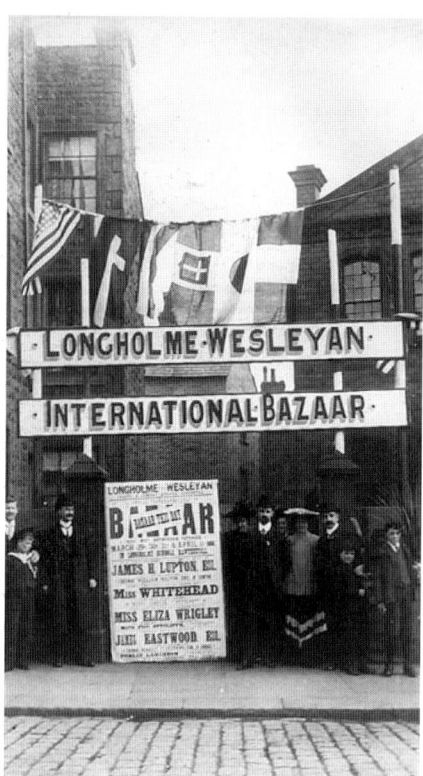

Longholme Wesleyan Methodist School, Bank Street, Rawtenstall. Thomas Whitehead laid the foundation stone on 23 May 1855 for this building, which served as a day school until 1910 when pupils transferred to Alder Grange School, and as a Sunday school which closed around 1956. Proceeds from the bazaar left, in 1905, were possibly used for Springside Mission (see p. 75), which opened in the same year as an 'overflow' to Longholme chapel, although the latter's seating capacity of 1,300 had been considered sufficient when it was built in 1842. Below, the same building as it appeared in 1950 with trees planted as a memorial to church members killed in the First World War. The school was demolished in March 1962 to make way for a supermarket on the site now occupied by Boots the chemists. The row on the right housed a wine and beerhouse from 1850 to 1878 called One to Many, referring to the number of drinks available, but corrupted to the much more colourful, One Too Many!

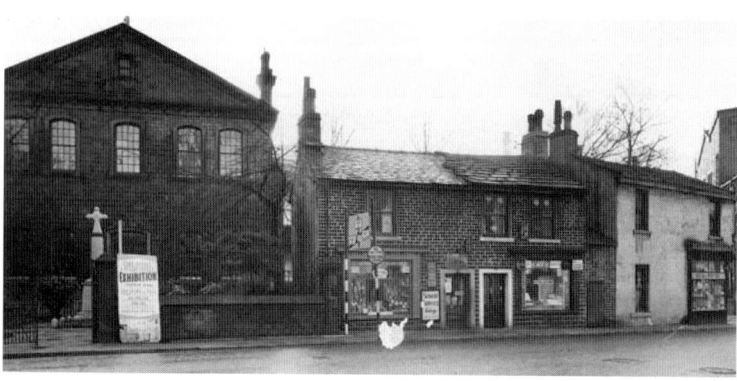

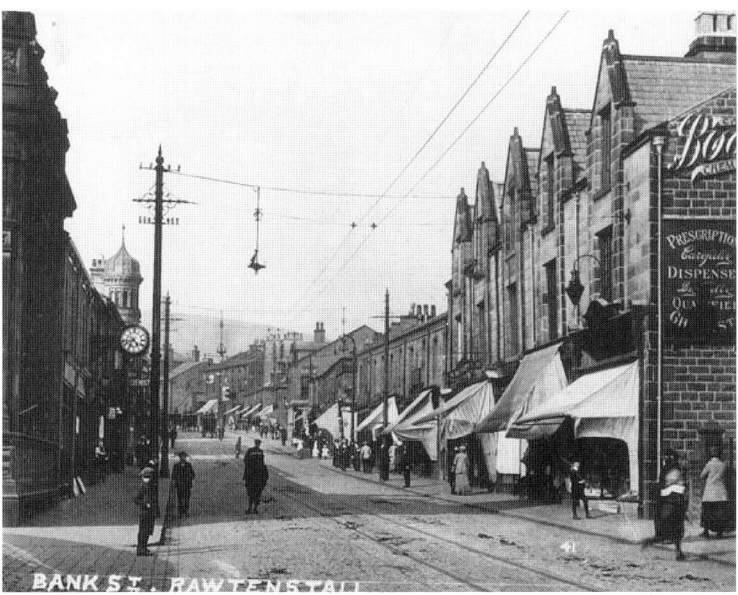

BANK ST. RAWTENSTALL

Bank Street, Rawtenstall, *c.* 1919. When this photograph was donated to Rawtenstall Library in 1949, a comment on the back stated 'Not much change has taken place generally' but the same certainly cannot be said today! All the property on the left in the front half of the picture up to what is now the National Westminster, formerly the Manchester and County Bank, and as far as Kay Street on the opposite side of the road, was demolished around 1968 for the bypass and the Valley Centre now occupies the area on the right. A funeral cortège can be seen at the top of Bank Street with evidence of their horse-drawn transport obvious on the road! On the left outside the watchmaker's and jeweller's business, Thomas Coupe and Son, is the clock which now adorns the exterior of Rossendale Museum. The road at the front left leads in to the Fold, shown overleaf and just off the picture at the front right there is a gate which belongs to Longholme Wesleyan School. Boots the chemists can be seen adjacent to its present location. Note the electric lights suspended from the tramlines.

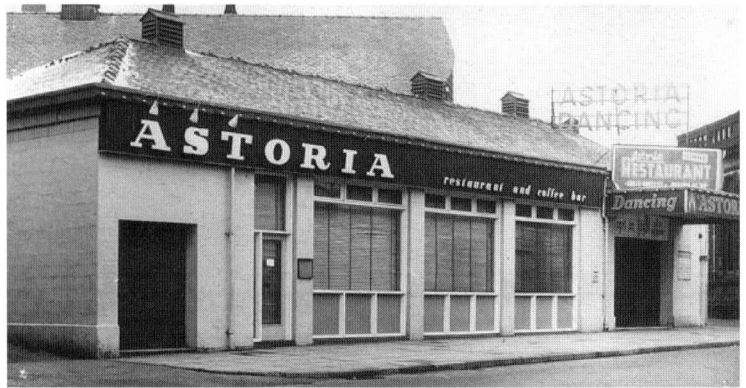

Astoria Ballroom, Bank Street, Rawtenstall, 1966-1967. Holly Mount School, built by the Whiteheads in 1839 for their employees' children, was converted in 1932 to a venue for many famous groups although initially without a licensed bar. The road developments caused the ballroom's closure on 7 February 1966 and a loud chorus of complaints from 'disgusted' teenagers who now had to travel out of town for their entertainment. The Old Fold Garden now commemorates the site and The Fold shown below is to the right of the picture.

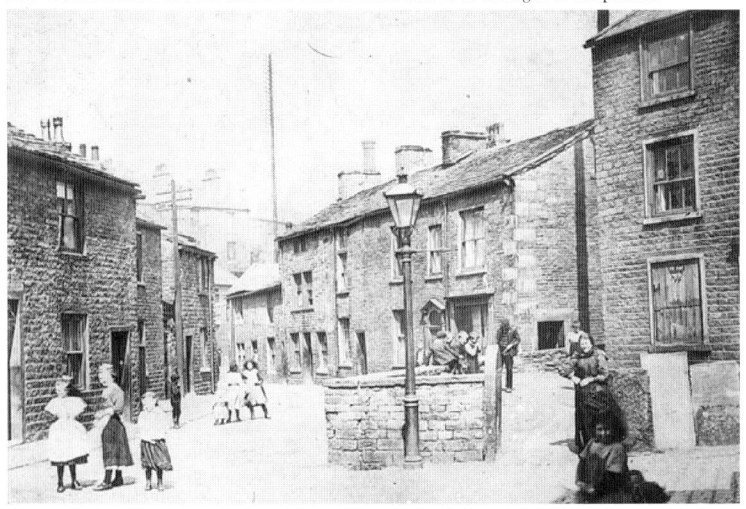

The Fold, Rawtenstall, c. 1910. This road ran from opposite the present Boots the chemists to Tup Bridge along the route taken by the new St Mary's Way for which these houses were demolished around 1968. Many of the residents of this area would have worked at David Whitehead's Lower Mill, the close proximity of which must have been a cause for anxiety on at least two occasions in 1841 and 1870 when the mill was damaged to such an extent by fire that it had to be rebuilt.

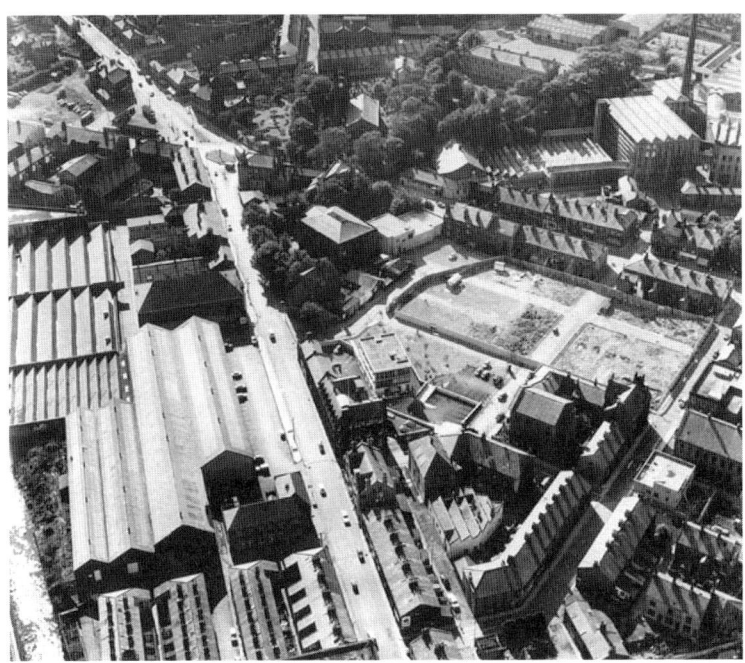

Aerial view of the centre of Rawtenstall as it was in 1967. Looking down Bacup Road towards Queens Square, the bus station and Grand Buildings are still opposite the library although soon to disappear for the large traffic island. In the middle left is the Longholme Shed cotton mill, now demolished and replaced by Do It All Ltd. In the bottom right, the buildings have since disappeared to make way for Kay Street car park and, next to the Baptist church, shops on the site of Annie Street are in the process of being constructed. On Lord Street in the centre, Jubilee Primitive Methodist chapel, adjacent to the police court and station, is yet to be demolished to make way for the present police station. The remainder of Lord Street, behind the properties on Bank Street, and Lord Street West have already disappeared to make way for the shopping centre and the new Astoria ballroom which opened in October 1968. The old Astoria can still be seen at the bottom of Bank Street. In front of David Whitehead's Lower Mill, parts of which were dismantled in the early 1980s, The Fold is intact but shortly to disappear for St Mary's Way. In the top middle of the picture on Henry Street is St Mary's C. of E. School, more recently demolished in 1995.

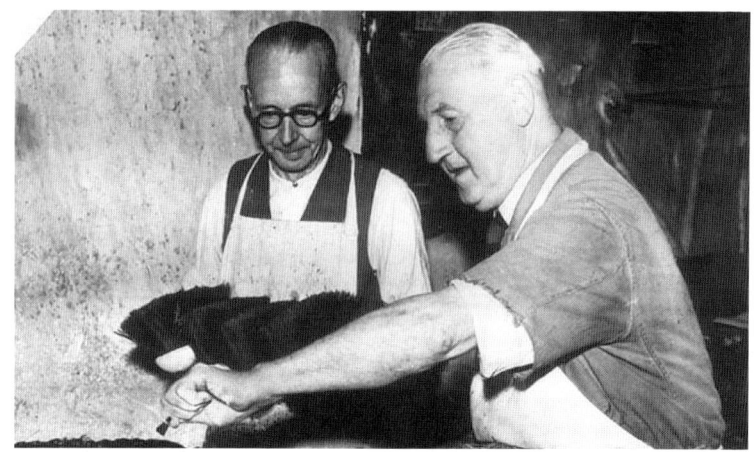

Above: Brushmakers, No. 32 Bacup Road, Rawtenstall, 1959: Edward Sweetman, 61 years of age, is on the left alongside Arthur Chadderton, 80 years old. Arthur's grandfather, James, founded a brushmaking business on Lord Street in 1861, moving to this shop by 1879. Arthur took over himself in 1923 after working as a half-timer and then starting his apprenticeship when 14 years old. Edward Sweetman of Bacup was the only other brushmaker in the valley and they supplied brushes for a wide range of uses from chimney sweeping to loom sweeping to road sweeping machines.

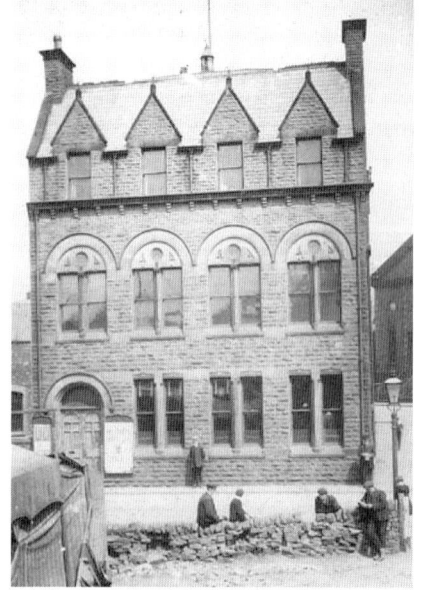

Left: Town Hall, Bacup Road, Rawtenstall, taken by H. Sykes, *c.* 1905. The fledgling borough council acquired these premises for their municipal offices as a temporary measure only when the town was incorporated as a borough in 1891. When the ambitious plans to build a magnificent Town Hall next to the library foundered, this building was retained and later extended. It had originally opened in 1875 as a share exchange and social club, where business could be transacted in surroundings more salubrious than a public house with rooms for conversation, smoking and refreshments. The canvas tent on the left is part of Rawtenstall Fair and Jubilee Primitive Methodist church can be seen on Lord Street.

Right: Alderman William Lord, first Mayor of Rawtenstall from 1891 to 1892, taken by Hammond of Bacup. Born in Cowpe in 1824, Lord was elected to Rawtenstall's first town council in 1891 but maintained a keen interest in his home village and one of his committees considered a hospital for infectious diseases at a time when there was a serious typhoid epidemic in the Cowpe area. He was an outstanding teacher at Cowpe Sunday School (see p. 85) and continued to be active as its treasurer and superintendent until his death in 1895. One of his talks there compared the journey through life with a plank and he urged the young people 'to walk the straight and narrow as (he had) tried to do'.

Below: Trinity Methodist church, Lord Street, Rawtenstall, *c.* 1965. Not to be confused with the Jubilee Primitive Methodist church, shown here further down the street, this church was earlier known as Lord Street United Methodist. It closed for worship in 1936 but, during the Second World War, served as a food office and was later occupied by Leslie Ellis as a wholesale draper. The premises were demolished in 1965 to make way for the shopping centre.

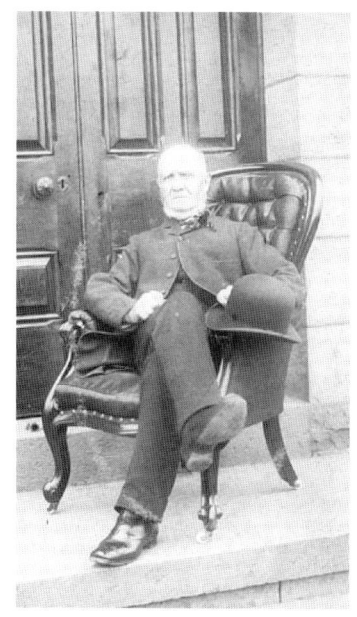

73

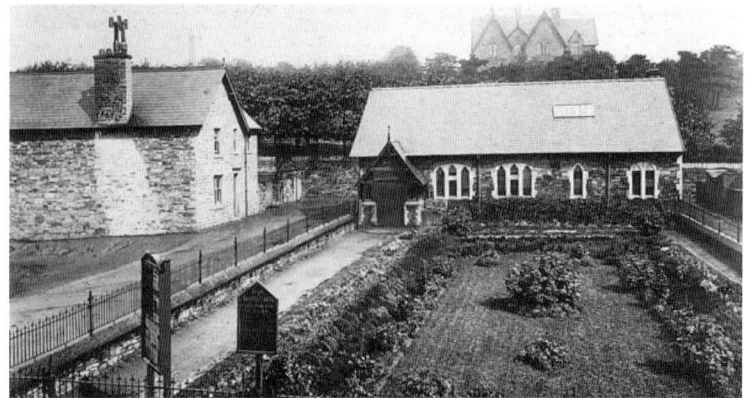

Kay Street Baptist chapel, Rawtenstall, before 1901. Richard Whitaker of Oak Hill became a benefactor of this church which opened in 1876 after eighteen individuals had left other congregations. In 1901 his wife, Sarah, laid one of the foundation stones for the existing chapel which was built on the garden shown here. A funeral service was held for him at the church in 1906 although he had by this time, like many other Rossendale industrialists, moved to St Anne's. Alder Grange House, built for Joseph Wood Whitehead in the 1860s and demolished in 1965, is in the background.

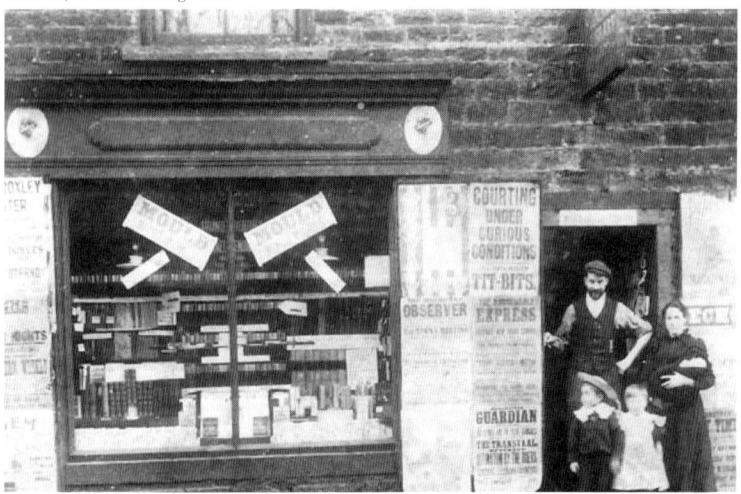

E.J. Mould, Printers, No. 70 Bank Street, Rawtenstall, c. 1901. Standing in the doorway are Edward James Mould, who was born in 1866 and died in 1937, and his wife Sarah Ann, holding their baby, Ada; their daughter, Elizabeth Mould, in a white dress stands in front of them next to Jim Woodcock. The billboard for the *Manchester Guardian* to the left of the door refers to the Liberal crisis during the Boer War and the sign over the door advertises a Lending Library.

Above: Burnley Road, Rawtenstall, 1935
(By courtesy of Mary Elizabeth Stansfield).
Left to right: -?-, Mr Kilsby, Bob Howarth,
Carrie Howarth (*née* Kilsby), Emily
Chadwick. A row of shops used to stand
opposite the cemetery between Kenyon
and Roberts Streets which included this
grocers, a greengrocers in the middle and
a cloggers at the other end. The flags are
celebrating the Silver Jubilee of King
George V on 6 May 1935. A grassed area
and car park now occupy the site.

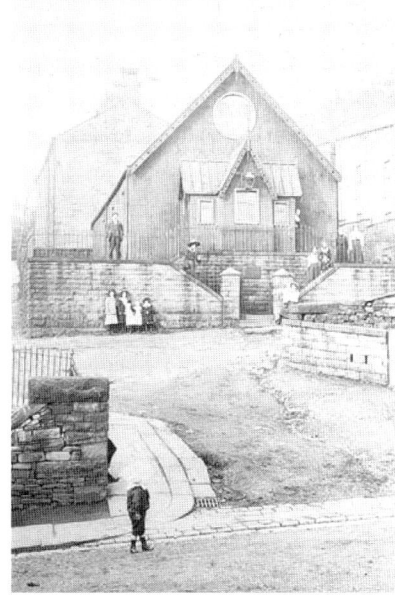

Right: Springside Methodist Mission Hall,
Newchurch Road, Rawtenstall,
c. 1900. Thomas Murphy's temperance
campaign in 1881 persuaded so many
people to sign the pledge that this 'Tin
Tabernacle' was constructed in 1882
at a cost of £500 to seat another 270
worshippers from Longholme. The interior
was lined with pitch pine and felting to
lessen the noise but it was replaced with
the existing premises in October 1905.
Whilst construction work was undertaken,
the 'tin mission' was dismantled and
rebuilt at Daisy Hill and the original
datestone, seen here between the
gateposts, was re-laid in the new building.

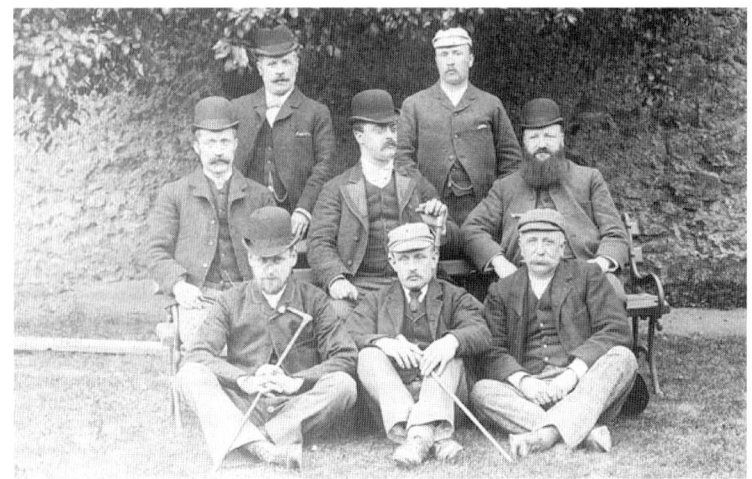

Rawtenstall Rambling Club taken by W.H. Lawdon of Ingleton, *c*. 1890. Dress was obviously a little more formal for ramblers in the last century than it is today! Their walks, however, were similar and an account in the *Rossendale Free Press* in 1912 describes thirty-two Rossendale ramblers under W.C. Horrobin, travelling by car to Lockgate and then enjoying a moorland ramble to Helmshore and on to Grane. Social activities, such as whist drives and dances, were also organised. Note the absence of female members who were possibly fully occupied at home!

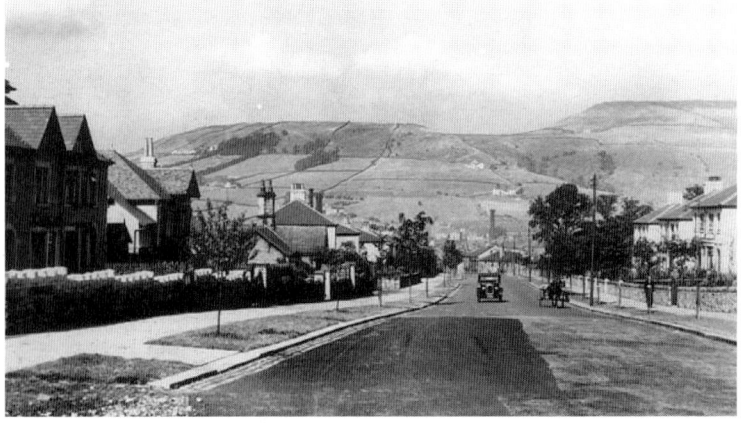

Newchurch Road, Rawtenstall, taken by J. Dickson Scott in the 1930s. Looking down towards Tup Bridge and across to Cribden Hill, the chimney, now demolished, belonged to the shoe and slipper manufacturing works of Ashworth and Hoyle Ltd. at Star Works on Burnley Road, but mature trees now obscure most of this view. One of the few changes to have occurred on this road is the ability to give such a wide berth to slow-moving traffic!

Six

Going East:
Cloughfold, Newchurch, Waterfoot and Cowpe

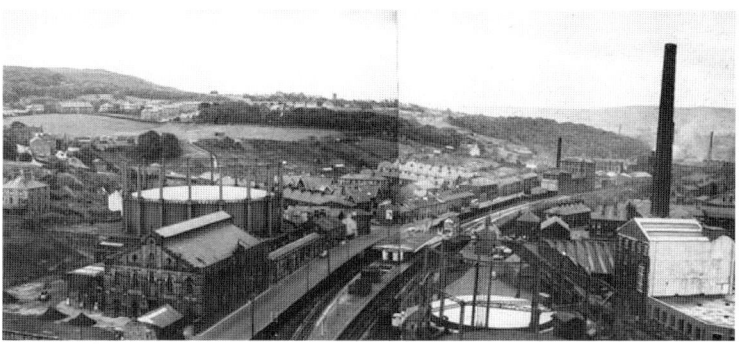

Bacup Road, Cloughfold taken by Norman E. Morris, *c*. 1951. Looking towards Waterfoot, the gas works' single-storey building on the left of the road collapsed in March 1967 and was demolished. The railway station opened in 1870 but was rebuilt ten years later as an island platform with access from the level crossing on Hill End Lane. Many of the mills and all the chimneys have since disappeared, but above the trees in the middle left can be seen the then Lea Bank Secondary Modern School of which Sir Rhodes Boyson MP was headmaster from 1955 to 1961. The council houses on Lea Bank above the school have just been built.

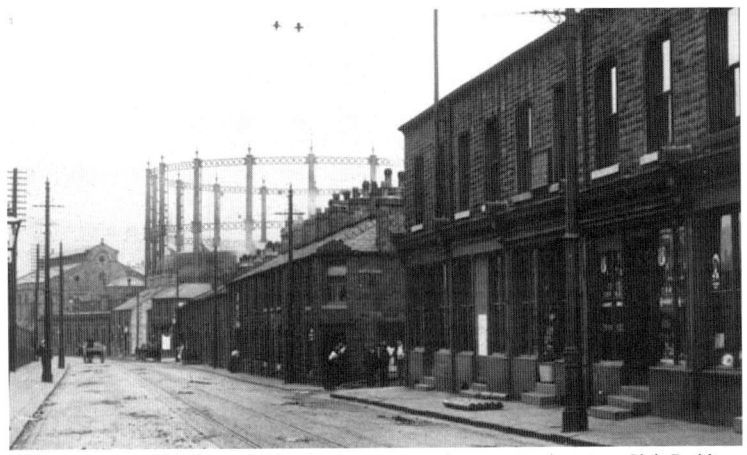

Bacup Road, Cloughfold, after 1909. Looking now in the opposite direction, Club Buildings are in the front right and the next row is Jackson's Buildings. The gas works on the left of the picture was opened by Rossendale Union Gas Co. on 31 August 1856 and in its heyday also supplied gas to Bacup, Haslingden and Ramsbottom. Thomas Newbigging, author of *History of the Forest of Rossendale* (1868), was the manager there from 1857 to 1870 and a national figure in the gas industry. It was demolished in 1968 and on the site now is Eastwood Crescent. Gas street lights are still in use even though electric tramlines have been installed.

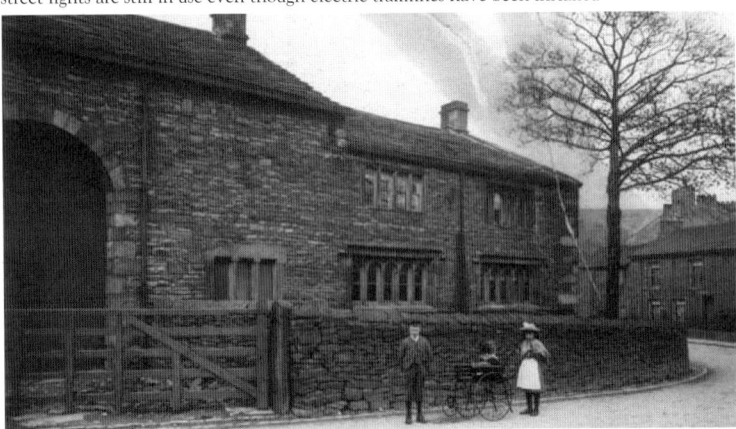

Lodge Fold Farm, Newchurch Road, Higher Cloughfold. The building adjoining the barn was built in 1629 by Revd William Horrocks, curate of St Nicholas' parish church from 1622 to 1641, and inhabited as a rectory until 1850. In the late 1920s, bonfire wood was stored in the barn safe from raiding 'bonfire gangs' because a female resident in one of the cottages would chase them away! It was demolished in the mid 1930s to open up a sharp bend and replaced with a garden area and public conveniences.

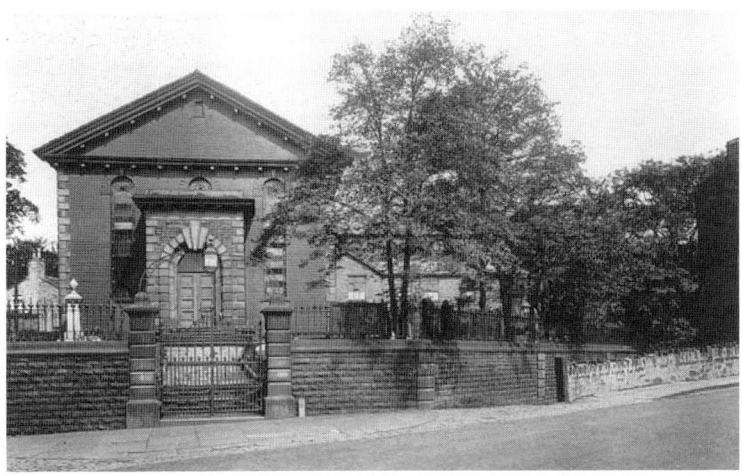

Sion Baptist chapel, Edge Lane, Higher Cloughfold, after 1902. Litchford House flats opened on this site in 1986, named after Robert Litchford who offered his house for use as a chapel in 1705. The building seen here was built in 1839 and enlarged in 1854. The Sunday school to the right of the chapel and beyond the graveyard had fourteen foundation stones laid in 1901, the largest number in any building in Rossendale, and the congregation transferred here in October 1984.

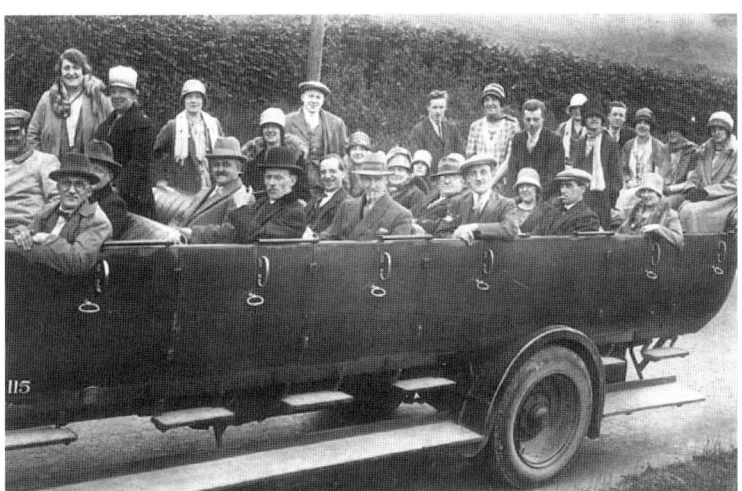

Hareholme charabanc, c. 1927. Motor trips in 'horse brakes' became a regular feature of leisure activities in the 1920s and men and women both dressed up for the occasion, but note the number of ladies wearing furs in days when there was less awareness of animal welfare.

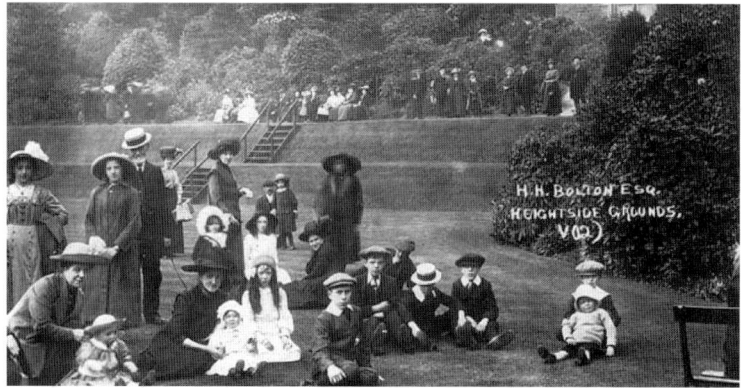

Heightside House Grounds, Newchurch Road, Newchurch. Built by Richard and Lettice Ashworth in 1783, the house was rebuilt in 1865 and then enlarged by Henry Hargreaves Bolton, a colliery and quarry owner, who treated the workers to a 'sumptuous dinner' at the Blue Bell Inn on the work's completion in 1877. The owner's love of horticulture led him to open the grounds every year and, on one Saturday in 1900, 7,000 visitors viewed the fine displays of rhododendrons. The house is now used as a nursing home and mental rehabilitation centre.

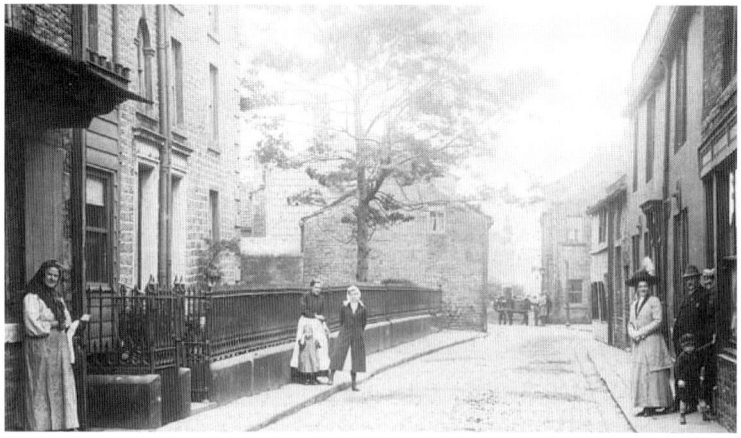

Church Street, Newchurch, c. 1910. Although a street of this name exists today, it certainly no longer looks like this! The original Newchurch township extending from Bacup to Rawtenstall owed its pre-eminence to its location next to the highway from Whalley to Rochdale. However, when Newchurch was included with Rawtenstall on its incorporation as a borough in 1891, its significance declined further to the 1950s when its seventeenth and eighteenth century cottages were crumbling with old age and inadequate for modern needs. Much debate occurred over redevelopment plans but demolition work was undertaken between 1960 and 1962, including the widening of Church Street to eliminate a narrow and dangerous bend.

Right: The Post Office, No. 65 Church Street, Newchurch, *c*. 1924. Left to right: George Sagar, Ralph Kershaw, Jack Metcalfe. Ralph Kershaw traded as a grocer in this shop from at least 1901 and by 1924 he had also become the postmaster. A post office had been in operation in Newchurch as early as 1828 at the top of Dark Lane, or 'Warehouse Lane', so named because finished products of handloom weaving were transported from a building there to Rochdale and Manchester.

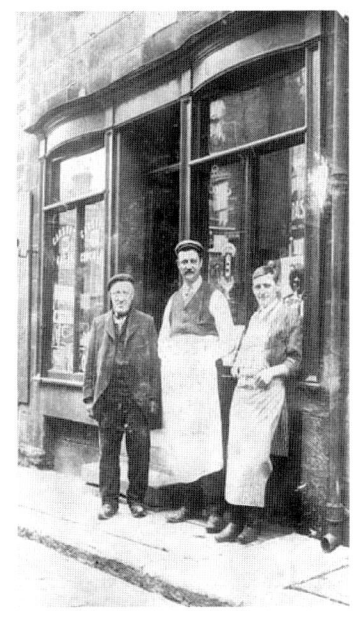

Below: Edgeside Hall, Waterfoot, 1955. Stone from nearby Scout Quarry was used by George Henry Ormerod to build the hall in 1861, but eight years later it was purchased by James Barcroft, a felt manufacturer of Todd Carr Mill. He was a member of the Rossendale Hunt and the stables were often used by horses and huntsmen during a ball. After he died in 1907, the house was unoccupied for several years but during the First World War it was offered by his son, Robert, to the war committee (see p. 120). Rawtenstall Borough Council bought the hall in 1922 to provide a public park and playing fields and the children's playground was later built on the site.

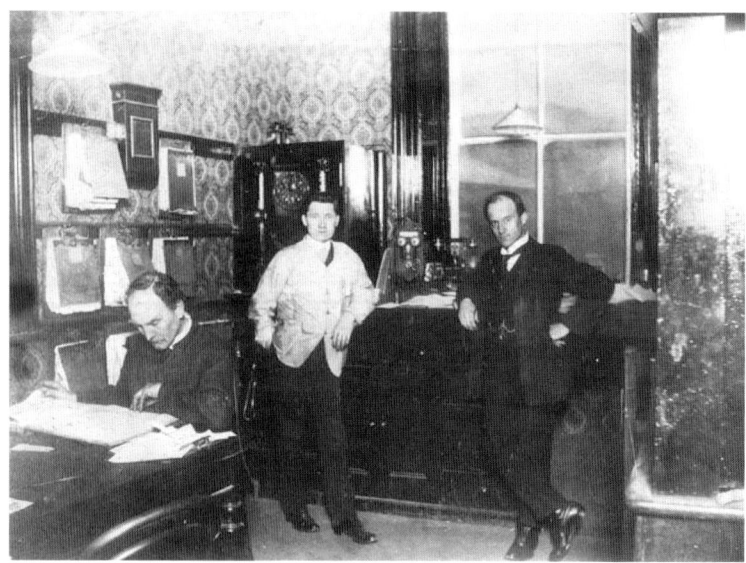

Office of John Butterworth and Sons Ltd., Dale or 'Lolly' Mill, Burnley Road East, Waterfoot. This mill started life as Edgeside Holme Mill in 1844, built for the baize manufacturers, Robert and John Munn, and in 1863 it boasted its own fire engine, *The Prince Albert*. The mill was known as 'Lolly' Mill as early as 1883, but was renamed in 1888 when an Oldham company, the Dale Mill Co. Ltd., took over. This company did not enjoy good fortune and in December the same year the building required a visit from the newly-formed Rawtenstall Fire Brigade (see p. 106) attending its first large fire. John Butterworth and Son Ltd. moved in around 1912 and the twenty-first birthday of the Butterworth's son, Jack, was celebrated in June 1932 with a 'special corridor train' taking a party of 450 workpeople to Blackpool for the day, each employee receiving 10s to spend! Trickett's Arcade shown opposite was the only building in 1899 generating its own electricity and both this modern facility and the telephone have now been installed here in Butterworth's office; the photograph does, however, still have a slightly more Dickensian feel about it!

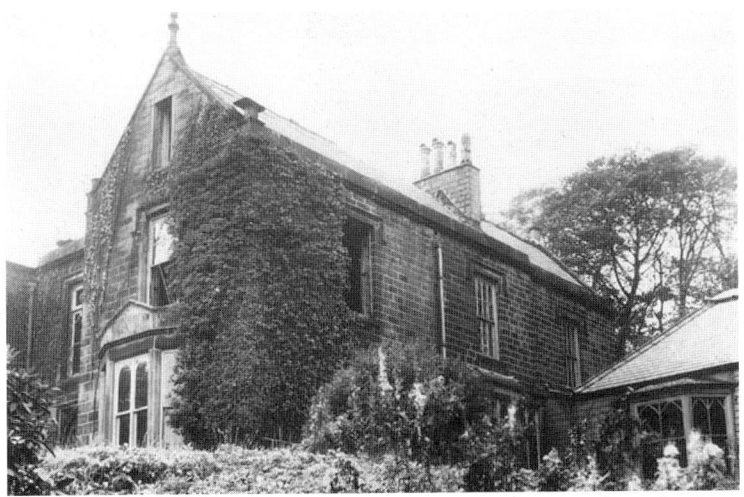

Springfield House, off Burnley Road East, Waterfoot, taken by J. Balshen during demolition in October 1956. Another design by Richard Williams, this house was built in the 1860s and occupied in 1881 by the felt manufacturer Robert J.C. Mitchell, a keen temperance advocate, with his wife Margaret and three children, all out-numbered by the seven servants. The name is remembered by the drive now occupying the site.

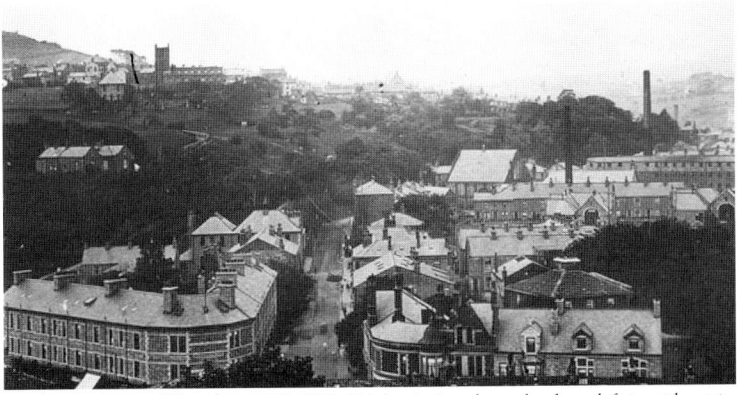

Burnley Road East, Waterfoot, 1899-1908. Trickett's Arcade at the front left is without its memorial clock added in 1914 as a memorial to Sir Henry Whittaker Trickett (see also p. 49), whose vision of Waterfoot as a major commercial centre resulted in its construction in 1899. The long building in the middle right is Gaghills Mill, now demolished, bought by Trickett in 1889 for his slipper works. Springfield House rises above the trees to the left. Electric tramlines were later laid on this road for a service to Water which commenced in 1911.

Old Liberal Club, off Bacup Road, Waterfoot. Now the present Palatine Club backing onto Warth Old Road, this building was used by Bethel Baptists in 1851 before their new chapel was erected in 1869. Following a meeting of Liberals at the Royal Hotel on 12 October 1869, their club was officially opened here in December the same year. Alterations in 1884 and 1892 did not alleviate the shortage of space and foundations for the new Liberal Club opposite St James' church were laid in 1895.

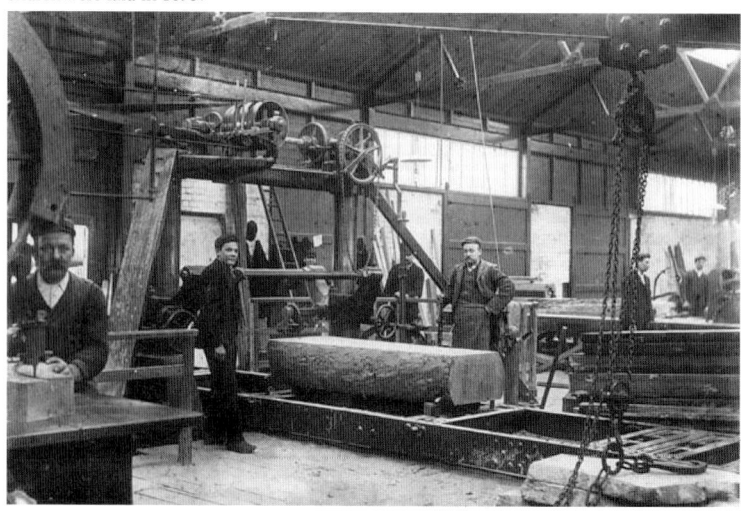

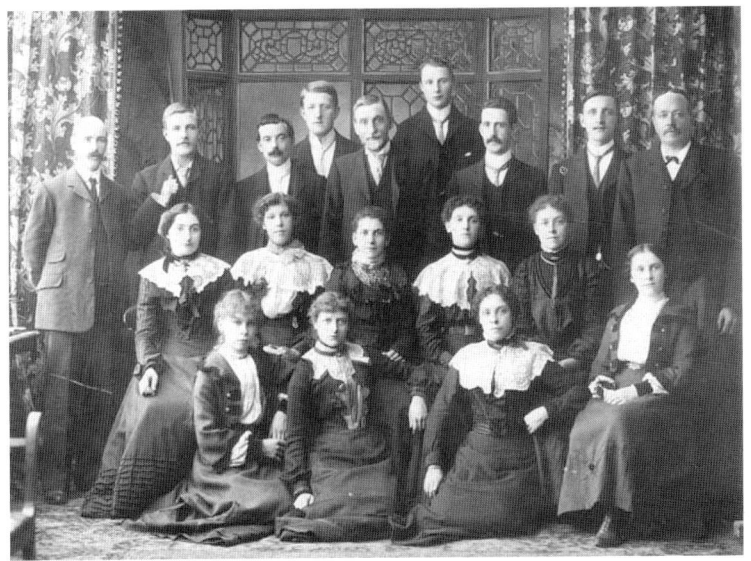

Above: Cowpe Sunday School Choir taken by Oakley and Sidebottom, *c.* 1900. Left to right, back row: Billy Pilkington, Walter Hardman, James Barnes, Willy Hardman, Sam Whittaker Junior (tenor), John Birtwistle, Haughton Scott, Arthur Birtwistle, James E. Buckley (bass). Samuel Whittaker was a teacher at the school from 1858 and the first choirmaster, recording the activities of the choir in meticulous detail including an account of the time in 1865 when the clarionet froze up with the cold! He was followed by his son, James, and then his grandson, Samuel Whittaker Junior, shown above, who was not only involved with the choir for forty-six years, but was also a committee member and auditor, receiving a Sunday school long service medal for teaching thirty-eight years. A special gathering in 1924 of past and present members of the choir paid tribute to his many services and he was presented with a gold watch and chain.

Opposite below: Warth Saw Mills, Waterfoot, *c.* 1900. The occupants of the mill in 1905, John Ashworth and Co., were described as 'English and Foreign timber merchants, sawing mills and printing block manufacturers'. A fire in 1909 with 'a seething mass' of flames, which could be seen from Rawtenstall, destroyed the four-storey building with its costly machinery and valuable finished timber products, including seasoned walnut and mahogany, causing the company to transfer all its operations to its other site in Trafford Park in 1911.

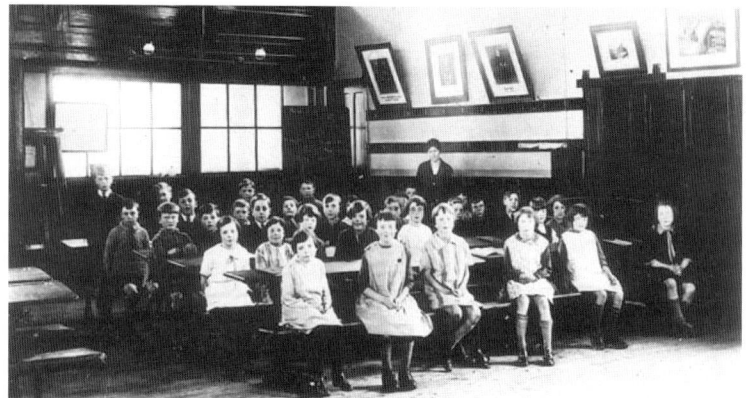

Cowpe School Class, 1931. A cottage served as a schoolroom before the Old Boarsgreave School was built in 1832 and the first schoolmaster, John Mellor, was paid the princely sum of 2d per week. Average attendances in 1849 were 125 and the existing building opened on 12 November 1881 while the original school continued as a newsroom and institute until 1896. Numbers on the roll gradually decreased, however, until the school closed in 1967. Do you recognise anyone?

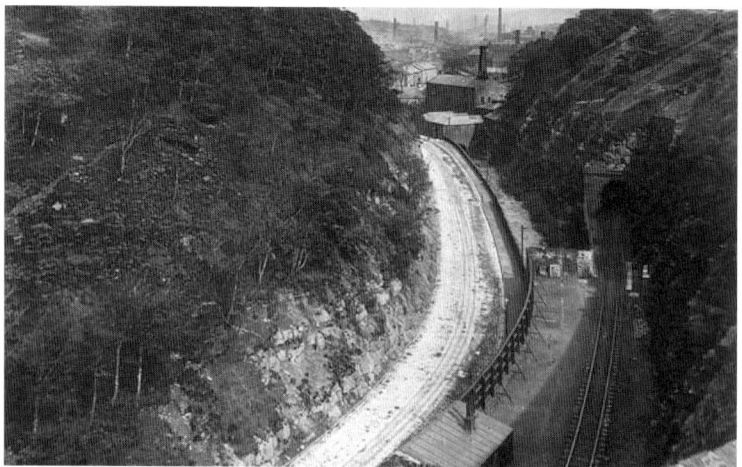

The Glen, Waterfoot, 1889-1893. The road was built in 1828 by unemployed workers following John McAdam's guidelines for grading small stones to form a resilient compacted road surface (see also p. 55). John Baxter's Glen Top Brewery next to the road supplied ales and mineral waters to public houses in Rossendale and beyond and was rebuilt in 1894 to cope with increased demand. Its new chimney in 1907 was the tallest in Rossendale at the time reaching 192 feet and was the last part of the brewery to disappear in 1972. Note the number of chimneys in the Stacksteads area.

Seven

Bacup and Whitworth,
the 'valley on the ridge'
and the 'white enclosure'

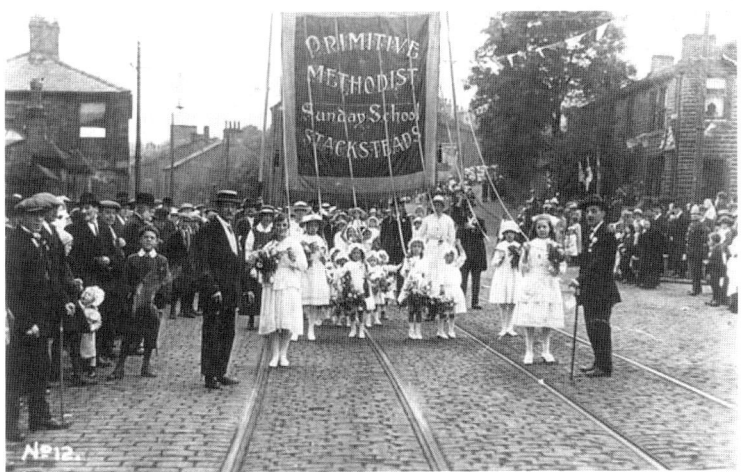

Booth Road Primitive Methodist Sunday School, Stacksteads, c. 1910. Services were originally held in a Sunday school as early as 1835 and a chapel opened in 1850 but, like many other churches at the time, it became too small for its congregation. A stone-laying ceremony for a new building on 28 March 1874 was prematurely shortened due to heavy rain, unfortunately a common occurrence in Rossendale! The Booth Road premises were struck by a thunderbolt on 5 June 1982 and demolished the following year, the site later developed for bungalows.

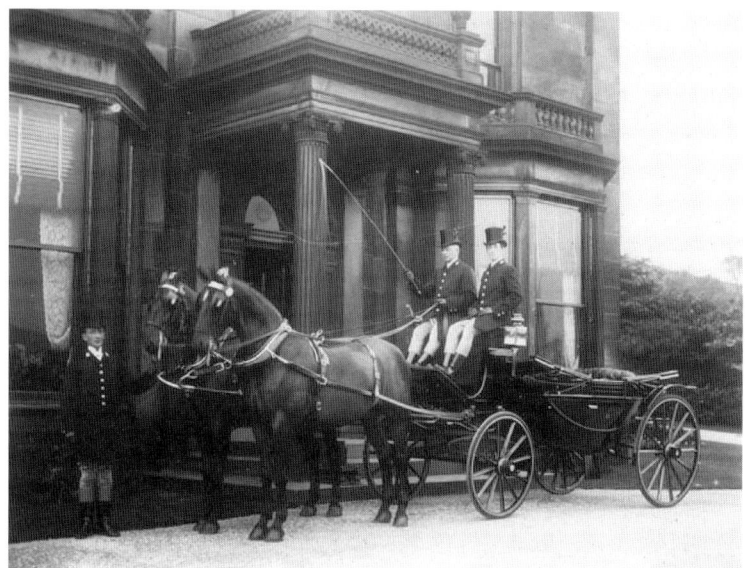

Rockliffe House, Newchurch Road, Bacup. The landau, driven by 'Gentleman Fred Smith', is waiting outside the family home of the Madens occupied by them until the 1930s and now a listed building. John Maden and the company he founded were one of the most significant influences on the economic and social development of industrial Bacup and by 1851 he employed 145 workers and was successful enough to buy the manor of Raw Cliffe Wood, where he built Rockliffe House in the 1860s. His move there involved adapting to a different way of life requiring domestic help and he employed a farm bailiff, 3 gardeners, a carter and odd-job man and 2 coachmen to drive the brougham, victoria, phaeton and landau stored in the coach-house! He invested his profits in diverse ways in farms, collieries, railroads in Argentina and shipping and his extensive business empire was inherited by his son, Henry, who in the 1871 census at the 'villa residence' was described as a 'county magistrate, landowner, cotton spinner manufacturer, master employing 181 men, 150 women, 69 boys and 56 girls'. He married Martha Darlington from Shropshire in 1874 on his forty-sixth birthday and, on his death in 1890, he was succeeded by his illegitimate but adopted son, John Henry, who became even more prominent a figure in Bacup life than his father and grandfather. When he returned home from his honeymoon in 1891, he arranged for his employees and their families, a party of 1,400, to travel to Blackpool for a day out. When John Henry died in 1920, he had been a JP, Bacup and County Councillor, Mayor of Bacup for thirteen years, MP for Rossendale from 1892 to 1900 and 1917 to 1918 and knighted in 1915! Note the boot-scraper on the steps behind the horses' legs.

Right: Demolition of Ross Mill chimney, New Line, Bacup, 29 October 1982. Fireworks from the top of this chimney, which was 213 feet high, had celebrated its completion on 5 November 1908 for Ross Spinning Co. Ltd. and its demolition was also marked in style. The last part of the mill to disappear, the fire beneath the timber shafts was lit by the then Councillor Jack Taylor who had started work there forty years before as an apprentice when 14 years old. Bricks which had originally been supplied by Shawforth Brick Company were thrown into the air and landed within 2 feet of the watching crowd standing at a safe distance! Ross Mill had been a major employer in the area, bought by Joshua Hoyle and Sons Ltd. in 1920 who built up a reputation for good quality calico, but the mill closed in 1981 due to foreign competition and the high level of the pound.

Below: Celebrations for the coronation of King George VI at Throstle Mill, Market Street, Bacup, 12 May 1937. Some employees in Rossendale enjoyed the day off for festivities but at this mill Messrs John Maden and Son gave their adult employees 5s and their younger workers 2s 6d. A service in Bacup was held in the morning to enable everyone to listen to the radio broadcast from Westminster Abbey. The Mayor of Bacup, Alderman E. Gledhill, and a number of school children planted fourteen sycamores in Stubbylee Park as a permanent memorial and to restore a tiny part of the original Forest of Rossendale.

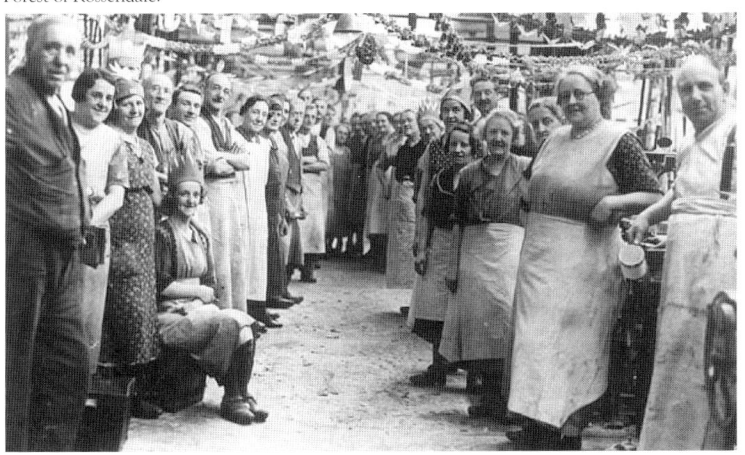

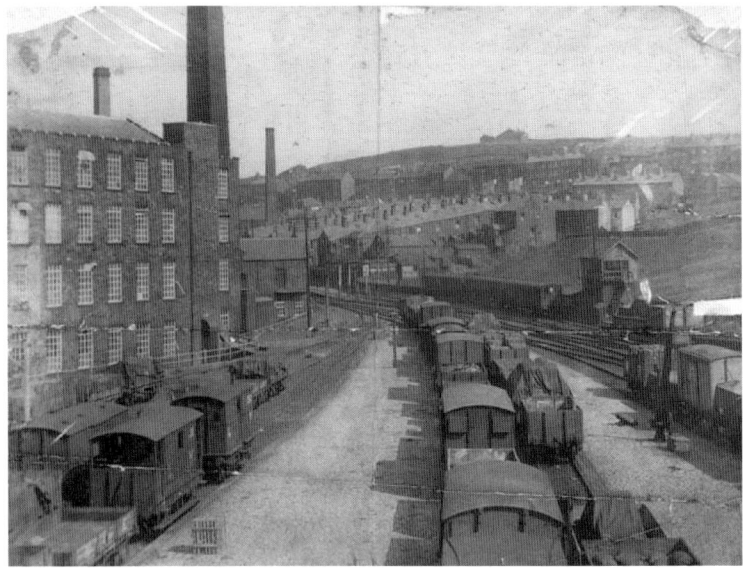

Railway line and sidings, Bacup, after 1915. Looking towards Bacup with the station just out of sight, this view of the goods yard has been taken from the goods shed, which was built in 1882 on the north side of the railway line from Rochdale. The line from Newchurch had been opened on 1 October 1852 by the East Lancashire Railway Co. but had proved difficult to build because of the need for three tunnels through The Glen. Facit was the terminus for the track from Rochdale from 1 November 1870 when the principal impetus for the line had been the desire to exploit the stone quarried from surrounding moors. The extension to Bacup was beset with financial problems and not completed until 1881 when it was opened without the usual formal ceremony. The line to Rochdale closed for passengers in 1949 but it was not until the Rawtenstall branch ceased to exist that Bacup's station closed on 3 December 1966. The site was soon redeveloped, occupied by E. Sutton and Co.'s Riverside Mill in 1976. On the left of the picture is the rear of India Mill, part of the Joshua Hoyle and Sons group of cotton mills, which was built in 1862 and demolished in 1972. Isaac and Edward Hoyle were caring employers and early supporters of industrial co-operation, indicated by the fact that by 1873 one quarter of their capital was held by their employees as partnership shares. The chimney to the left belongs to John Maden and Son's Springholme Mill and that to the right to Rockliffe Mill, both now demolished, as is Mettel Cote, the farm on the skyline.

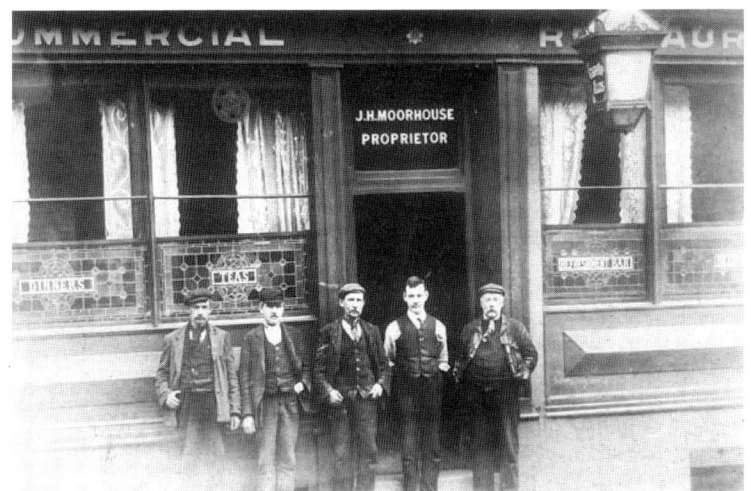

Above: Commercial Restaurant, No. 28 Market Street, Bacup, 1904-1910. James Hardman Moorhouse was the 'refreshment house keeper' in this period, succeeded by Mary Brassington whose son, Horace, was the Mayor of Bacup from 1967 to 1968. Mary's tenancy lasted until 1927, during which time customers would run from the back door to the bottom of King Street for a prize of a gallon of ale. A walking race from Rochdale involved the unusual sight in the 1920s of one contestant wearing grey flannel shorts! The restaurant closed on 6 January 1940 and the site is now occupied by Heald's Supermarket.

Right: Argenta Meat Co. Ltd., No. 27 Market Street, Bacup. Bank Street is to the right of the shop which has traded until recently as a jewellers. This butcher's business provided meat to the residents of Bacup and other east Lancashire towns from at least 1900 to 1924. One of its advertisements in 1914 boasted 'You can save money enough for your summer holidays… if you buy your joint from The Meat Bazaar'.

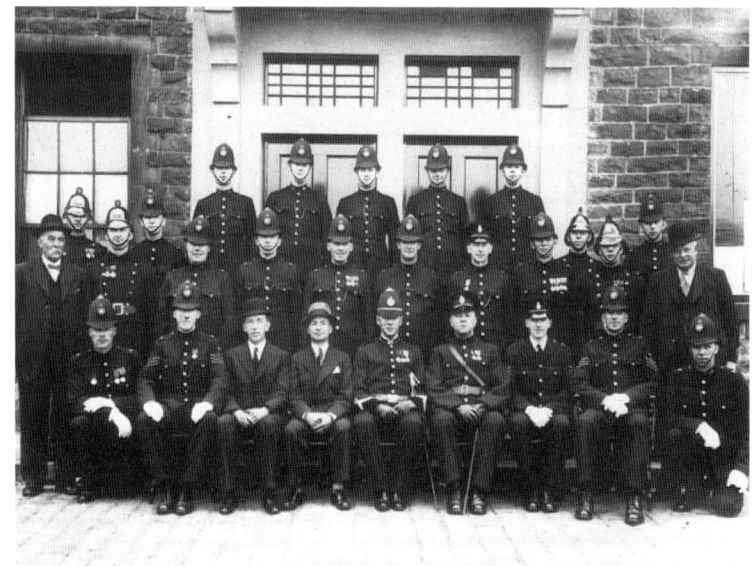

Bacup Borough Police Force Jubilee, 1937. Left to right, back row: PC 19 William John Pauling, PC 24 John Kay, PC 8 Ernest Langton, PC Richard Calland, PC 15 Benjamin Burton. Middle row: Inspector John Barrow (retired), PC 11 Richard Holden, PC 16 Joseph Walsh, PC Norman Scott, PC 17 Abraham Milne Jones, PC 7 Harvey Lord, PC 13 Fred Jenkinson, PC 22 Cornelius Coward, PC 6 William Gladstone Wales, PC 9 Henry Gribble, PC Frank Jackson, PC Robert Wild, PC 23 Henry George Marsh, PC Charles Williams Windle (retired). Front row: PC 21 Thomas Bennington, Police Sergeant 2 Wilfred Martin, Detective Sergeant 1 Percy Bayley, Dr John D. McVean, Police Surgeon, Chief Constable Ernest William Sturt, Inspector John David Thomlinson, Police Sergeant 4 John Spencer, Police Sergeant 3 Richard Edward Russell, PC 14 John Askew. Bacup ran its own police force from 1 August 1887 to 31 March 1947 when it amalgamated with the Lancashire Constabulary. The original instruction book for new recruits included the exhortation 'to remove orange peel etc. from the footways' but warned that the culprit guilty of such a misdemeanour would be fined 40s plus the cost of any damage caused. Litter was obviously a problem even then!

Bacup Borough Police Push Ball Team, 1927. Left to right: PCs Richard Hartley, Fred Lye, Joseph Walsh, William Malpas, Sergeant Job S. Brearley, PC Henry Gribble, Inspector Frank Bunn, PCs Thomas Bennington, John Askew. The mascot sitting on the ball was R. Gribble. A ball game with a difference, a push ball match was played on Bacup Borough Football Ground on 12 April against Rochdale Borough Police Force with proceeds going to local charities. The push ball was 6 ft in diameter, weighed 60 lbs and was provided by the *Daily Mail*.

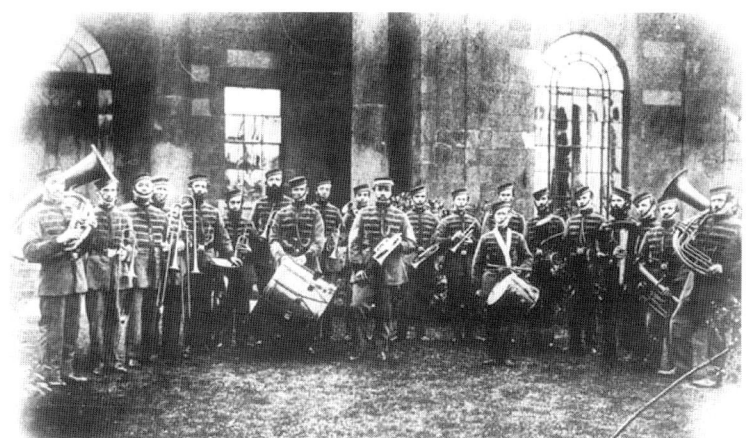

Bacup Old Band at Forest House, Bacup, in the late 1860s. Originally the Broadclough Band formed in 1858, these outstanding musicians came fourth at their first appearance at Belle Vue championships in Manchester in 1862, but only two years later were awarded first prize and, out of forty-eight contests, they won no less than thirty-three first prizes and held the record for thirteen first prizes in succession! Their conductor was John Lord, later a town councillor, but it was the untimely death of their trainer, George Ellis, in 1871 which caused them to disband.

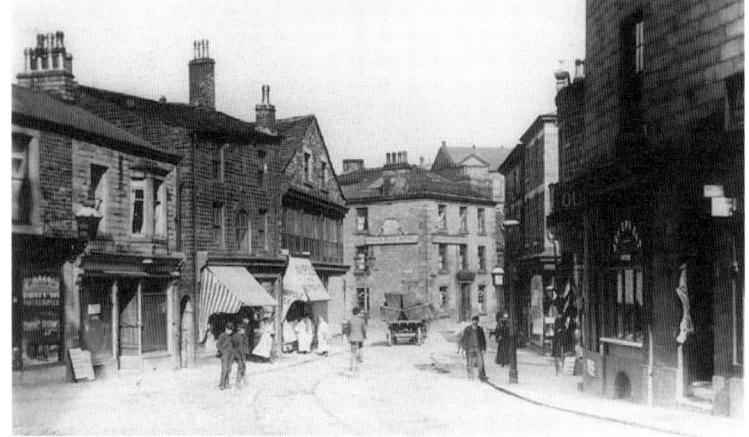

Market Street, Bacup, 1889-1908. The Bull's Head Hotel was demolished in 1911 and replaced by the King George V public house, now converted into offices, but, at the time of the royal visit in 1913 (see also p. 118), it was the only hostelry in the country to bear the name of the reigning monarch. Ebenezer Baptist church can be seen above the hotel's roof. The buildings on the right have been demolished and those to the left, although at first glance appearing similar to today, have been extensively altered.

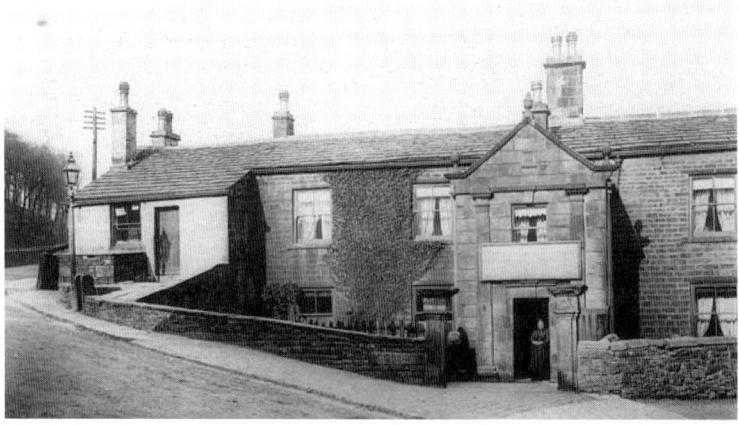

The Roebuck, Higher Broadclough, Bacup. The datestone of 1739 is not legible but refers to John Lord who owned much property in the area and the inn served travellers using the old packhorse route from Bacup to Burnley, now Bacup Old Road. Inside the porch, there was a recess where tankards could be left while the mules were tended in the courtyard. The inn closed on 14 January 1959 and was demolished in 1971 in a slum clearance scheme, in spite of efforts to save it as a building of historical interest.

Mount Pleasant Methodist church, off Lanehead Lane, Bacup. The earliest Wesleyan Methodist church in Bacup was opened on the western side of this lane by John Wesley himself in 1761. The third church, shown here, was built in 1841 on the opposite side of the road, partially funded by John Maden of Rockliffe House who donated the land and £1,000. As the church's influence grew, a day school opened in 1844, but the first master, Leonard Posnett, had to pay a small rent to the Sunday school. After the church amalgamated with Waterside as Central Methodist in December 1951, this building was demolished in 1953 and the site is now a grassed area.

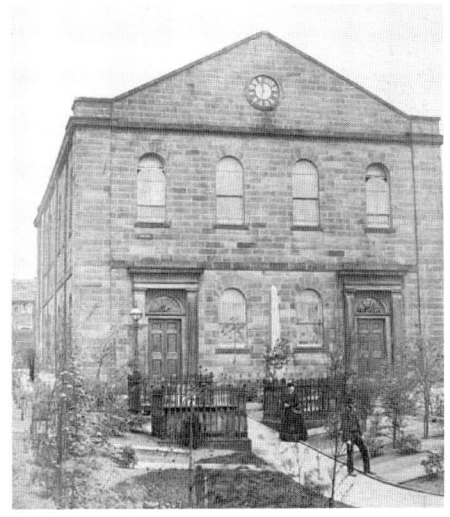

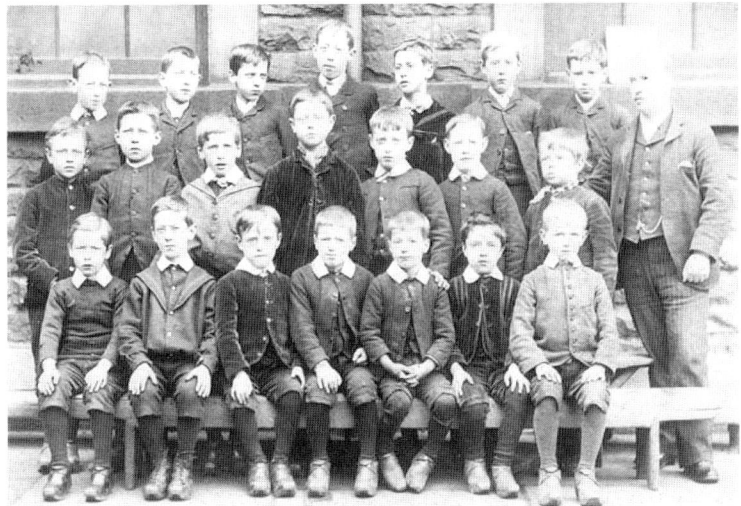

Mount Pleasant Day School: Standard 5 Class, 1891. Back row, third on left: Percival Brown (later Dr). Middle row, on right: George Ashworth. The teacher is R.H. Hall. In 1870, 115 out of 135 boys and 121 out of 195 girls were half-timers but, by 1905, with improved access to education the numbers had dropped to the level where all the half-timers could be transferred to Central School to make up a full class. It is heartening that in the Sunday school, as early as 1846, four attendances were rewarded with the privilege of borrowing a book from the library!

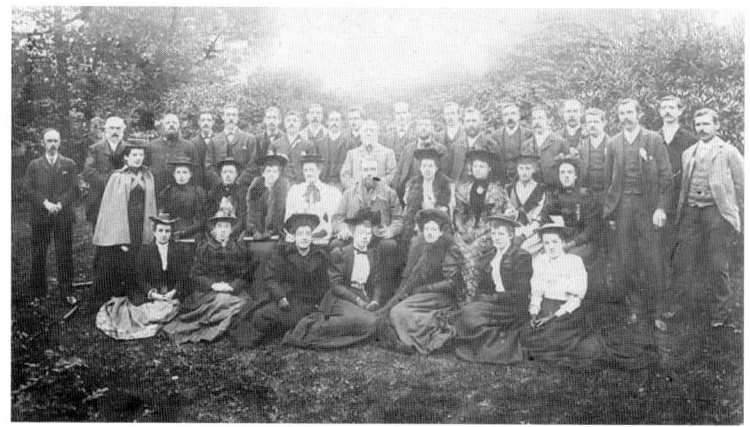

Bacup Temperance Prize Choir taken by Wilkinson Bros., 18 August 1894. Millworkers conducted by a loom overseer, Charles Hollows, were awarded first prize in a Co-operative music festival at Crystal Palace. Twice-weekly rehearsals after long shifts in the mill were attended by the forty-two members, the majority of whom also belonged to Bacup Choral Society and their own church choirs. They obviously took their singing seriously and vetted new members to ensure they were of a high enough standard.

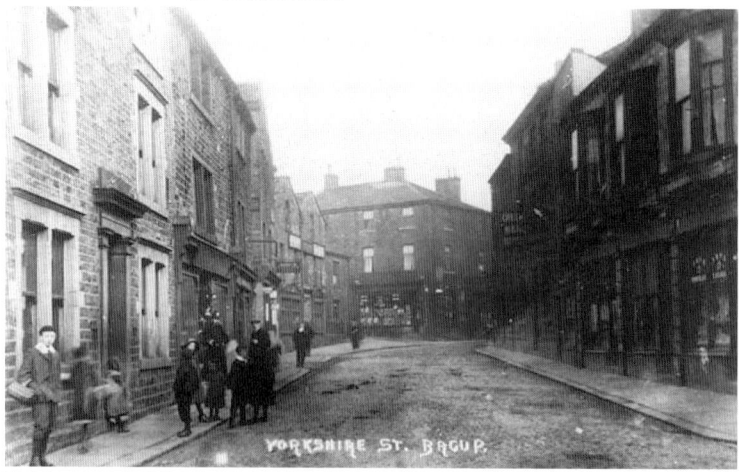

Yorkshire Street, Bacup, before 1912. Buildings in the middle distance were demolished in the 1950s, but the adjacent property on the left at No. 24, originally the Hare and Hounds Inn, has been occupied by the Bacup Natural History Society since 1949. In 1906, there were ten licensed houses within 100 yards, another three of which can be seen here: the Queens Hotel at No. 12, the White Horse Inn at No. 22 and opposite, the Green Man Hotel, whose licence was refused as unnecessary in 1924! Note the policeman on duty in the middle left of the picture.

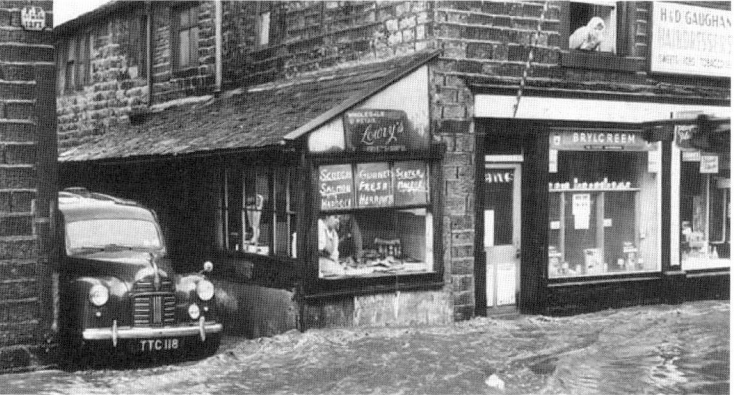

Boots the chemists, St James' Square, Bacup. A long established presence in the town, Boots Cash Chemist (Lancashire) Ltd. opened in 1915 on what was then Bridge Street. Many changes have occurred opposite the shop where the property, known as Townhead and including the George and Dragon Inn, was demolished in the late 1920s to ease traffic congestion; an open cobbled square was later replaced in 1952 with a roundabout.

Union Street, Bacup, 18 July 1964. The fish shop on the corner of Kershaw Street, now occupied by the Bacup Animal Welfare Society, is suffering the effects of most of July's average rainfall of four inches falling in one day. Holidaymakers setting off on their Wakes Weeks' holidays from other east Lancashire towns were caught in the deluge of hailstones one inch in diameter. Earlier heavy rainfall contributed to flooding in Bacup to a depth of more than eighteen inches in spite of valiant efforts by firemen to pump the flood waters away.

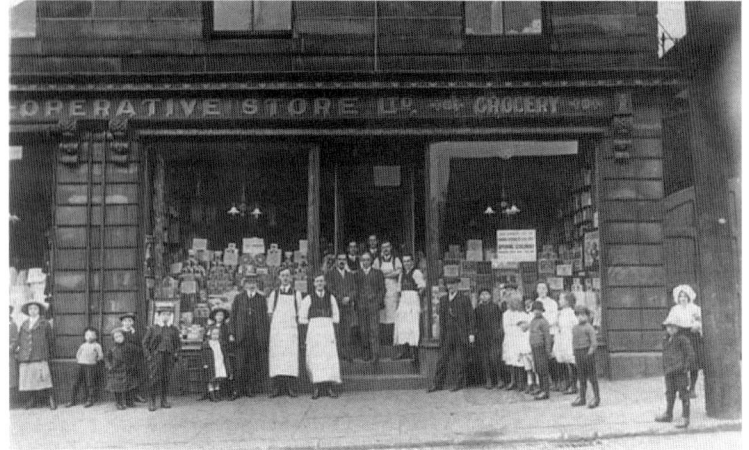

Co-operative Store Ltd., Rochdale Road, Bacup, 1914. A meeting of seven individuals in a garret in 1847 resulted in what became the largest society in Rossendale. This shop opened in 1863, on the site now occupied by the car park next to the Maden swimming baths, and the tea party to celebrate the opening of such a large store 'was the greatest social gathering there had been in Bacup'. The poster in the window is publicising the opening on 27 June 1914 of the Co-op building with a clock tower, now occupied by Age Concern and the Citizens Advice Bureau.

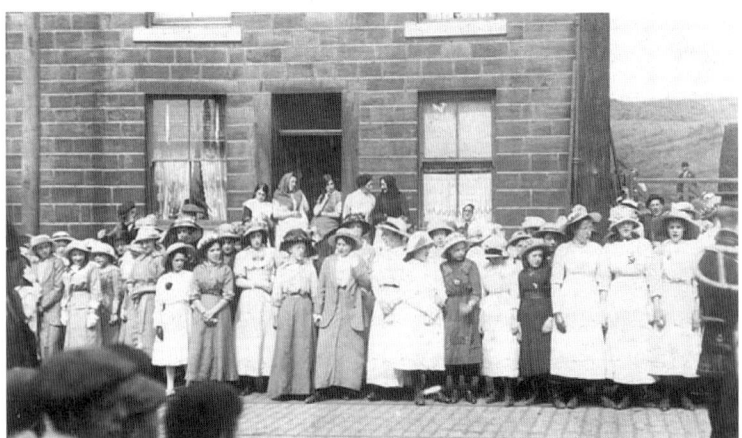

Number 172 Rochdale Road, Bacup. An expectant crowd is gathered outside this terraced row now demolished and replaced by new housing. The procession awaited is from Thorn Wesleyan Methodist church built on Alma Street in 1872. The chapel and Sunday school for Thorn had, however, developed from the Union Street School of 1851, known locally as 'Chapel for the Destitute' or 'Bacup Ragged School'.

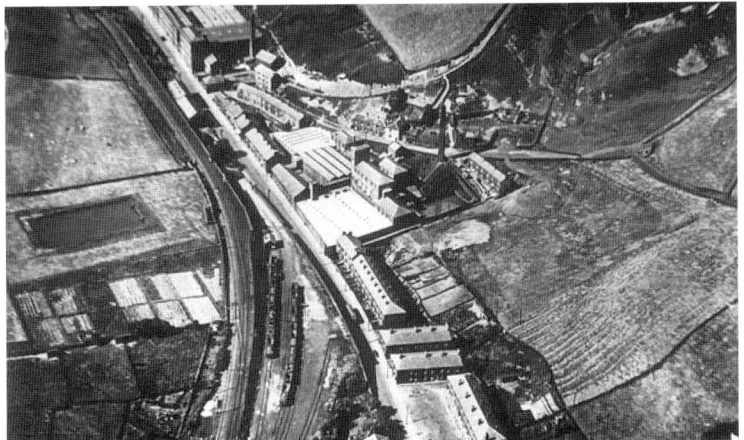

Market Street, Shawforth, c. 1950. The site of the railway line is now occupied by the Knowsley Crescent development where the first semi-detached council house in Shawforth at Knott Hill was officially opened in 1964. During the Second World War the now demolished Freeholds Mill, in the centre with the white roof, was used to store emergency food supplies transported through Shawforth Station. Peel Mill at the top suffered a destructive fire in November 1956 but its datestone survives set in grass in front of British Flowplant Group Ltd. which now occupies the site.

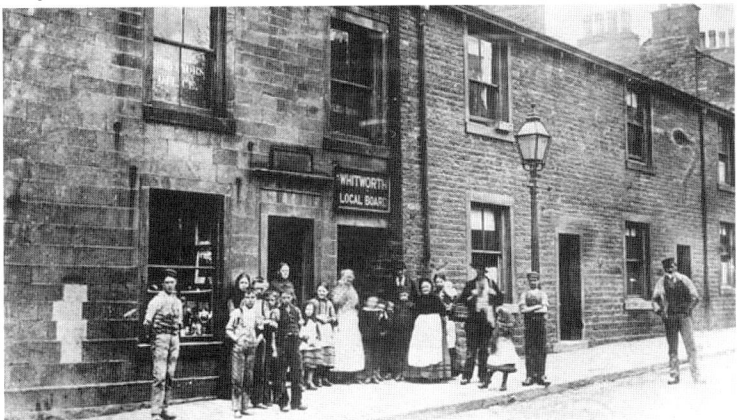

Whitworth Local Board, No. 741 Market Street, Facit, before 1894. Ratepayers in 1874 voted by 1,069 to 554 for the formation of a Local Board which administered Whitworth for twenty years until the Urban District Council was established. At the council's first meeting, William Ernest Whitworth, the former chairman of the Local Board, said 'Whitworth is generally spoken of as a decaying village but this is a mistaken impresssion'. These offices are now occupied by Len's Bakery and the row to the right has been demolished.

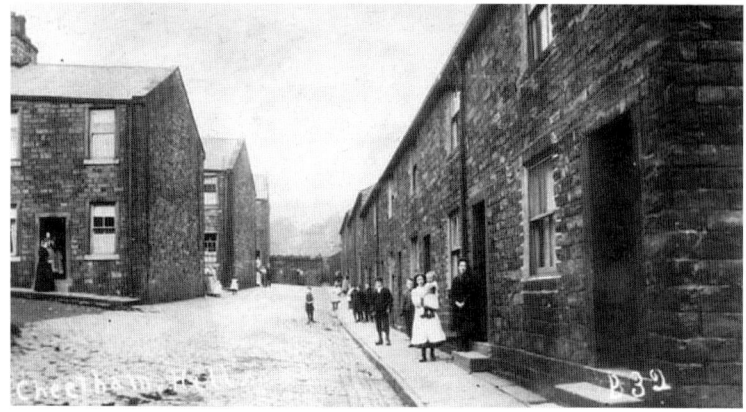

Cheetham Hill, Hud Clough, Facit, c. 1910. The official opening of a redevelopment scheme in 1970 heralded the replacement of this small community behind Facit Mill with Grange Road. One of its residents, Esther Smith, a 36-year-old weaver, was one of two fatalities in 1891 when a goods train of twenty-four trucks laden with stone from Britannia ran in to the rear of a passenger train at Facit in what was the most serious accident to occur on the line.

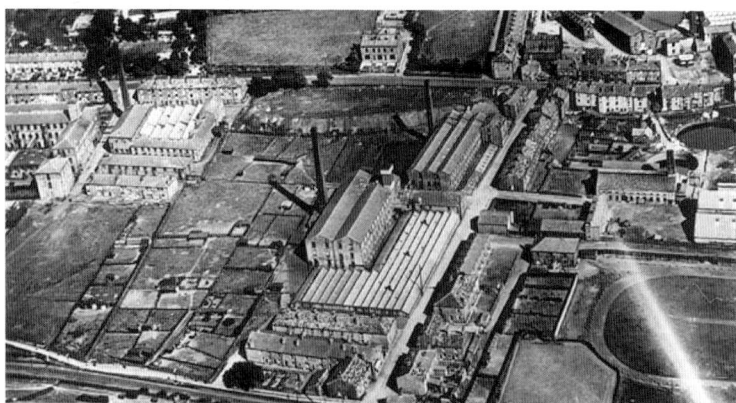

Tong Lane, Whitworth, 1950s. Cowm Park Way, where the first council house in Facit for thirty years was officially opened in 1967, now follows the course of the railway line, running along the front of the picture. Whitworth Vale Gas Works with its two storage tanks in the centre right was closed in 1929 and later replaced by Brenbar Crescent, so named after Brenda and Barbara, daughters of one of the directors of the construction company, A. Train and Sons. Just off the photograph to the top left is Stoneyroyd House which was replaced by a housing development in 1967.

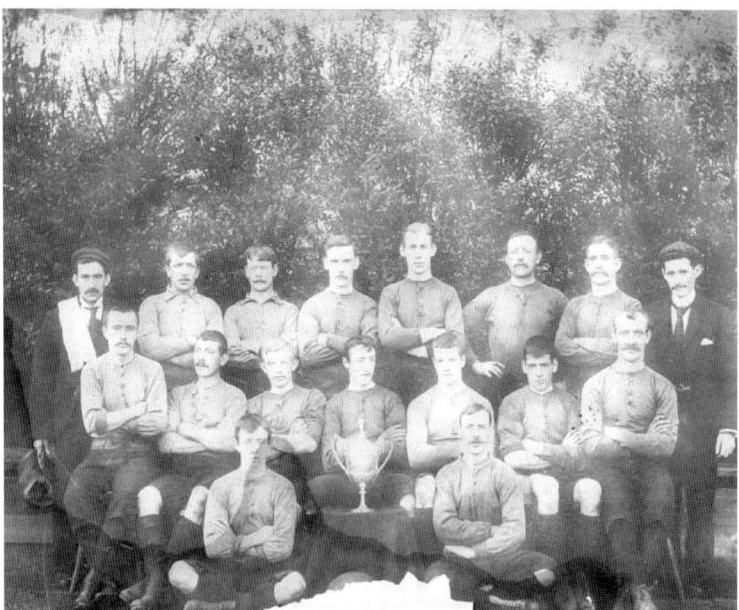

Whitworth Football Club, 1890s. Left to right, back row: ? Allen, J. Heyworth, J. Fitzgerald, J. Taylor, F. Farmer, -?-, -?- Farmer, C. Whitworth. Middle row: H. Chaplin, J. Malone, E. Hardman, ? J. Taylor, -?-, -?-, J. Riley. Front row: H. Stott, W. Grindrod. The Rochdale and District Charity Cup competition for rugby union football began in 1887 when £90 was made for various charities and Whitworth Football Club were the winners for three years in the last decade of the century in 1890, 1894 and 1895. The team shown here is not, however, the winning side for any of these years, so the photograph must have been taken for another occasion. In 1890, Whitworth won by 19 to 13 points against Albion. In 1894, Castleton Moor was beaten by 21 to 9 points in front of a large crowd; there were 20 minutes injury time when J. Fitzgerald, shown here third from the left on the back row, broke his leg and was taken to hospital. The hat trick was achieved the following year against Littleborough with a score of 7 to 1 points in front of a 'rather thin' crowd of 5,000.

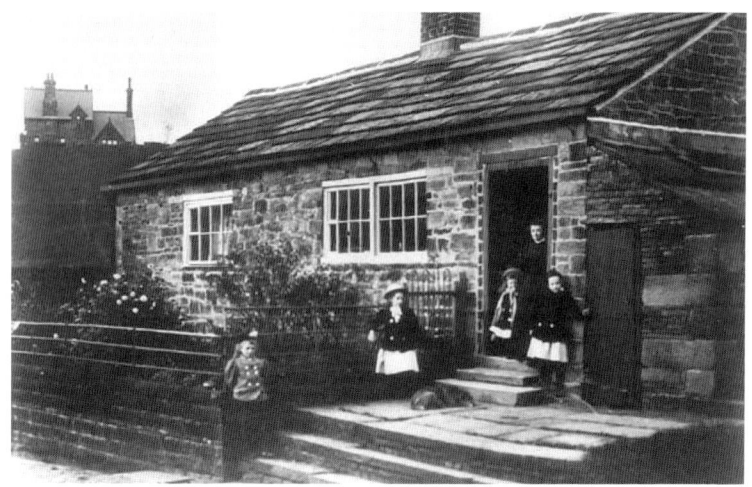

Syke Inn, Tong End, Whitworth. Beyond this building, originally a farmhouse dated 1683, is Cowm Brook House, the reservoir keeper's house for Cowm Reservoir. Water supplies were often cut during the summer and a three-month drought in 1868 led to every source of water being used, even mill and colliery lodges. Construction of the reservoir on the site of Cowm village commenced on Boxing Day 1868, but was not completed until 1877 due to geological problems. Pollution from burning tyres has prevented its use for drinking water since 1975.

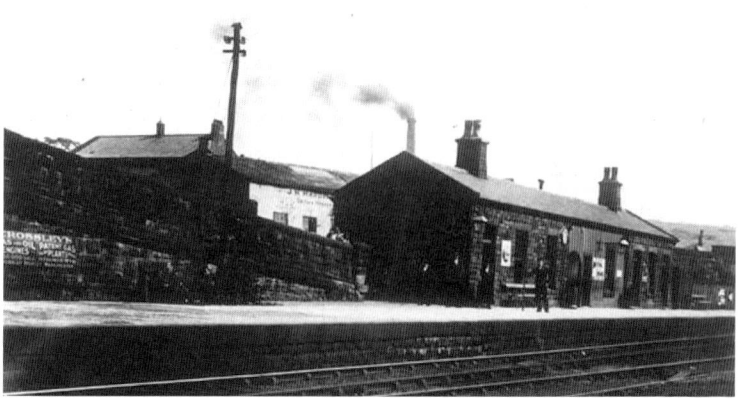

Railway station, off Hall Street, Whitworth. Long negotiations with landowners demanding high compensation for their land delayed construction of the line until August 1865 for a tender of £82,500, but the contracts for the stations at Facit and Whitworth were not signed until 1868. The last coal train into the sidings here was in August 1967. The Riddiough Court and Masseycroft sheltered accommodation complex now occupy the site.

Eight

Travelling around Rossendale:
from foot to horseless carriage

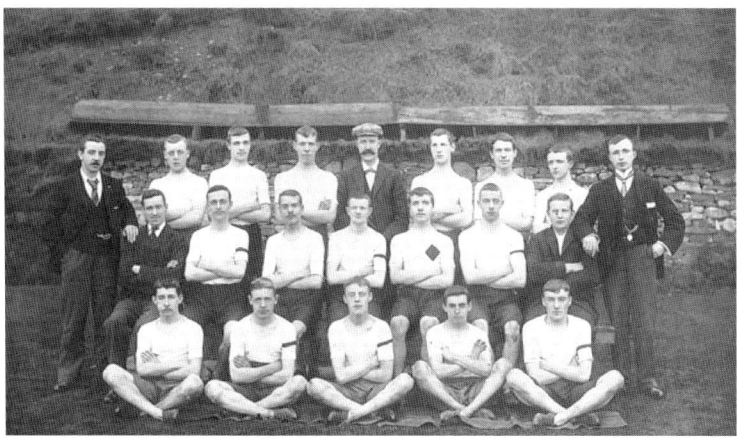

Haslingden Harriers, *c.* 1900. No doubt taken before a hard day on the race track, the group includes runners Crutchley, (G.H.?) Pilkington and (P.M.?) Howarth. The club's first athletic sports gala was held on 30 July 1892 with over 250 entries for seven races and Stubbins Vale Brass Band played some 'pleasing music' during the sports and for dancing after dusk. Winners were rewarded with some valuable prizes amongst which were a brass mounted clock costing £3 for the 120 yards flat race and an electroplated tea and coffee service for the 880 yards event.

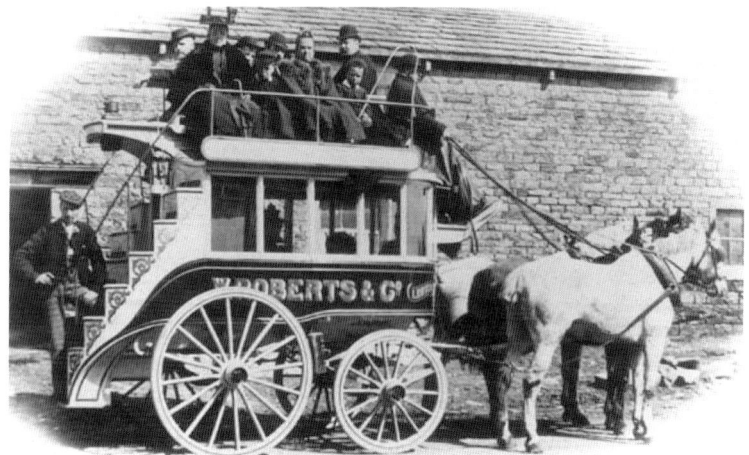

Bill Collinge, driver of the W. Roberts and Co. horse-drawn bus between Rawtenstall and Burnley 1899. William Roberts founded the Rossendale Division Carriage Company in 1864 with horse-buses to Rochdale three or four times a day, neighbouring towns on market days and for funerals. He stabled up to twenty horses at the former Bishop Blaize Hotel, Rawtenstall but on the arrival of steam trams he progressed to motor buses and was succeeded by his son, John, who ran the company until the First World War.

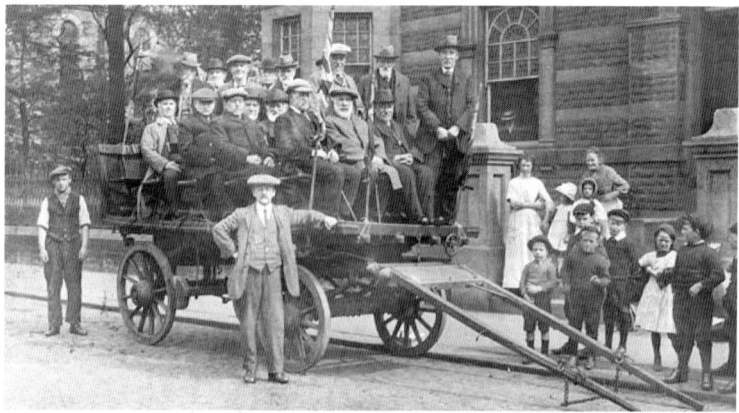

Waiting for a horse on an outing from the Liberal Club, Burnley Road, Bacup. The land and half the £4,000 cost was donated by John Henry Maden for this new club which opened in 1893. Rules for a fundraising bazaar held the previous year ordered that 'Grumbling, fault-finding and offence-taking are strictly forbidden'. Children from St Mary's Roman Catholic School were temporarily housed here for three years when their Dale Street premises were declared unsafe in 1956 and the Aged, Blind and Disabled Club moved into the building in 1966.

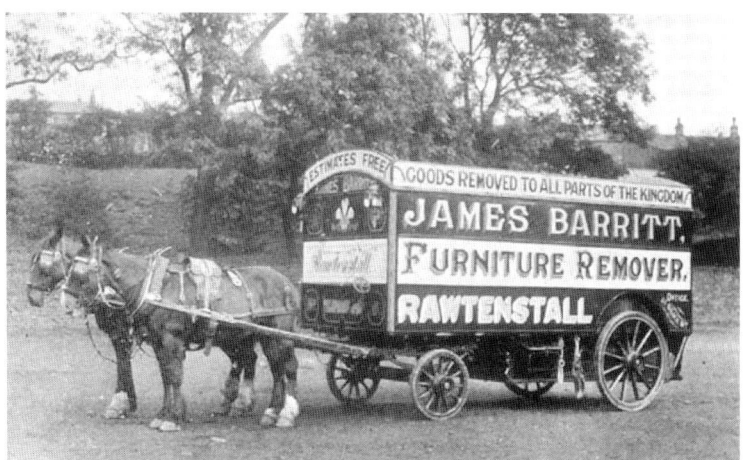

Above: James Barritt, removal contractor, Rawtenstall, *c.* 1910. This unusual combination of a coal merchants and furniture removal business began on Newchurch Road in 1885 with its offices moving to No. 51 Bank Street in 1895 for forty-eight years until the property was demolished to make way for Woolworths. The use of horse-drawn vans obviously imposed travelling restrictions and, for customers moving to Blackpool, this involved a three-day job with horses stabling overnight at Freckleton. James Barritt was a great benefactor to Rawtenstall serving as its twelfth mayor from 1921 to 1924 and, when he died in 1948, he was also described as a JP and an alderman.

Right: Grand Buildings, Haslingden Road, Rawtenstall, *c.* 1903. Although John William Ramsbottom was listed in trade directories as a confectioner, an advertisement of 1903 described him as a 'Government science teacher, medical botanist', whose specialities were herbal packets for common ailments and herb and fruit beverages manufactured by the Garrick Brewery. The Garrick Cafe offered a botanic bar, smoking and reading rooms. In the background is Longholme Mill, which was built in 1885 as a corn mill but taken over by the woollen manufacturer, Richard Ashworth, ten years later. It became known locally as 'Dickie Deb's Mill' and was demolished in 1973 to be replaced by Asda's Superstore.

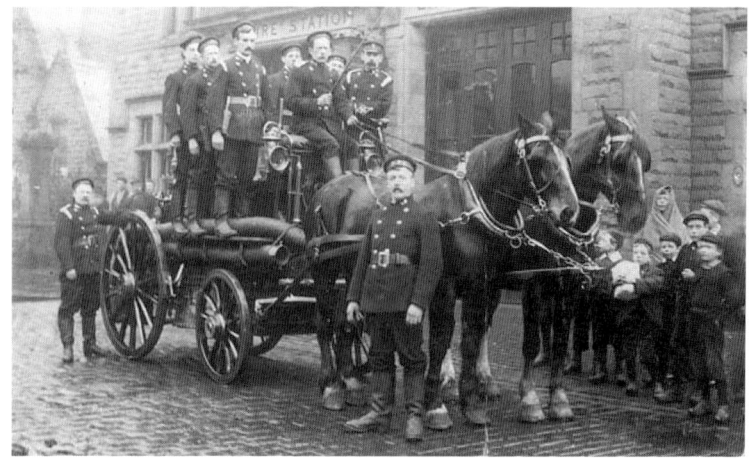

Above: Rawtenstall Fire Brigade, Burnley Road, Rawtenstall, *c.* 1900. Rawtenstall Local Board established a fire service in 1887 advertising for volunteers to staff each of the three fire stations at Crawshawbooth (see p. 15), Waterfoot and Rawtenstall with six men. In 1888, they only had one steam fire engine and a second was not bought until 1897 to serve a population of 30,000, after which arrangements were made to form a permanent staff by enrolling lamplighters as firemen.

Foundation stones were also laid in 1897 for this fire station with a two-stall stable at the rear, where the horses were to be trained to run to the front of the fire engine when they heard the fire bell! This building was taken over for a community centre when a new fire station was built on the traffic island in 1987.

Left: Richard and Will Moorhouse, pioneers of the penny farthing, in a studio portrait 1891. Although cycling was originally an aristocratic pastime, it had become regarded by the late 1870s as a suitable sport for boys. The penny farthing reached the peak of its development in 1885 with a growing range of accessories including lamps although, with solid rubber tyres, comfort could not be said to be one of them! The popularity of the bicycle was highlighted in May 1894 when 800 cyclists entered an annual fancy dress parade in Rochdale. Jack Cordingley of Haslingden, winner of many cycling championships, turned his hobby into a business and by the 1890s was building bicycles with 'Rossendale' as his trademark. Just visible at the bottom left is the studio linoleum under the 'grass'!

Rossendale Bicycle and Tricycle Club, July 1898. Second from the right is H.J. Whitworth, winner of a one-mile race on the track, now home of Whitworth Football Club. When the club was founded by the 23-year-old Whitworth in 1878, he was the oldest member! However, as captain for five years, secretary from 1883 to 1899 and winner of the five-miles tricycle championship five times in succession, his elderly condition obviously did not hinder his activities too much. All members did admit to some weariness in 1879 after a thirty-four mile trip from Water to Todmorden and back to Waterfoot!

Stacksteads Station. This third-class station with wooden buildings opened in 1852 spanning the River Irwell on an island platform. Several private sidings nearby served by narrow gauge tracks transported stone from the extensive quarries to the south. When the single line was increased to a double track, both Bacup and Stacksteads stations were rebuilt, the latter re-opening on 23 July 1880. Demolition followed after the line's closure in 1966 but the disused bridge is still there between Sidings Street and Blackwood Road.

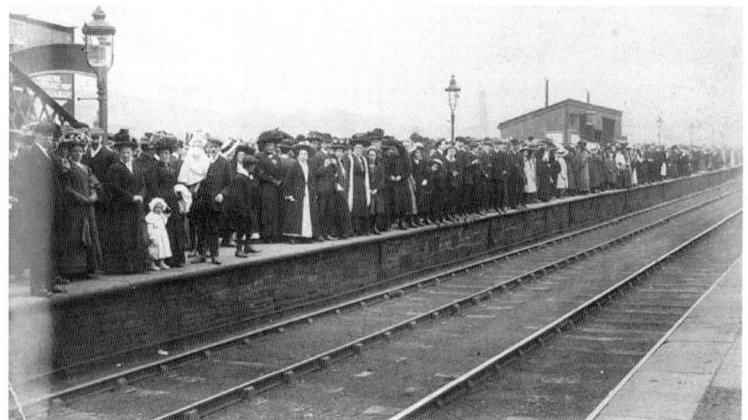

A day out from Haslingden Station, *c*. 1908. The Trades Half-Holiday Association founded in 1886, later renamed the Tradesmen's Association, campaigned for a weekly half-day closure for shop workers and against the late opening hours becoming the norm again! For twenty-one years they arranged popular annual half-day picnics which by 1894 had become full day's outings. Destinations included Boulogne in 1905 and Brussels the following year thanks to the cosmopolitan ideas of their secretary, William Herbert Blayney.

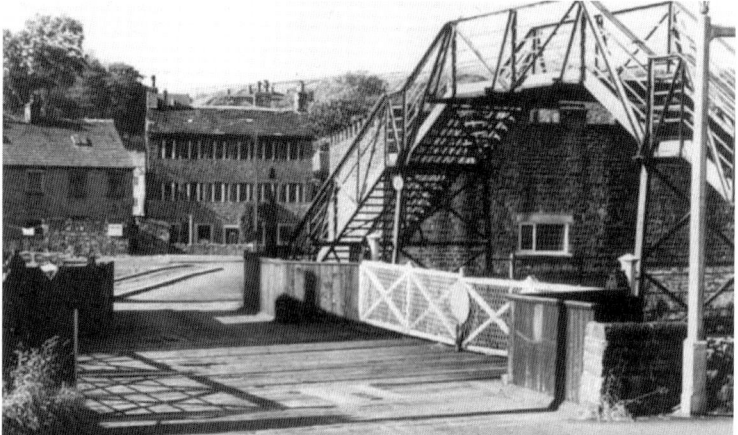

Ilex Level Crossing, Fall Barn, Rawtenstall, *c*. 1966. The railway line extension from Rawtenstall to Newchurch opened in March 1848 but when it closed soon after this photograph was taken, it was replaced on this site by Bocholt Way. The weavers' cottages in the middle of the picture date from the 1780s and are one of the finest examples of surviving loomshops in Rossendale. Saved from demolition in the 1970s after a listing of historical importance, they were bought in 1975 by Rawtenstall Civic Society and carefully restored as its headquarters and are open to the public at weekends and Bank Holidays during the summer.

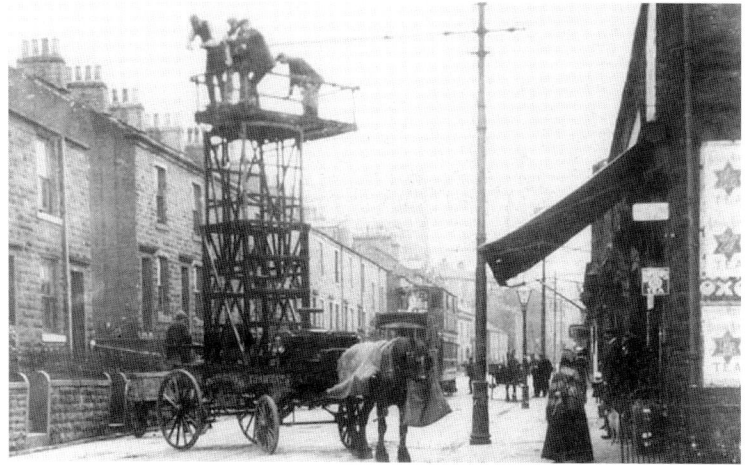

Erecting overhead wires in 1908. Looking towards Haslingden from No. 194 Blackburn Road, a horse-drawn tower wagon, owned by Accrington Corporation's Cleansing Department, is used for installation of the newer technology of electric tramlines! Trams were housed overnight in the John Street depot to enable an early morning service to commence from Haslingden but, when heavy motor wagons and waste paper for the war effort were stored there in July 1916, Accrington officials considered this a fire risk and withdrew the trams to garage them in Accrington.

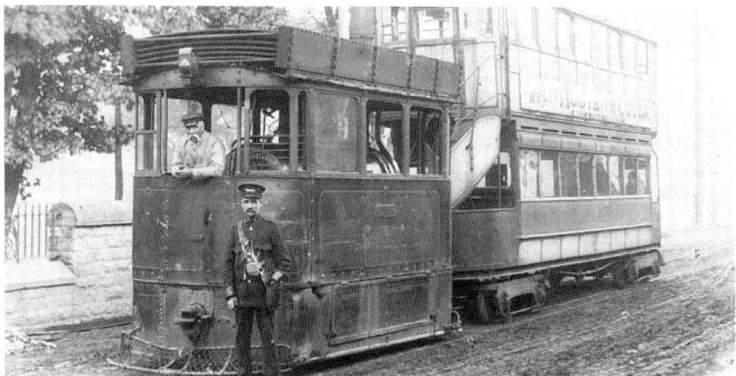

Last of the steam trams, July 1909. The Rossendale steam tram service was the last in Lancashire to be converted to electricity but one of the engines was used for ceremonial purposes for Jubilee celebrations in 1928 and for the official change-over from trams to buses in Rawtenstall in April 1932. Tramway companies were expected to maintain the road either side of the tram lines but the knowledge that corporations had the right of compulsory purchase on the expiry of their lease evidently did not give them any incentive to undertake this as a priority!

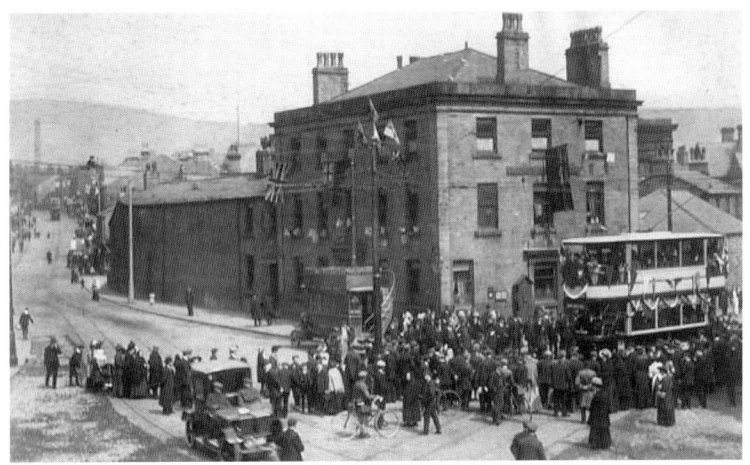

Official opening of electric tramways, Queens Square, Rawtenstall, 15 May 1909. A ceremony at Hareholme Electricity Works saw the christening of the engines followed by a journey around the borough. The cars were driven by the mayoress, Mrs J. Grimshaw; the wife of the chairman of the Electricity and Tramways Committee, Mrs Coupe; and Mrs T. Cryer, wife of the ex-mayor. Proceedings concluded with lunch at Longholme School. Shops and public houses were decorated for the occasion as can be seen here. Note the open top motor bus and early car.

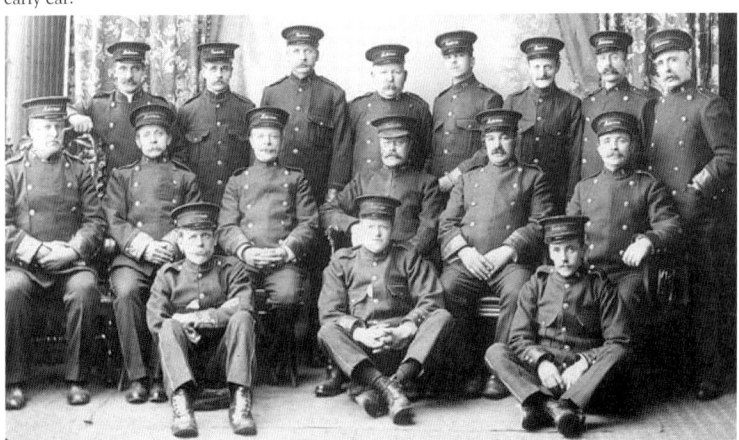

Rawtenstall Corporation tram crew, c. 1909. First on the left in the middle row is Tom Wright, social club steward. Rossendale Valley Steam Tramways Co. was bought by Rawtenstall Corporation but workers were re-employed to work on the electric trams. Their designation, 'Motorman' for driver, 'Conductor' or 'Inspector', is marked on their caps and it appears that applications would be favourably considered from those wearing moustaches!

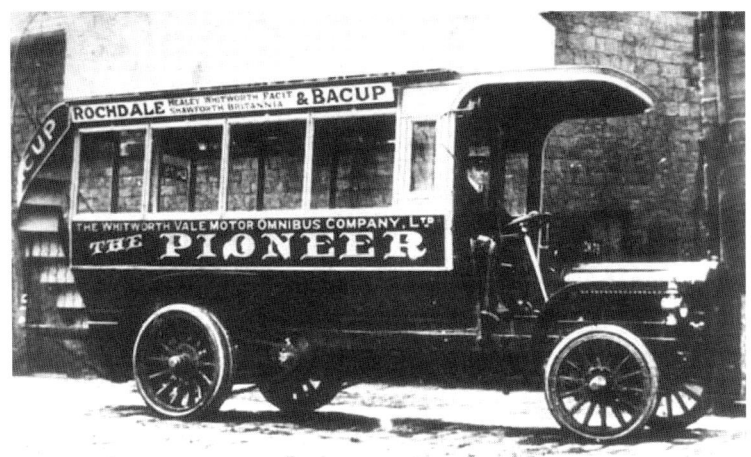

Above: The Pioneer Motor Bus, *c*. 1907. The Whitworth Vale Motor Omnibus Company Ltd. was registered as a limited company in 1906, its prospectus proposing a service from Rochdale to Bacup of 'an up-to-date character' to compete with the 'infrequent and inconvenient railway' whose service ran only every eighty-five minutes. Negotiations with Whitworth Urban District Council to extend the Rochdale electric tramway system had failed due to the £40,000 cost of laying tramlines and Healey became the tram terminus from Rochdale until 1910 when electric trams did finally make their way in to Whitworth. The half-hourly bus service between Healey and Bacup in 1907 provided a less than reliable option but was, however, much used by commuters travelling between Rochdale and Whitworth.

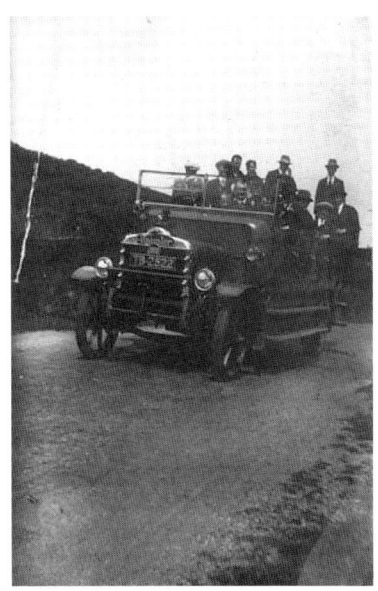

Right: A men-only day out from the Orama cotton mill, Whitworth, 1922. These workers were setting off from the Hallfold mill originally named Thor, which was owned by the Thorburn family and renamed during the war following the death of the owner's son serving on the SS *Orama*. It later closed after a strike and in the 1930s was taken over for the production of wool. Travelling on the open road could not only be an uncomfortable experience on solid tyres with dust or water from unpaved roads thrown on to the unprotected passengers but also a dangerous one. Maximum speeds of 20 mph and less crowded roads did not prevent a fatal accident rate of 76 per cent of today's total.

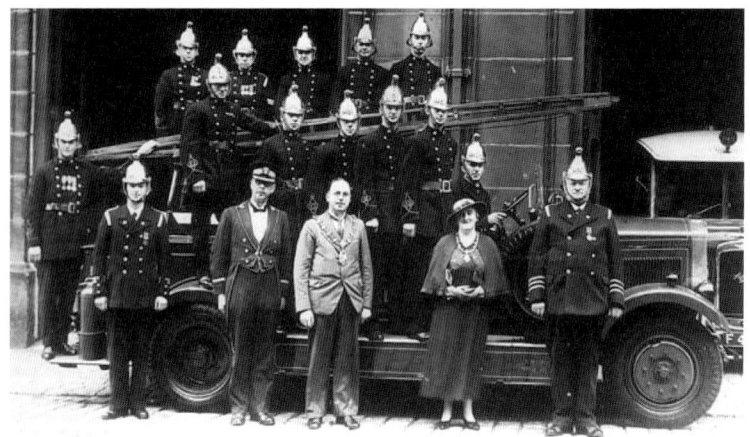

Haslingden Fire Brigade June 1935. A more modern version of a fire engine is standing outside the fire station adjacent to the Public Hall on Regent Street with the mayor, Councillor F. Brandwood, and his wife officiating. A fire brigade of sixteen mostly young men had been established by the Local Board in 1877 after protests about the 'disgrace to the town' that no service was in operation. After the Public Hall was bought by the corporation in 1898, the service transferred to this site from West View on Bury Road with a loan of £3,121 for the construction work. Note the Austin car in the garage.

Burnley Road, Bacup in the snow. The wonder of the combustion engine meets its match in the snows of Bacup! The programme for the Festival of Britain celebrations of 1951 in Bacup highlighted the delights of local climatic conditions when a gentleman arriving at the railway station was reputed to have asked a small boy 'Does it always rain in Bacup?' The boy replied, 'Oh no, it snows sometimes!'

Nine

Peace and War

Folly Clough, Crawshawbooth, c. 1900. The 'jewelled splendour' of this popular beauty spot with its 'walls of emerald' was said to be the haunt of the fairy, Jenny Greenteeth, and was visited by local residents for many more leisurely pursuits than this one! Note that at least the combatants' feet are well protected!

Garden Party, possibly in the grounds of Stubbylee Hall, Bacup, *c.* 1905. James Maden Holt lived here from 1856 until his death in 1911 when he bequeathed it to the people of Bacup and the park was officially presented to the corporation in 1914 with the hall used as municipal offices from 1920. As another influential industrialist, Holt financed the building of St Saviour's church, vicarage and school and, during the cotton famine, created work for the unemployed in laying setts on Rooley Moor Road, hence known as Cotton Famine Road.

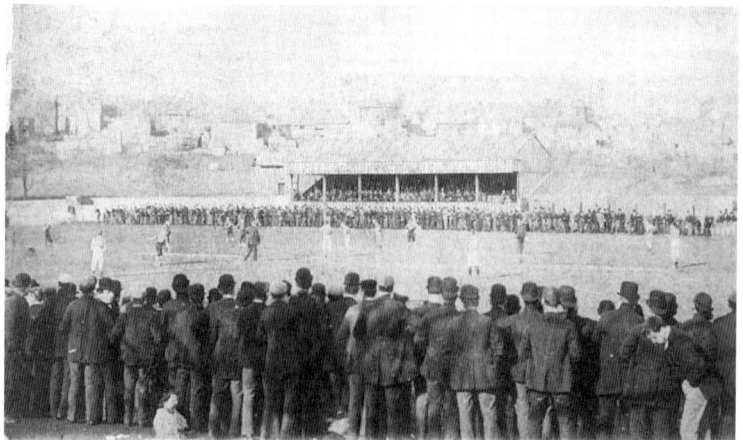

Rossendale United Football Ground, Newchurch, taken by Lewis Lord in 1908. Sandy and Wally Lamberton travelled from Scotland to work in Waterfoot in the 1870s and introduced local men to the rugby which they had played at home. The resulting Myrtle Grove team, based at Dark Lane, was superseded by a new Rossendale team playing the more popular football. The club disbanded for a season but another group founded Rossendale United on 6 July 1898 and their first annual meeting was held at the new Liberal Club in Waterfoot.

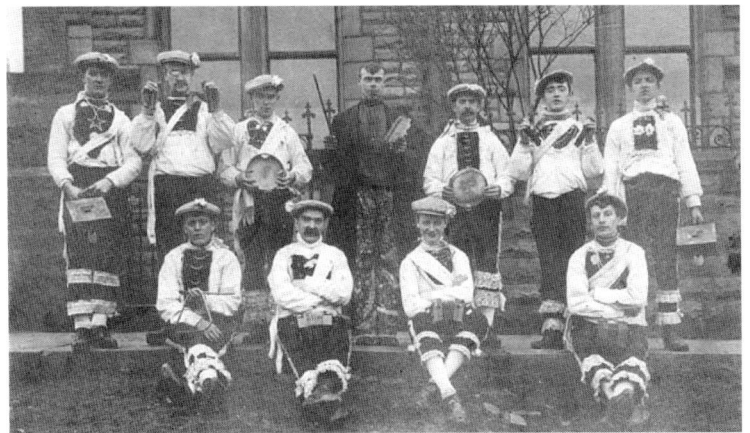

Pace Eggers, Haslingden, 1910. Every Easter, Jolly lads, in ribbons and flowers, would parade around their neighbourhood singing rhymes and playing tambourines and other instruments for pennies collected from bystanders. Some groups of pace eggers, such as these, performed plays all based on the story of St George and special sashes and tin swords were sold in Rochdale in the 1920s as pace egging costumes. Eggs, hard-boiled and decorated, were originally given to the performers and used in egg rolling contests.

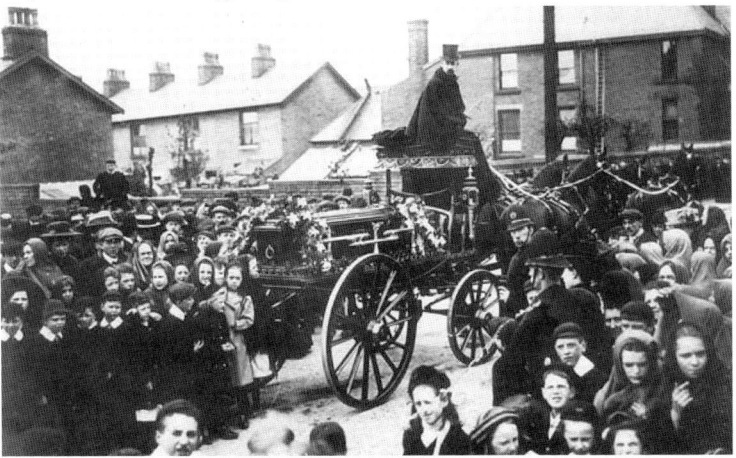

Father Notterdam's funeral, Haslingden, May 1910. Peter Notterdam was born in Belgium but ordained in Salford in 1887 and served many east Lancashire churches, devoting himself to alleviating poverty and suffering. Unfortunately, his health began to fail soon after becoming the pastor of St Mary's RC church in November 1904 but, before his premature death at forty-nine, he gave considerable assistance to the sick and dying at Haslingden Union Infirmary and Workhouse, now Rossendale General Hospital.

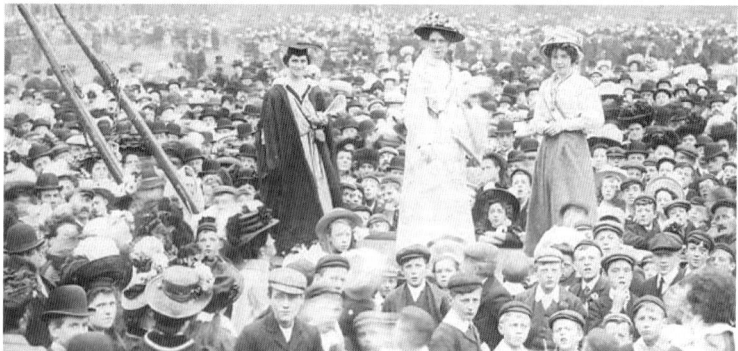

Edge End Farm, Crawshawbooth, *c*. 1912. Here the ladies, Emma Stott and her daughter, have given up their seats for the gentlemen! Emma's father, Thomas Henry Bishop, is sitting on the right. A studio portrait with a difference, the rug and pot plant are used in the unusual setting of a cobbled farmyard. Note the slippers worn by Thomas, possibly forgotten for this formal photograph taken outside!

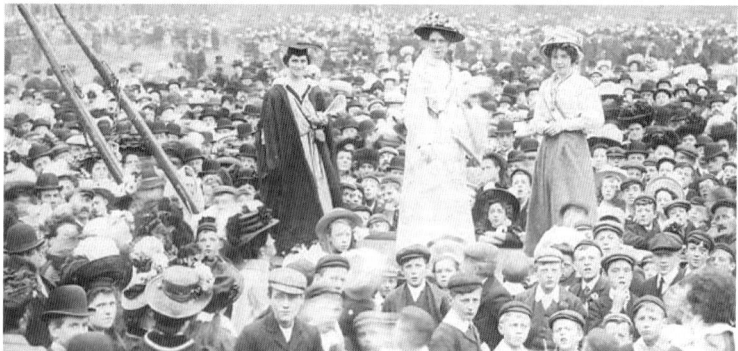

Votes for women meeting, Bacup Road, Rawtenstall, *c*. 1910. Speakers include Miss Clarkson and Miss Marsden. The Rossendale suffrage campaign began at Christmas 1909 when twelve suffragists travelled from Manchester to publicise their parliamentary candidate, Arthur Kilpin Bulley, by organising lunch hour meetings at mill gates and evening speeches in town squares. Bulley, a Liverpool cotton broker and keen horticulturist who founded Ness Gardens on the Wirral, polled a mere 639 votes in the 1910 General Election against the sitting Liberal MP, Lewis Harcourt (see also p. 49). One wonders on the extent of curiosity value for these meetings given the number of young boys in the picture!

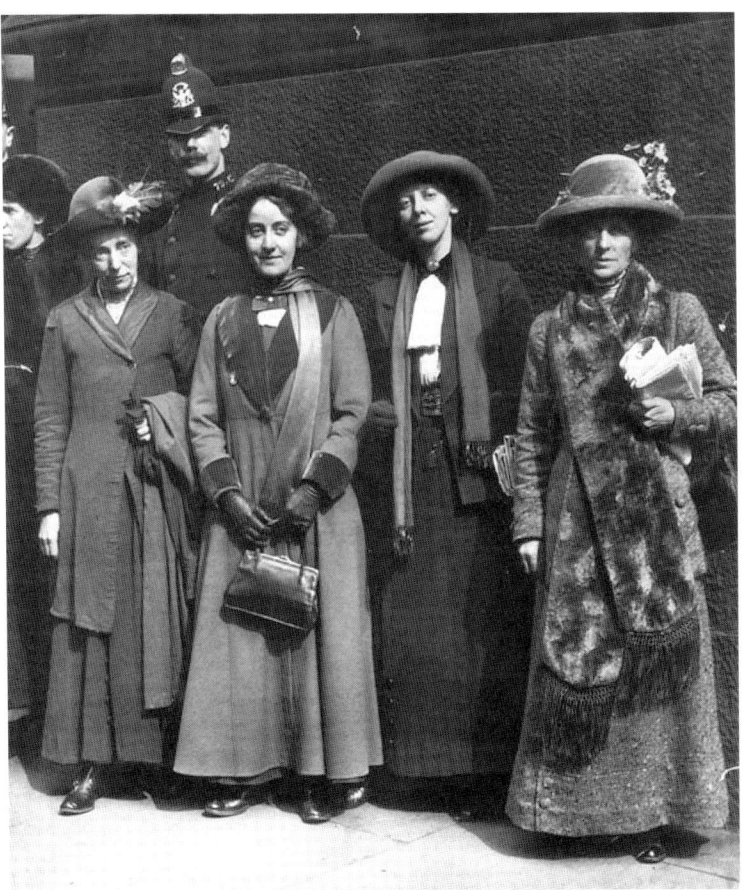

Suffragettes appear in court at Manchester, 1913. Left to right: Annie Briggs, Evelyn Marresta, Lilian Forrester, Jenny Baines. The first public women's suffrage meeting in 1868 in the Free Trade Hall was attended mainly by middle class women but, by the 1890s, considerable support had been drawn from working class women because of their experience of harsh conditions and low pay in the textile mills. During a bomb scare at the museum in Whitaker Park, Rawtenstall on 24 May 1913, a caretaker found a tin canister full of charcoal and a fuse with a note saying 'Votes for Women! Votes we mean to have!' However, it was only women's contributions to the war effort which changed attitudes nationally and in 1918 women over thirty were granted the vote, extended to those over twenty-one ten years later.

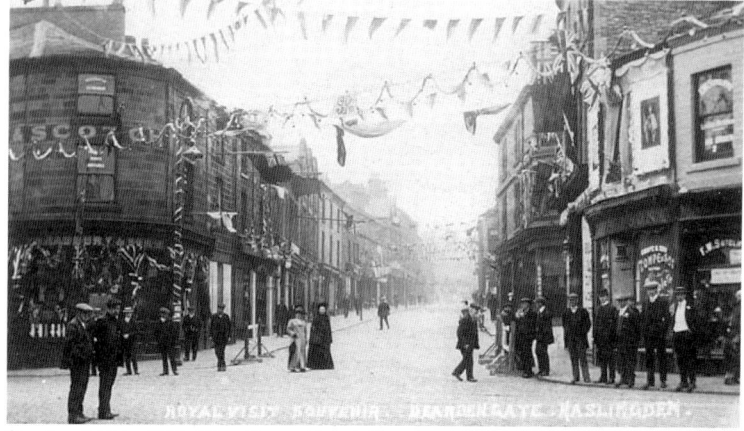

The Royal Visit, 1913. King George V and Queen Mary spent 'a long and tiring week' in Lancashire from 7 July 1913, expressing a wish to see its industrial life. On Wednesday, they departed from Lord Derby's home in Knowsley at 9.55 am for the train to Colne, then driving through Nelson, Burnley, lunching at Gawthorpe Hall with Lord and Lady Shuttleworth, on to Accrington, Rossendale and Rochdale, departing from there at 6.40 pm – a whirlwind tour indeed! On arrival in Haslingden, above, the mayor, Alderman J.T. Warburton, greeted them and announced a public appeal to raise funds for a motor ambulance to commemorate the visit. *Below*: Mills closed at noon to allow workers to begin gathering in front of the royal stand on Bacup Road, Rawtenstall along with 4,000 school children. The party arrived at 4.05 pm to one of many 'excellent receptions' to be introduced to the mayor, Councillor Joseph Grimshaw JP, and other officials, and the king congratulated the town on the beautiful platform enabling so many people to be present. They left at 4.15 pm!

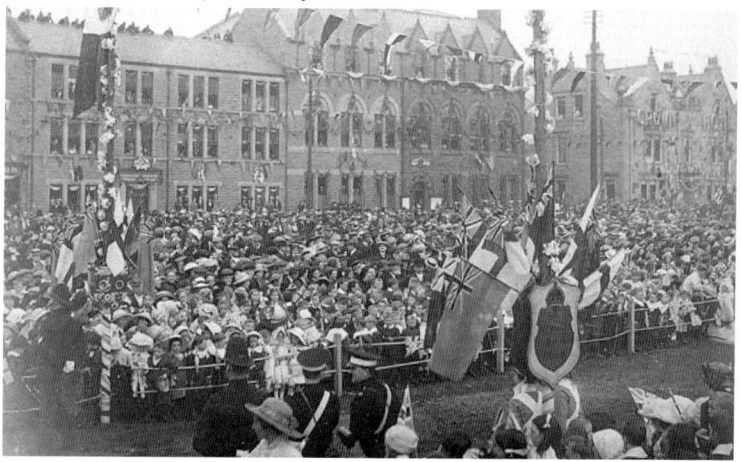

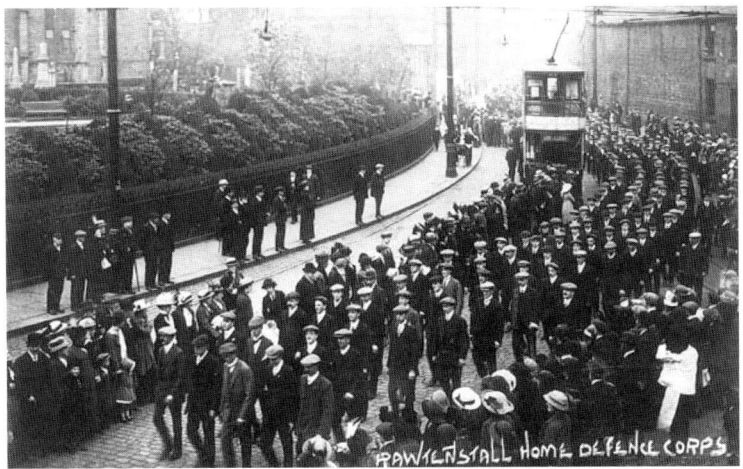

Civilian Defence Corps, Rawtenstall, *c.* 1914. Home defence volunteers, many of them too old for active service, were allocated essential duties including work in textile mills and their initial enthusiasm is evident from the number marching down Bank Street. Telegrams from the war were posted in the windows of the library and their contents telephoned to other information points at the fire station, shops, public houses and councillors' homes.

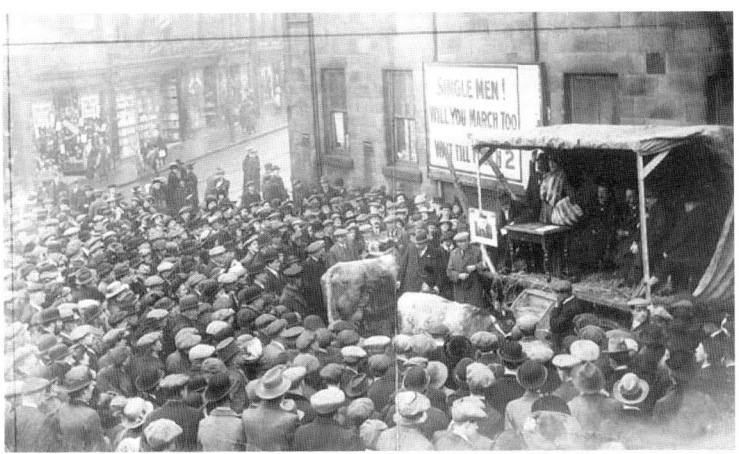

First World War recruitment campaign, Mechanics' Institute, Bacup, *c.* 1914-1915. When war was declared on 4 August 1914, the army was manned by volunteers but the number of recruits could not keep up with the demand and, in July 1915, the National Registration Act compelled men between 15 and 65 years of age to register followed by conscription on 27 January 1916. Men used to enlist at the Mechanics' Institute and receive the 'King's shilling'.

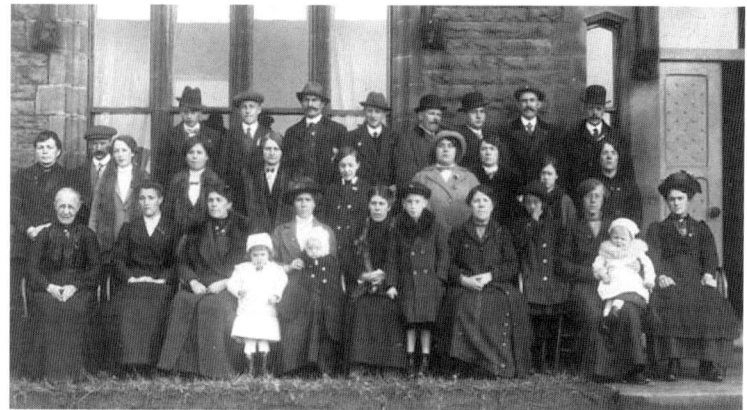

Belgian refugees at Edgeside Hall taken by Walter Heys, Waterfoot, c. 1915. The hall (see p. 81) became a welcome home to thirty-one Belgian refugees, who were greeted on their arrival by thousands of onlookers waving flags and who stopped working until their procession had passed. Many local people had donated beds and other items of furniture for the newcomers who repaid this hospitality by working hard in the gardens and a few of whom stayed on after the war.

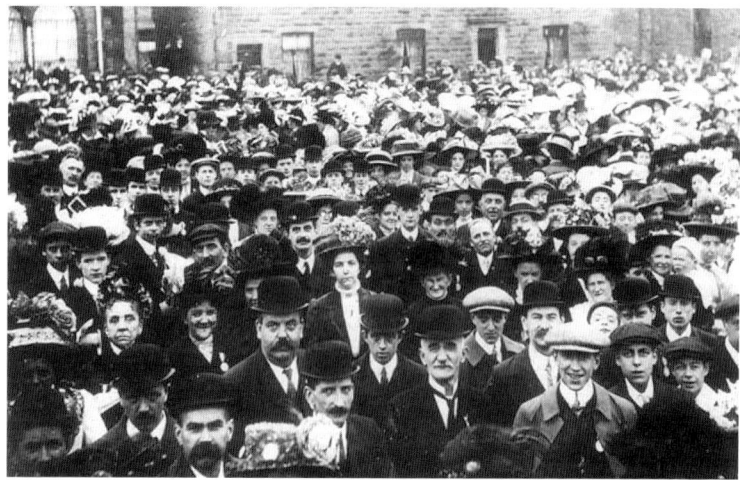

Peace celebrations, Marsden Square, Haslingden, Saturday 19 July 1919. A morning service with hymns was followed by sports activities in the afternoon and an evening firework display with 6,000 children from seventeen of the nineteen Sunday schools participating in the events. Everyone who attended the morning processsion received a peace commemorative medal, worn by many in the crowd. The inmates of the workhouse had extra cause to celebrate when they were served special meals by courtesy of the Board of Guardians.

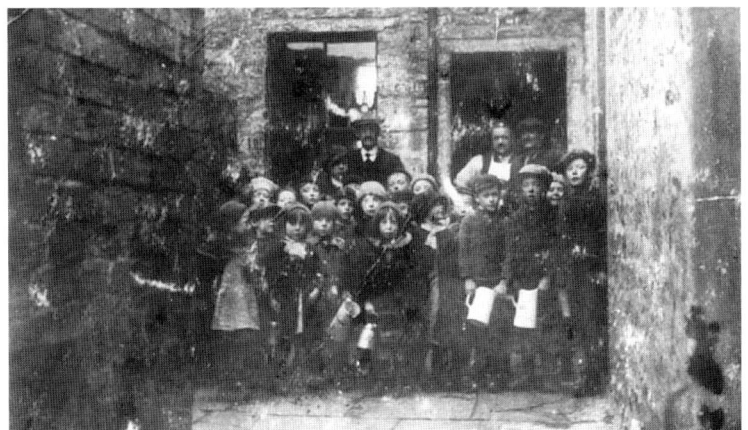

Poor children in Haslingden waiting for soup, c. 1920. The aftermath of war with its national debt brought higher prices and taxes with unemployment soaring to two million in 1921. This was especially severe in Lancashire where a shortage of raw materials for the cotton industry during the First World War had caused the beginning of the industry's decline. Many children suffered malnutrition and, in an attempt to cope with increasing welfare demands, the government recommended that out-relief granted by the Haslingden Board of Guardians in 1922 should be reduced from £3 to £2 10s. The Victorian Poor Law structure did not survive long and was dismantled completely in 1930.

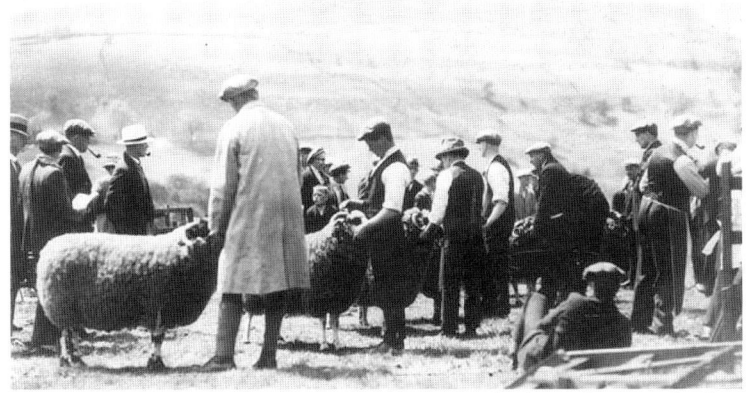

Kirk Show, Newchurch, 1923. An agricultural cattle show was held annually in Newchurch on 29 April with another grander affair following on the first Monday after midsummer's day. On 4 July 1874, the *Bacup Times* considered that the Kirk Fair 'must be visited to be appreciated. It beggars description.' Animals and 'articles of clothing and pedlery' were bought and sold but there were other such delights as roundabouts, theatres, marionettes, skittles, thimble ringing and wheels of fortune.

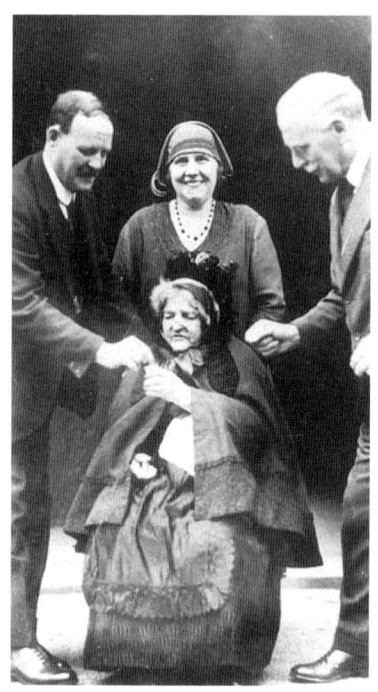

Left: Arthur Law MP on the left on the campaign trail with his wife, Lucy Ellen, *née* Whittaker (standing), in the late 1920s. The first Labour MP for Rossendale from 1929 to 1931, Arthur started work for a railway company when seventeen years old and achieved the dream of many a small boy in working his way up to be a driver of express passenger trains. Not content with this, however, he played an active role in the union which later became the National Union of Railwaymen. He was adopted as Rossendale's parliamentary candidate in 1926, the year of the General Strike, fighting his campaign on the promise of full unemployment benefit.

Below: Anti-gas training for Ivy Hill, centre, in Haslingden, 1938; Ivy was Haslingden's Borough Librarian. Gas masks had to be carried at all times but the cases were uncomfortable as were the masks themselves. The eye pieces soon steamed up and attempts to stop this by rubbing soap inside the mask only resulted in sore eyes! Children used to carry sweets and secret treasures inside their masks which could prove embarrassing if there were a sudden gas drill! The heavy masks were, however, useful for fighting and the child with the most dented gas mask was the hero!

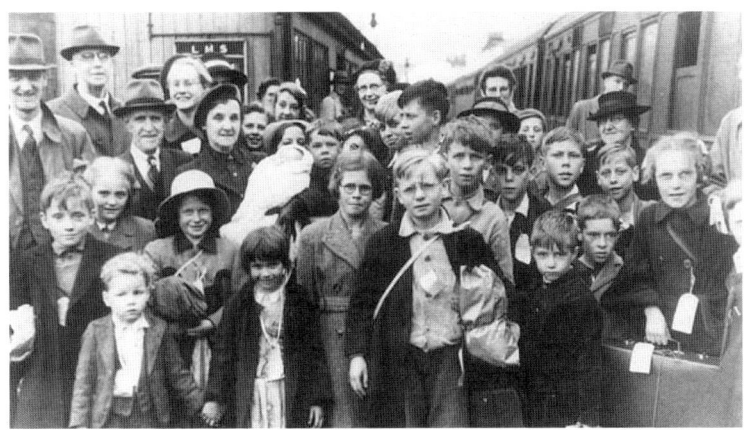

Evacuees from Salford in Haslingden, 1939. Plans to evacuate 190,000 children and adults from Manchester were put into effect from 1 September 1939 and, after earlier rehearsals, this railway trip was the 'real thing'! Each child had to take the obligatory gas mask, identity tag, a change of clothes, night-clothes, hankies, slippers, toothbrush and comb, face-cloth, towel and soap and food for twenty-four hours, many of which caused problems for poorer families. A warm coat also had to be worn, as seen above at the station, even though it was a very hot day! Children were allocated the number of a railway carriage in which to travel with ten other children and one helper and, on arrival, they were taken to the reception centre at Albert Mill for allocation to their new homes by the Billeting Officer. Evacuation proved a traumatic experience and a culture shock for some children and their hosts and, when the anticipated bombing raids failed to materialise, 40 per cent of the unaccompanied children had returned home by January 1940. A party is held below at Haslingden Library with toys and sweets provided by the USA.

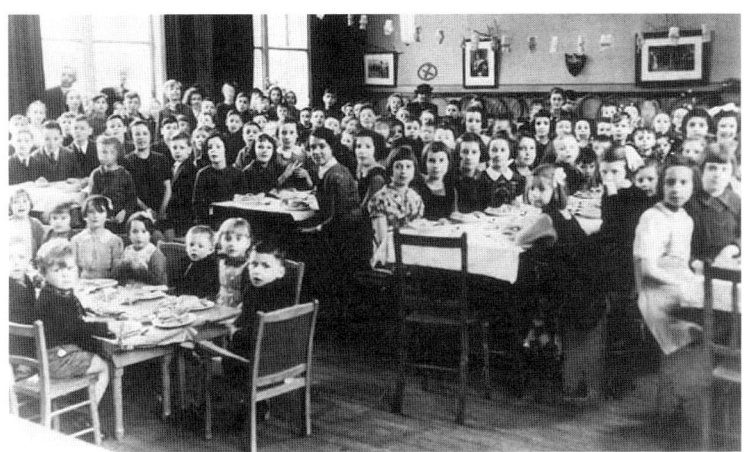

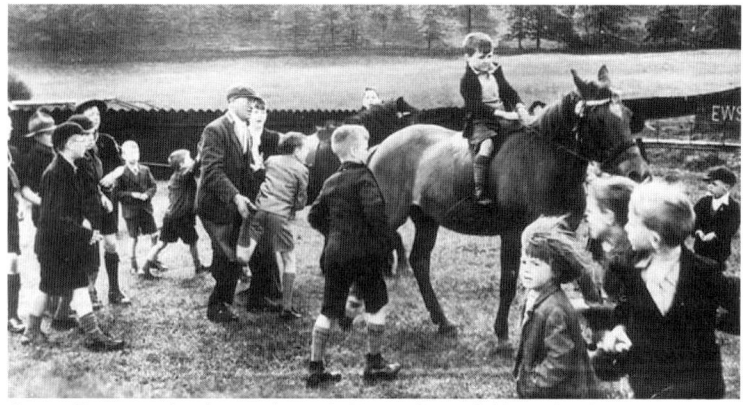

Georgie Berry providing horse rides on St Mary's playing fields, Haslingden, 1940s. Georgie was a popular rag and bone man using his horse and cart to collect household rubbish and was still giving out donkey stones to customers in the 1960s. Members of the WVS were appointed salvage stewards during the Second World War and organised local children, 'cogs', in collecting waste paper, metal and household bones for the war effort; they are here being entertained as a way of saying 'thank you'. Note the EWS sign – Emergency Water Supply.

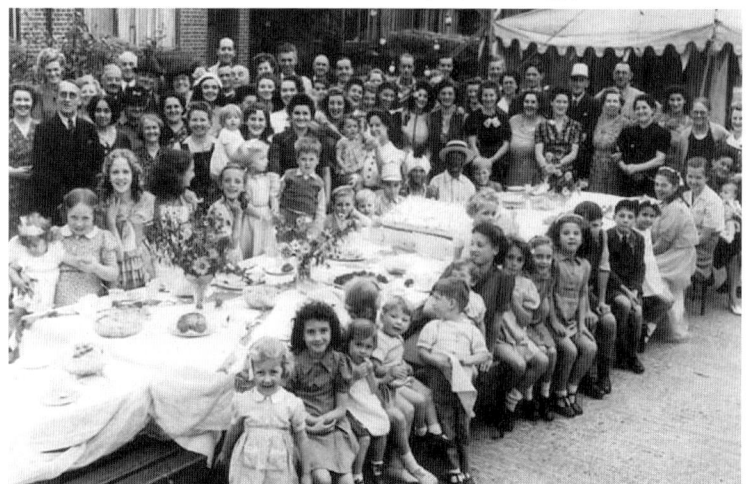

VE Day Celebrations, possibly Stacksteads, 1945. Victory in Europe Day on 8 May was celebrated with as much fervour in Rossendale as the rest of the country with bonfires on the hills and street parties. Fairy lights in the centre of Bacup lit up the area for music and dancing and one Bacup butcher celebrated his patriotism in style with black puddings and eggs decorated in red, white and blue! Do you recognise the street or any of the party-goers? If so, or if you can provide information for any of the other photographs, please contact Rawtenstall Library.

Index